Charm,
Belligerence
& Perversity.

THE INCOMPLETE WORKS OF GBH.

Peter Hale

Mark [signature]

[signature]

**black dog
publishing**
london uk

We've worked with Philippe Starck for over 15 years now. We naturally thought it would be a nice touch if he'd write us a foreword. We asked him and this is what he sent back....

FRIENS OF ELEGANT GRAPHIC DESIGN
Bonjour.

GBH
is :

WICKED
CHARMING
PERVERSE
RADICAL
SHOCKING.
BELLIGERENT
ELEGANT
ANIMAL
HUMOUROUS
UGLY.
POLITICAL
VIOLENT
~~OBSCENE~~
POLITE
VERY

HAPPY TO READ YOU.
FANTASTIC LIKE ALWAYS.

PH.S
MERCI

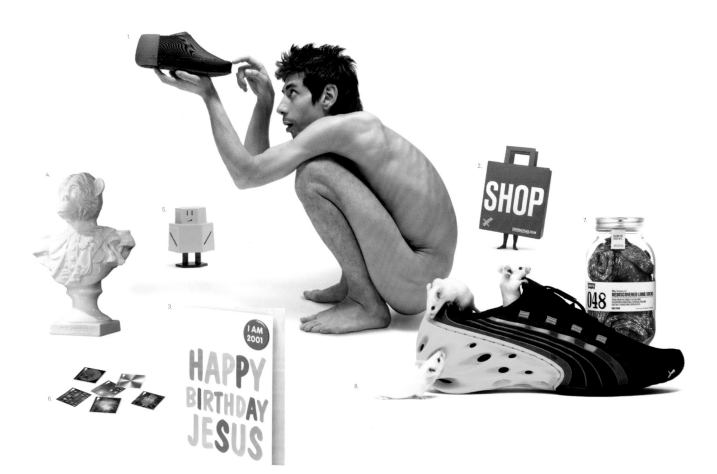

1.

2. **SHOP**

3. I AM 2001
HAPPY BIRTHDAY JESUS

4.

5.

6.

7. 048 REDISCOVERED LONG SOCKS

8.

9.

How to use this book.

Fig (i)
The GBH Business Model

GBH on the Couch.

We've always wanted to make a book about our work, but ever since someone mentioned the phrase "vanity project" we've shied away from it. The last thing we wanted was to make one of those self-aggrandising coffee-table books— a monument to 20 glorious years in the business-kind of thing. We wanted to do something that felt a little more 'us'. We just had to be sure what 'us' was. So when we finally decided the time was right to collect our works together into this modest tome, we realised we had to put ourselves on the couch, dive deep and take a good look into the GBH psyche....

Coffee-table book | noun. A large, expensive, lavishly illustrated book, intended to impress. A long-held dream of every designer.

What we concluded, after some light Freudian analysis, was that the success of GBH has forever rested on a knife-edge. We realised that we're a group of complimenting and opposing personalities, an oddball mix of approaches, skills and viewpoints. Our fragile creative process led by a range of emotional and irrational factors. Of course there's overlap and agreement, but there are differences and tensions and the full spectrum of strange psychological states that we go through, individually and collectively, on the road to making good stuff. Immersed in a process that's hard to plan for, manufacture or even analyse too deeply. But within all this we also realised there's a strange alchemy that's led us to interesting places, surprise and joy. That alchemy we've managed to boil down scientifically to three distinct qualities which we believe are at the heart of our continued success: charm, belligerence and perversity.

These qualities are how we've managed to dream up the stories, ideas and images we have and how we've battled and bewitched our clients into letting us make them. Of course, the delicate balance of a creative partnership is ever present, driven by the internal battle of emotions: fear and paranoia, self-loathing and despondency, exuberance and elation, bravado and self-belief. Like any functioning personality, we've developed coping mechanisms; project managers ensure

things stay on track, administrators make sure the business ticks along and we've even developed a little science to convince the world there's method to the madness. But the emotions are always there, bubbling just beneath the surface.

This book is a collection of our favourite projects seen through the filter of the GBH psyche. Categorised and classified not chronologically, not based on clients, not even on media, but by psychological state. A rounding-up of recurring thoughts on our profession that will hopefully evoke a feeling of what it's like to do this job if you just so happen to be considering getting in to the business. There's no design agency jargon or puffery here— just a frank look at some of the issues that we and everyone else in our industry experiences on a daily basis but aren't stupid enough to write about. Like, how making great work is similar to tearing out a piece of your heart to mollify an angry God. How it's emotionally draining and means constantly having to reinvent yourself. How absolutely nothing is ever good enough, processes are inefficient and it's often quite scary. But please don't get the wrong idea—it's not always that much fun.

We like to say GBH is a "not normal agency". We'd like to think this is a "not normal design book". Commercial suicide, obviously—but let's give it a go.

GBH, NOVEMBER 2016

Fear of Failure.

Welcome to the deepest recesses of the GBH psyche. We'd like to tell you it's all puppies and kittens in here, a kind of Willy Wonka factory of maverick creativity. Wise characters dressed in colourful blazers sharing brilliant philosophies on design, scores of upbeat artisans creating beautiful imagery and objects in real time whilst rays of positivity and confidence brim from every surface. But it's not like that. It's dark in here. It's cold and at times it can be rather lonely. Because at the heart of GBH is the fear of failure.

Failure / noun. A lack of success. GBH's second project was a book titled The Extraordinary World of the Football Fan. *It took six months to design. The day after its launch, we took this picture after seeing it in the window of a second-hand bookshop in Notting Hill.*

We like to think of the fear of failure as an overarching umbrella which houses an array of anxiety-inducing subsets: fear of looking stupid, fear of scary clients, fear of frosty suppliers, fear of big presentations, fear of the great unknown (and sometimes the even-greater known), fear of money (and running out of it), fear of people who know so much more than you, fear of being told you're out of touch, fear of being safe and boring, fear of the perpetually looming deadline (it will never, ever go away), fear of knowing that it's just a matter of time before you get found out by the talent police and finally, fear of yourself. This, my friend, is the happy reality that lies at the heart of our, and probably any, creative agency.

It's ironic really. With a name like GBH you'd think we'd be as hard as nails. Throw our weight around willy-nilly, bully clients into accepting high-risk concepts even if they have only a slim chance of success. You'd expect us to have a few epic battle stories where a creative type is up on a boardroom table, making an impassioned Braveheart-style speech while dangling a laptop out of a window. Or maybe locking the boardroom door and sitting it out until the client breaks and agrees to "go with that insane (but interesting) idea". Or dramatically storming out of that boardroom shouting something about "pussies". But somehow, it's not like that. In fact, it's never been like that.

You see, despite the fact that we're awarded, respected, consulted, courted, feared (OK, maybe only by graduates who haven't seen behind our curtain yet), after nearly 20 years of dazzling and delighting with big ideas and beautiful image-making, we've never overcome that feeling of panic

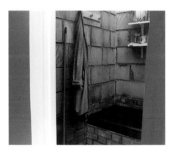

PUMA Stores
Branding and Interior Installations

One of our first big projects has also gone down in GBH folklore as one of our most frightening after we were approached by PUMA to help reinvigorate their expanding retail presence, bringing the brand's trademark irreverence and wit into what were then very stylish, but neutral, interiors. Thus we kicked off a series of untried and untested ideas, code-named 'Redworld', that continued over several years.

One initiative was changing rooms designed to transport shoppers to unexpected environments. Making bespoke wallpaper, we soon realised that no PUMA changing room in the world was a common dimension.

At the same time we had the idea to shock customers by placing realistic latex mannequins in stores. Each mannequin was life-cast from a PUMA customer by Hollywood prop makers—some sported overly personal details! We also styled them to look appropriate to the cities they appeared in, for a little added realism.

While dealing with issues arising from using naked rubber people, we began embarking on various video installations like the 'interactive shoe wall'. An overly ambitious POP display rewarded customers for picking up a shoe by playing positive film clips, then playing negative versions when they put the shoe back down.

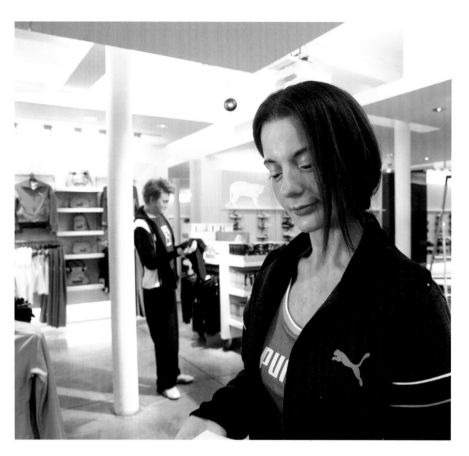

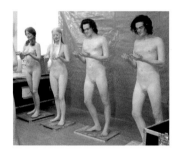

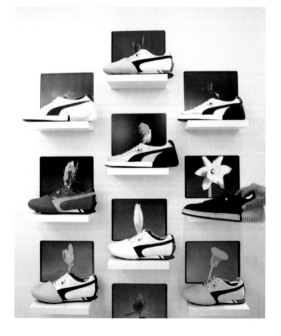

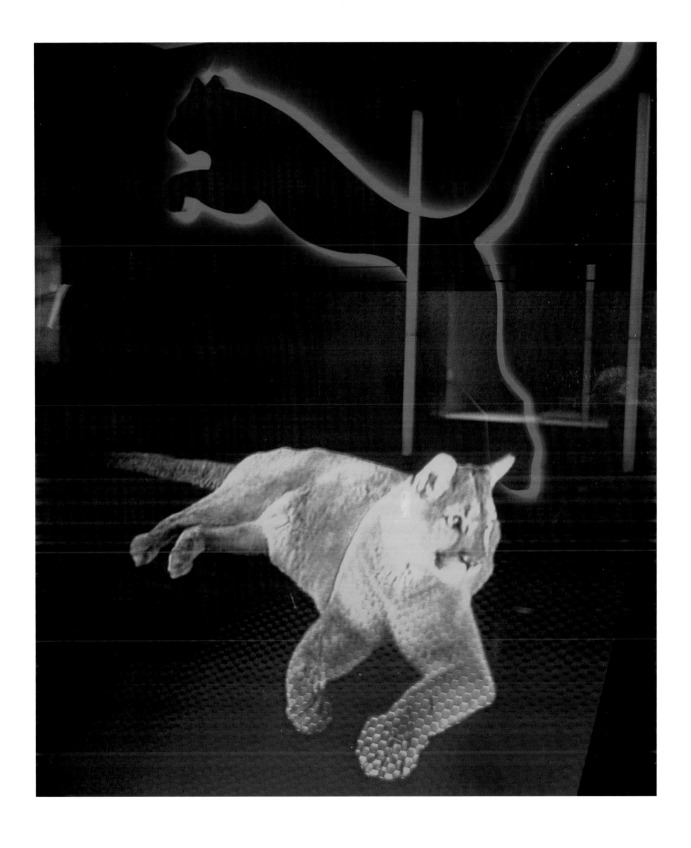

Dylan the Real Puma
In-Store Cat and Other Projections

It seemed like the most obvious and straightforward idea to us—why not put a real live puma in their stores? He could walk around in the day then sleep in the window at night. As soon as the words were uttered in the presentation, the fear started to build. So many questions.... Where do you find a puma to film? What can you expect it to do? How do you project it on the walls of the store, make it walk around and look realistic? And why is all this complicated tech making a simple idea so very expensive?

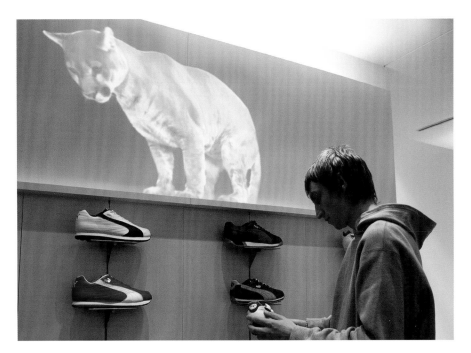

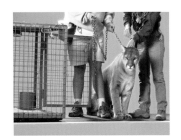

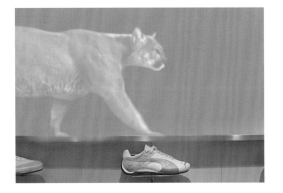

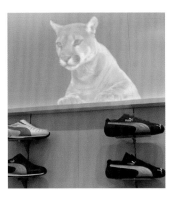

A shoot with Dylan the puma and Siegfried & Roy's white tiger handlers in LA generated hours of footage. Green screen removed, the difficult task of using DMX code to keep the image sharp and keystoned across 8-metre distances began. Complex angle maths and playlists were created for each store's unique space and finally PUMA's puma prowled the store, just like we drew it.

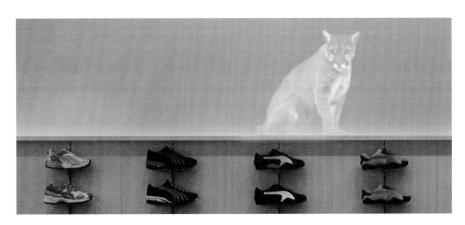

when that fantastic new brief lands on our desk. After the initial elation and happiness that always comes with being offered a new project has subsided (by the way, we really do appreciate the work) a whole gamut of darker thoughts begin to build. "Hang on, this is complicated, how can we possibly make sense of this mess? And what about the time, there's not enough time! Oh god, did we over-promise? The expectations are huge, how will we make it better than the last thing we did? They'll be expecting the Second Coming, what if we don't live up to the reputation? Come to think of it, does the client actually know who we are or what we do, maybe they've mixed us up with another design agency? What if we unwittingly tricked them into commissioning us?" These are all, to varying degrees, fairly typical responses at GBH.

The question is, is it really all that wrong or unusual to feel this way? Are we just overly sensitive oddballs? Surely all creatives have feelings of insecurity, right? After all, we're doing a creative job that requires us to reinvent ourselves with every new brief. To put our ideas, our reputation and ourselves in the firing line. Thinking about it, isn't this exactly what we like about our work and our daily lives? Getting to do different things and to do things differently? So are we all suckers for punishment? Or are we maybe addicted to the spikes of sheer unadulterated pleasure that come from being thrown into peculiar and unknown situations? The answer is "A bit of both".

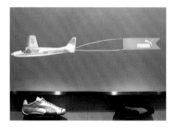

A few years ago, when GBH was a new kid on the block, we made it our mission to be the most creative group around. It was more than a company

Land Securities
'Multiple Choice' Campaign

Bankside Mix is a Land Securities development of shops and restaurants located at Bankside, London—an area bursting with culture, from Shakespeare's Globe Theatre and art at Tate to historic walks and landmarks. As a place that attracts people looking for mental nourishment, we were nervous about how to sell down-and-dirty consumerism to such a highbrow audience. In the end, rather than fight it, we just went with it and acknowledged that this is the mall to drop in to if you need a break from all that culture. A no-frills aesthetic completes the no-nonsense humour.

policy (there were only three of us in a tiny room with a computer so it was barely a company at all), it was a personal obsession. As personalities, we got a thrill out of surprising, delighting, outsmarting and making people smile through the work we did (for the record, we're convinced this is still the best way to reach an audience). Sure, we wanted to make a living from doing what we did, but the big draw was in getting to do unexpected and unusual things. And we were addicted to the buzz you get from playing mental ping pong. That's when, unwittingly, we chose the 'difficult option'. Rather than being content with playing it safe and giving clients exactly what they'd asked us for, we innocently embarked on a path of difficulty, anxiety and fear because we made a choice to do things the interesting but hard way.

The history of GBH projects is chock-full of examples of doing it the hard way. Trying to give direction (using tasty cuts of meat) to a live puma. Attempting to project Arsène Wenger onto a 25-foot wall of water on a freakishly stormy night on the River Thames. Needing a Japanese model with full-body tattoos who'll be happy to pose naked for us. Having to commission ten original oil paintings for a five-star hotel with a $1,000 budget. Looking for a way to apply a black livery to the deck of a competitive sailing boat even though each and every one of the 12-man crew wants to take you below deck and beat the shit out of you. All activities designed to invite unforeseen problems at every turn and to induce maximum anxiety when the clock is ticking and you have no idea if what you are doing has any chance of working.

☐ Romeo
& Juliet

☐ Gilbert
& George

☒ Sausage
& Mash

New Cafés & Shops
behind Tate Modern
banksidemix.co.uk

Bank**Side** MIX

☐ Russian
play
☐ German
artist
☒ Irish
coffee

New Cafés & Shops
behind Tate Modern
banksidemix.co.uk

Bank**Side** MIX

☐ Mondrian

☐ Monet

☒ Margarita

New Cafés & Shops
behind Tate Modern
banksidemix.co.uk

Bank**Side** MIX

☐ Look round
a church

☐ Look round
a gallery

☒ Look for a
new frock

New Cafés & Shops
behind Tate Modern
banksidemix.co.uk

Bank**Side** MIX

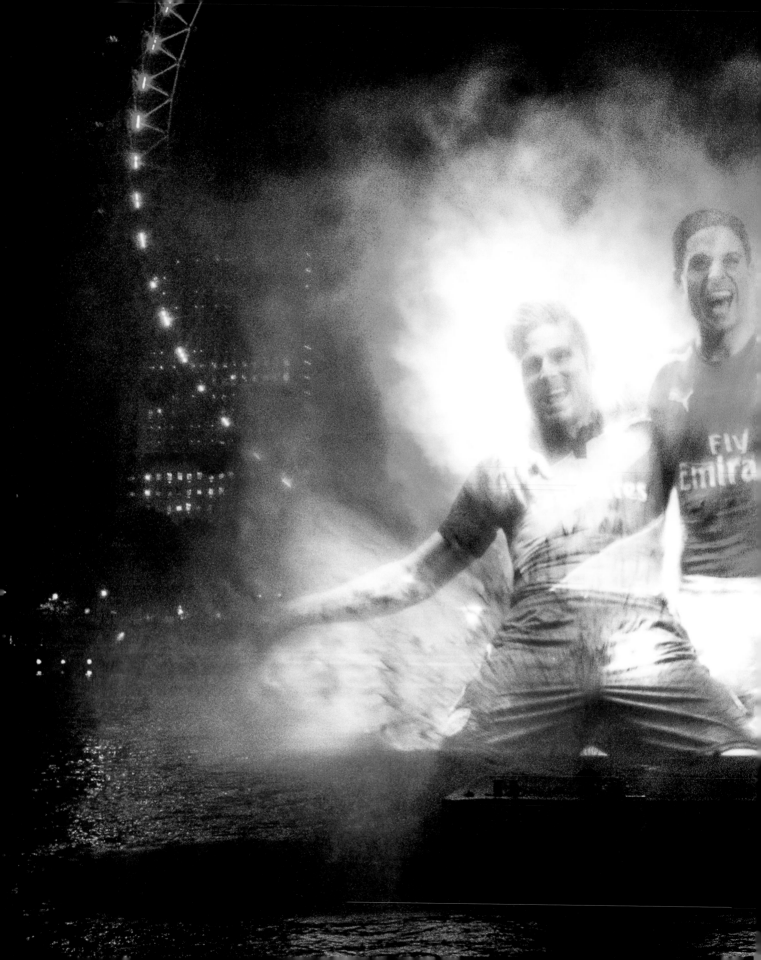

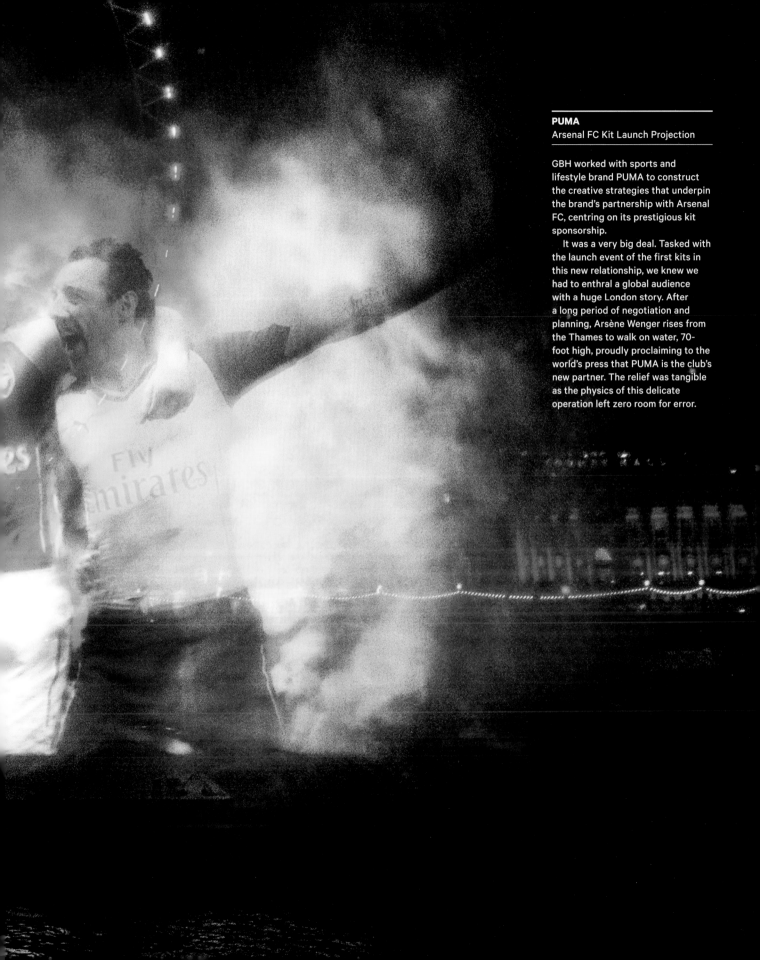

PUMA
Arsenal FC Kit Launch Projection

GBH worked with sports and
lifestyle brand PUMA to construct
the creative strategies that underpin
the brand's partnership with Arsenal
FC, centring on its prestigious kit
sponsorship.
 It was a very big deal. Tasked with
the launch event of the first kits in
this new relationship, we knew we
had to enthral a global audience
with a huge London story. After
a long period of negotiation and
planning, Arsène Wenger rises from
the Thames to walk on water, 70-
foot high, proudly proclaiming to the
world's press that PUMA is the club's
new partner. The relief was tangible
as the physics of this delicate
operation left zero room for error.

A shoot with Arsène Wenger and PUMA players Olivier Giroud, Santi Cazorla and Mikel Arteta was organised at Elstree Studios. The resulting film starred the London Eye as Arsenal's famous 'Clock End' clock and was broadcast live from the banks of the Thames, halfway between their Woolwich past and their Emirates Stadium future, projected via a 25-metre high wall of water sprayed into the night sky from a pontoon.

The event was time, tide and weather-sensitive but streamed live to millions worldwide via a timed satellite link. Testing the system from the water in the middle of the Thames, we had a freakish rising tide and a forecast of storms set to ruin it all. The final process was more about mathematics than design, but with distances calculated, tide levels finally agreeable and everything crossed, we were ready to go. With a remote control for the London Eye's lighting system in our pocket, walkie talkies in our hands and the Thames River Police watching on intently, what could possibly go wrong?

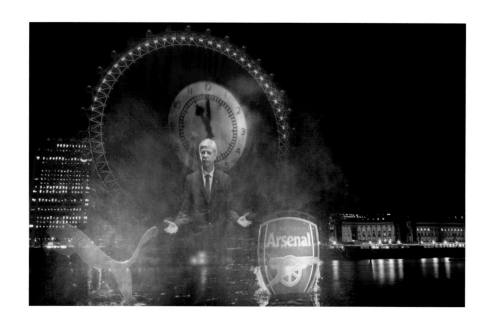

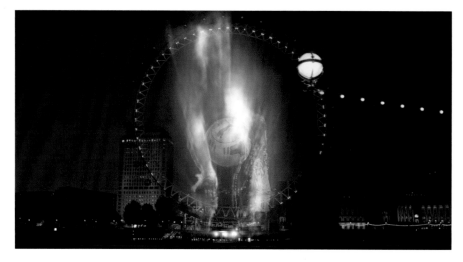

AA

AA

SECTION AA

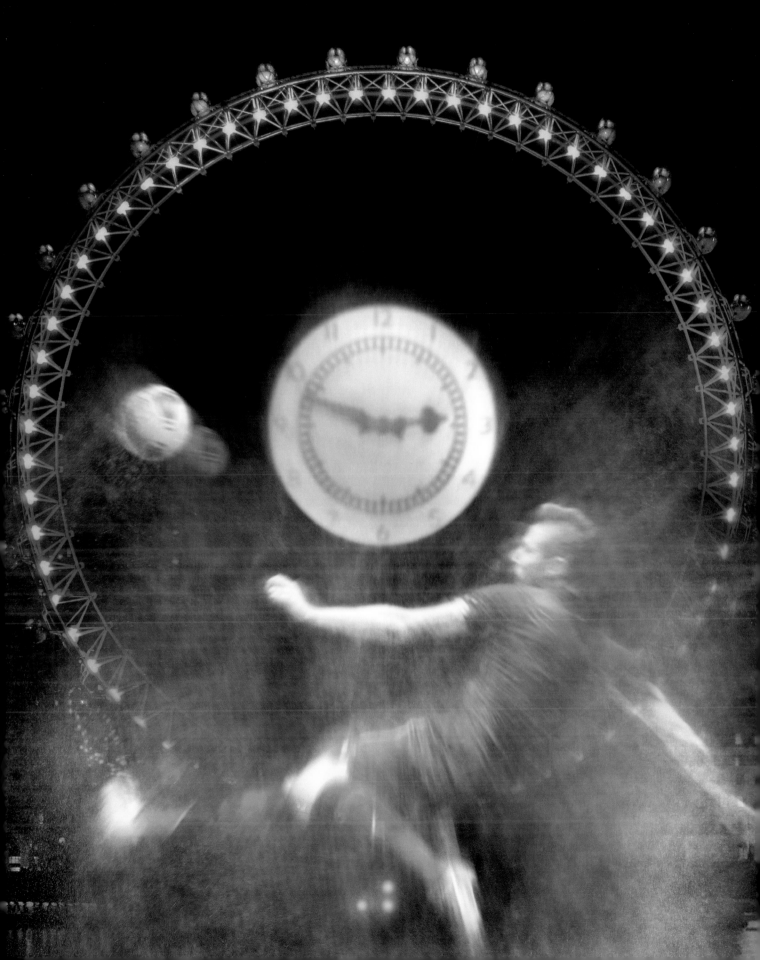

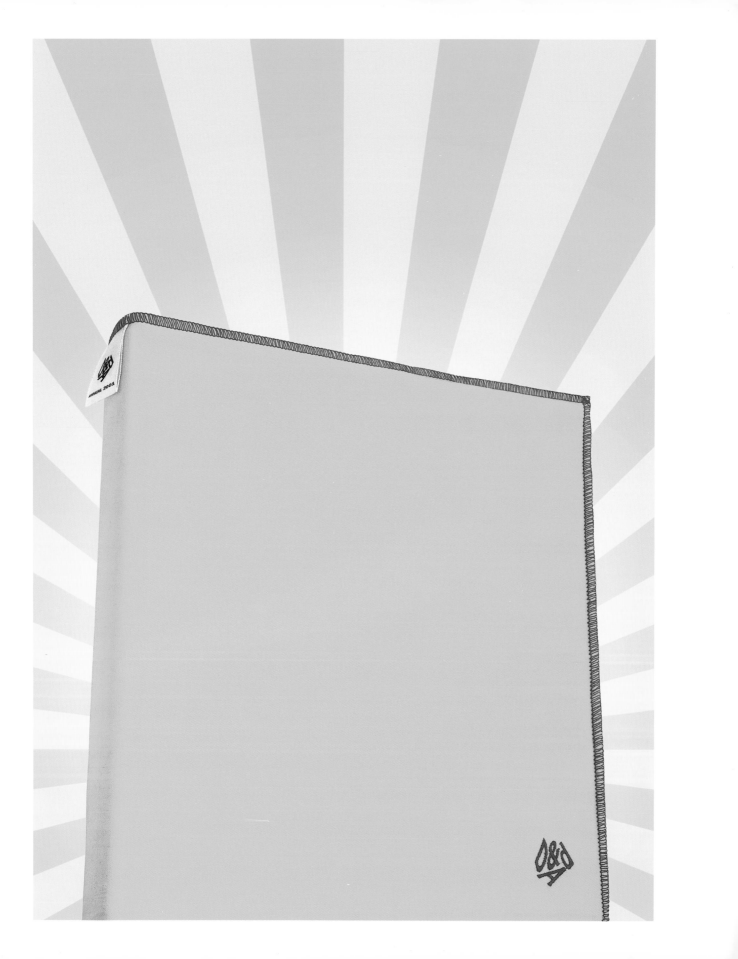

So you're probably wondering now if there's an upside to this story. Well, we're pleased to say there is. Fast forward a few years and because we chose the hard way, while the pressure has been greater and the stakes higher, the buzz has continued to grow. Mixed in with the fear is, believe it or not, great joy. Because we learned that when you push your boundaries, your comfort levels and make yourself a bit scared, you're on the road to actually making a difference. And as psychologists will tell you, feeling like you make a difference is ultimately the one thing that makes us all happy. Other things like money and awards are nice, but they don't make you happy in the way that engaging someone through a totally brilliant, out-there idea does. It's really very hard to say what came first. The fear, or the thrill. They're like fighting siblings, always vying for attention, different but closely related.

When it comes down to it though, even the fear is actually a positive. After all, who wants to be the guy that's always super-confident in his abilities to deliver. The guy who knows exactly what the end result will look like and can look you in the eye and tell you right at the start of a project. That's not the GBH way. That guy's a dick. King of the dicks in fact. And let's face it, the work he produces is mediocre at best, all puffery without the magic. When it all boils down and we're lying on the couch, we'd probably admit that we actually like the feeling of being scared, of not knowing what we're going to do or how it's all going to work out.

That fear is what stops us from getting complacent, thinking that we know it all, that we're 'experts', falling back on our reputation or old habits.

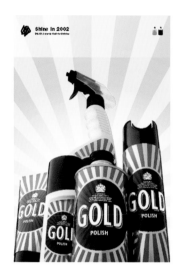

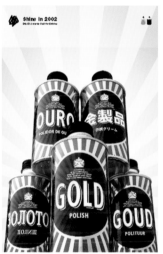

D&AD
The 2001 Annual

The Design and Art Direction (D&AD) Awards are often referred to as the "Oscars of the design and advertising world". The truth is, they're far more important than that. GBH were asked to design the annual by the organisation's then-President, David Stuart. At the time it felt like the biggest responsibility we'd ever have, with the eyes of our industry fixed on our handiwork.

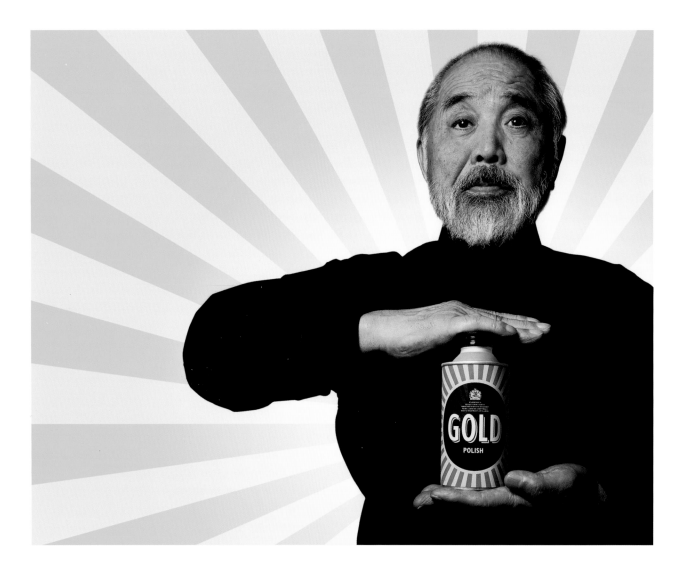

The big idea was all about lovingly polishing the iconic Gold and Silver Pencils, which meant the jacket simply HAD to be made from a D&AD yellow duster cloth, complete with a red embroidered monogram, a bespoke woven satin label and the unmistakable red stitching that adorns the edge of duster cloths.

To contribute to the theme, we enlisted icons of the design and advertising world, convincing them to hold up cans of Brasso-like gold polish, a little like you might see in advertising back in the 1950s.

Here is Kenji Ekuan, Japan's greatest product designer, looking entirely comfortable with the idea. Graphics legend Wim Crouwel wasn't so sure.

Meanwhile, films featured on one analogue showreel. Wikipedia states that DVDs were invented five years earlier, so it's anyone's guess as to why we were asked to put everything onto an old-school VHS tape. Then again, it did help us extend our polishing theme to a very pleasing shoeshine-style tin.

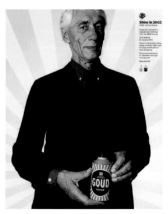

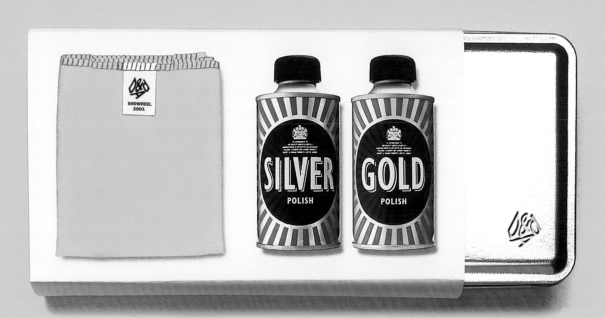

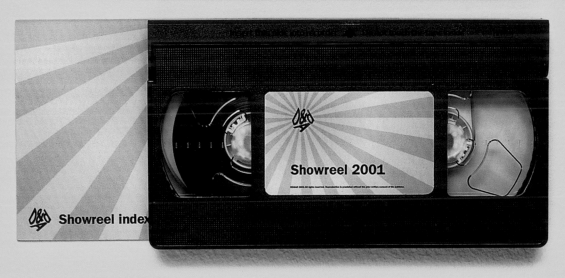

Complacency is the enemy of surprise and innovation. It prevents you from challenging yourself and challenging the expectations others have of you. No, the fear keeps your brain fresh. It's rational. It forces you to listen to the small voice that says "this isn't quite right" (because that small voice is always right). It makes you constantly put yourself in the place of the people you're making this for—let's call them the client and the consumer (terrible words but we can't think of better ones). Is it right for them? Will it delight and surprise them? Will it pack a punch and make a difference to them? If there's a chance it won't do any of those things then you really need to rethink what you're doing.

Fear is the catalyst that really focuses the mind and, somewhat counter-intuitively, makes you want to take even more risky approaches, especially weird and out-there ones, very, very seriously. It backs you in to your own dark, creative corner from which you come out fighting with imagination, energy, wit and surprise.

No, fear of failure is a very good thing. But of course, the art is in knowing how to handle the fear and use it to your advantage. If you can't do that, well you're really just a basket case.

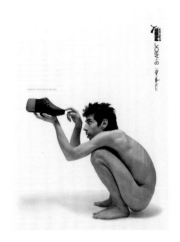

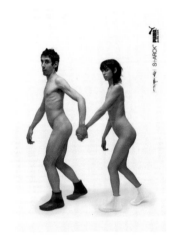

STARCK PUMA
'Highly Evolved Shoes' Campaign

Casting for the ideal 'monkey man' to highlight these highly evolved shoes by Philippe Starck provided its own brand of fear. Was this idea too weird to exist? Could we pay anyone to do it? The answer was yes. Dozens of casting sessions later, this man made the naked role his own. He was the shoe-wearing monkey for several seasons, later even acquiring a mate.

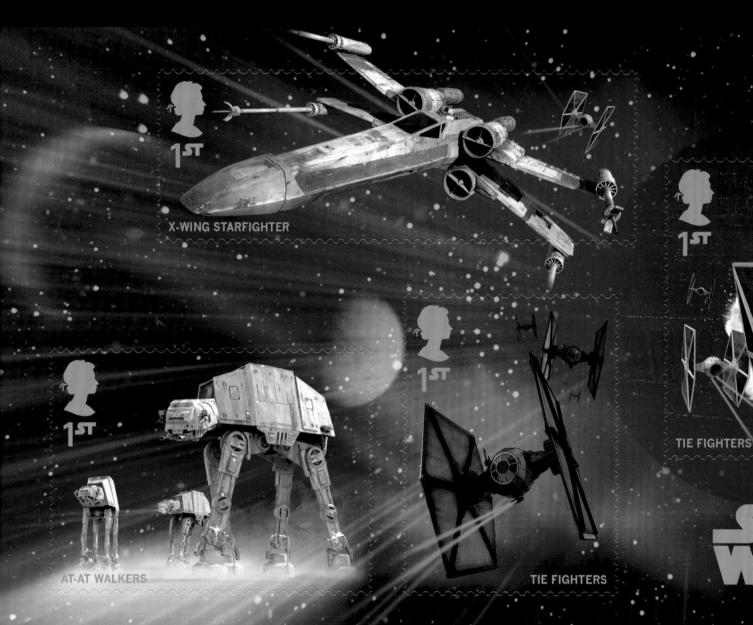

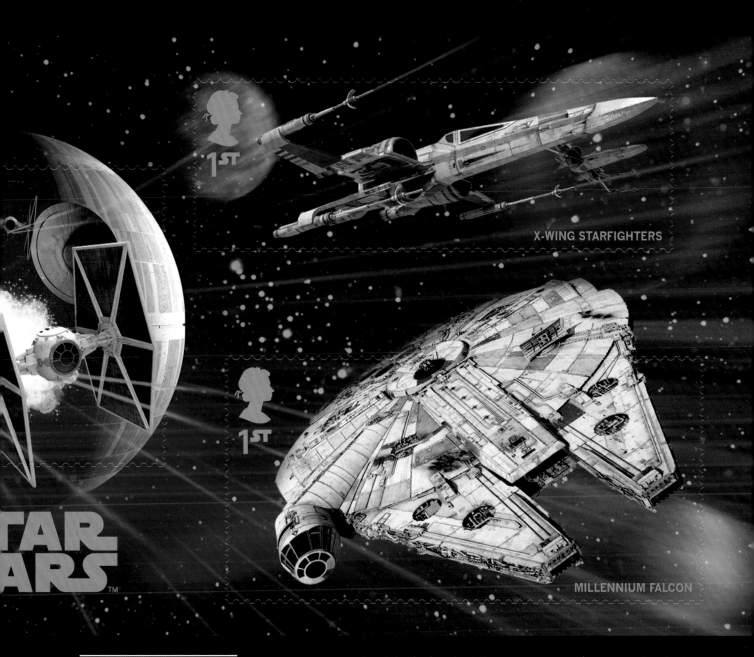

X-WING STARFIGHTERS

MILLENNIUM FALCON

STAR WARS™

Royal Mail
Star Wars™ Minisheet

An epic battle of good vs evil was the inspiration for this fighter pilot's view of the *Star Wars* universe. Classic and new vehicles combined for the mother of all dogfights, individual stamps united in one heroic scene. Elements from the original trilogy were restored and combined with new CGI material from *Star Wars: The Force Awakens*. A final touch... the unique '1ST' device. The Force is clearly strong in us.

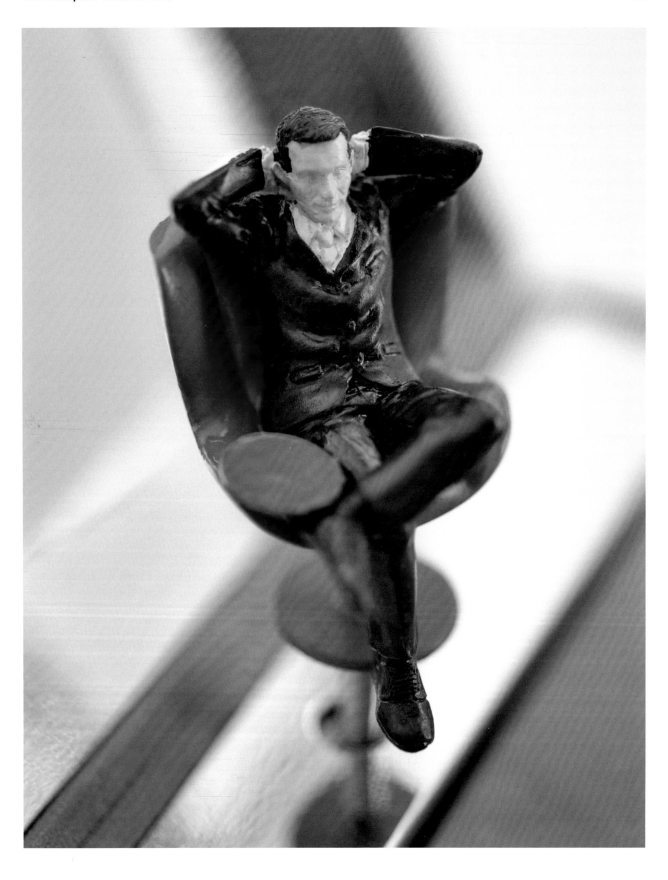

Eurostar
35 Step Nightmare Press Kit

Sometimes projects cause stress due to timings, scale or budget. But every now and then it's just a series of mundane, mini disasters that push us closer and closer to the edge.

Eurostar briefed us to design and produce 1,000 A4 press packs to launch a £30 million rebrand and facelift of trains, lounges and stations. The packs were invitations to press events happening simultaneously in London and Paris.

We proposed a music box— a flock-covered classic music box housing a detail-filled hardback book and a miniature businessman revolving in a Philippe Starck-designed Eurostar business chair (replacing a conventional ballerina). We had four weeks to make it happen. What could possibly go wrong?

1. GBH suggest making only 100 boxes due to the complexity and expense, sending only to the most desirable publications. We proposed 900 extra books not in a box for wider use.

2. Eurostar decide upon 400 boxes, split between English and French, and 600 extra books not in boxes.

3. After a little back and forth, we shake hands on 300 in total and 700 extra books—we have very little time and the boxes must be handmade. We employ a printer to make the cloth-backed books and a bookbinder to make the boxes, believing it'll be quicker separately.

4. Having developed the design and had sign-off, we order the fabric (Light Grey 2). Days later we hear that there is "not enough of the colour left in the UK". We split what there is between printer and bookbinder so they can start and find a French supplier who has some in stock they can sell us. It should only take two days.

5. After four days no cloth has arrived. Our French supplier has sent the cloth to the wrong depot. We try to recover the cloth but discover the courier has gone bankrupt. The cloth is impounded by French authorities.

6. We pay again for more of the same. They send it again but it takes another two days to arrive.

7. The cloth arrives, but it's a slightly different grey colour.

8. The cloth suppliers in France say it is definitely Light Grey 2. We say it isn't. They say it is, and it all gets a bit awkward.

9. We call the manufacturers who turn out to be in the UK. Eventually they admit that they changed the colour of Light Grey 2. It's now darker than it was before.

10. They confirm there is none of the "old" colour available anywhere, but they don't have any of either in the UK at the moment.

11. We make a third order of the new Light Grey 2 from the French supplier. (The darker one.) Are you keeping up?

12. OK, so we have some books and boxes in the lighter grey. Snap.

13. We plan to make some darker books and darker boxes. We post-rationalise that the darker ones are French and the lighter are English language. Secretly we're hurting inside.

14. A sample book turns up in the light grey with silver foil blocking. It's lovely. However, it's about 15 millimetres too wide to fit inside its box.

15. We call the bookbinders who say all of the boxes are made. We call the printers and they've already made up 1,000 covers (at the larger size) because they were running out of time.

16. We hear the French press launch is put back by one week. Hallelujah! We've now enough time to make up a new 150 boxes at the correct size to fit in the box, and remake the 150 French versions.

17. The boxes are light grey and the new books are darker grey but we can close the lid now. We tell ourselves that the two-tone grey looks deliberate. Inside we are hurting even more.

18. The sample model of the plastic businessman in Starck chair arrives. This is to be the model that revolves when the lid is lifted and the music plays. It's 20 per cent too large. We send it back to the model-maker.

19. Meanwhile the clockwork mechanisms that will chime out "Somewhere over the Rainbow" while the plastic businessman rotates in his chair have not arrived yet. It transpires they have been impounded by customs in Hong Kong. Their release date is beyond our deadline.

20. Using a mix of diplomacy and bribery, the mechanisms are released by customs and arrive at GBH by special courier a few days later. However the mechanisms in the box are not identical to the sample as the screws to hold it in place are thinner. The bookbinder has drilled larger holes in all the boxes to prepare and now the mechanisms are wobbly.

21. The springs we are going to attach our models to have a strange plastic shape moulded to the end of them, which has to be cut and scraped off by hand. It takes three of us all day to do 150.

22. The spring is shorter than the early sample and it is much more 'springy'. When the model is attached and the lid put down, the lid springs itself open.

23. We peel off part of the box lid lining and glue in lead to keep the lid closed. This makes the box heavier and creates a higher postage cost. We are halfway through now. Just the French-language boxes to finish.

24. Having charged £1,000 to make the first 150 models, our model-maker tells us calmly, five days before the deadline, that he won't be honouring our contract to make the second batch. "Much too fiddly", he explains.

25. We are forced to throw money at the problem and eventually agree on nearly £9,000 to make the remaining 150 figures. That's £59 per two-inch-tall plastic figure!

26. We receive a call with only four days to the delivery deadline, telling is it's going to take at least ten days to finish the job.

27. With very little option (other than to declare a "force majeure") we decide to sack the model-maker and find a new one.

28. Incredibly, we find someone new, for less money. They can finish the job in three days.

29. The second lot of boxes are finished and we wait for their French-language books.

30. The French books arrive at the larger size and wont fit in the boxes. Again.

31. All other correct size books have been foil-blocked with English. Printers work through the night to try and make more French books as we must put 150 on the Eurostar to Paris the next day.

32. No books by morning. 15 copies arrive at lunchtime. More trickle in during the afternoon. We decide that the 7.00 pm train is the last one before it's too late. We miss the 7.00 pm train.

33. Couriers won't guarantee an early delivery to Paris at this time. By 11.00 pm we are in despair. The final books arrive at our studio, as if mocking us, at 11.59 pm.

34. We decide to deliver the books ourselves. We pile all the boxes into a little hatchback and drive to Calais via the Eurotunnel. We cross the channel at 3.00 am and arrive at Gare du Nord in Paris at just after 7.30 am.

35. We just make it.

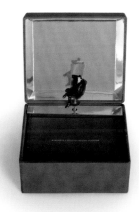

Outside the Circle.

It seems to us that most people expend an inordinate amount of effort trying to fit in. Of course we all want to be liked, we all have a need to be valued by those around us, we're told it's the source of all happiness. It's only natural to want to be part of the group, because, let's face it, fitting in is fun. Being accepted inside The Circle just makes sense because that's where all the really good stuff happens, right?

The Circle / noun. An elite set, a group with a shared profession, interests or acquaintances.
A club that everyone wants to be a part of that should be fiercely avoided at all costs.

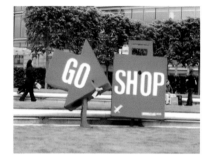
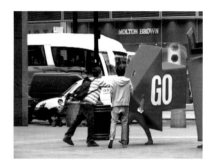
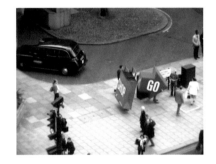

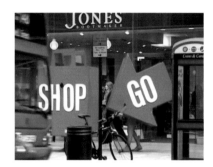
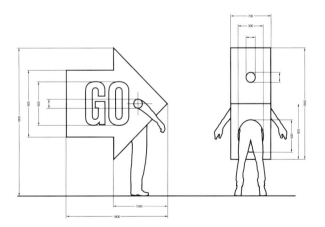
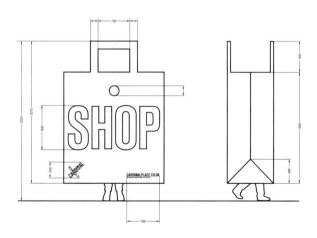

From around the age of three, most of us start to understand this principle. We see there are rules of play, certain ways to behave if we want to be included in the game. It's confusing at first because these little groups are formed and dissolved frequently. One minute you're inside, the next minute you're outside. It's as if the boundary of The Circle keeps getting re-drawn. Something changes and we quickly realise we'd better change too, otherwise we risk becoming—shock, horror—an outsider. Trying to conform and gain acceptance from The Others is a theme that continues into most of our adult personal and professional lives as we scheme, manoeuvre and fight to avoid being the one left on the outside of The Circle.

Why is it so important to everyone to be inside The Circle? The answer is from Darwin: it's a survival mechanism. It's in our programming. In the wild there is always the very real risk that if you stand out from the herd you'll soon become the hunted. There's security, stability and that glowing sense of belonging that's surged through our veins since prehistoric times inside our cosy circles. That all sounds like pretty good stuff, doesn't it? It has worked for us for this long, everyone's doing it, so it's probably better to stick with the herd whatever the cost, right? WRONG!

In the design world it's absolute madness. GBH have a very simple philosophy on this topic. We say "Forget The Circle". That's right, we said it: "Forget The Circle". We don't need it. We don't want it. Because being outside The Circle is the very best place we can possibly be.

Land Securities
'Bag & Arrow' Campaign

Promoting a new shopping centre next to London's Victoria Station took an unexpected twist when we appeared to hand over the task to a pair of amateur costume artists. The pair became local celebrities through an online mockumentary series, winning the public over and getting the job done to the best of their limited abilities, with sheer pathos and an unpolished charm.

By putting a professional spin on the unprofessional, we created a knowing parody which struck a chord with a difficult crowd. The duo also featured in person at special events and went on to make a second series of their show.

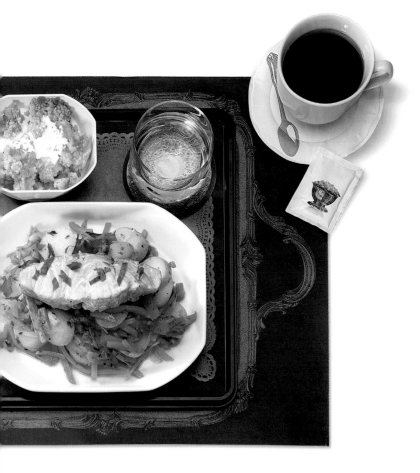

Eurostar
The Business Premier Experience

How do you do business class travel on a train that doesn't really feel like any train travel you've experienced before? At GBH we looked to the great age of rail travel at a time where things were done properly, where elegance, grandeur and decorum were the buzz words for the industry.

Referencing the worlds of hotels and film we created a complete experience that felt luxurious and a little bit in-the-know. We were especially proud to have been able to make on-board dining more elegant for no more cost than the existing design and returned a little charm to travelling by train.

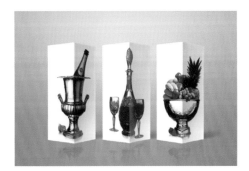

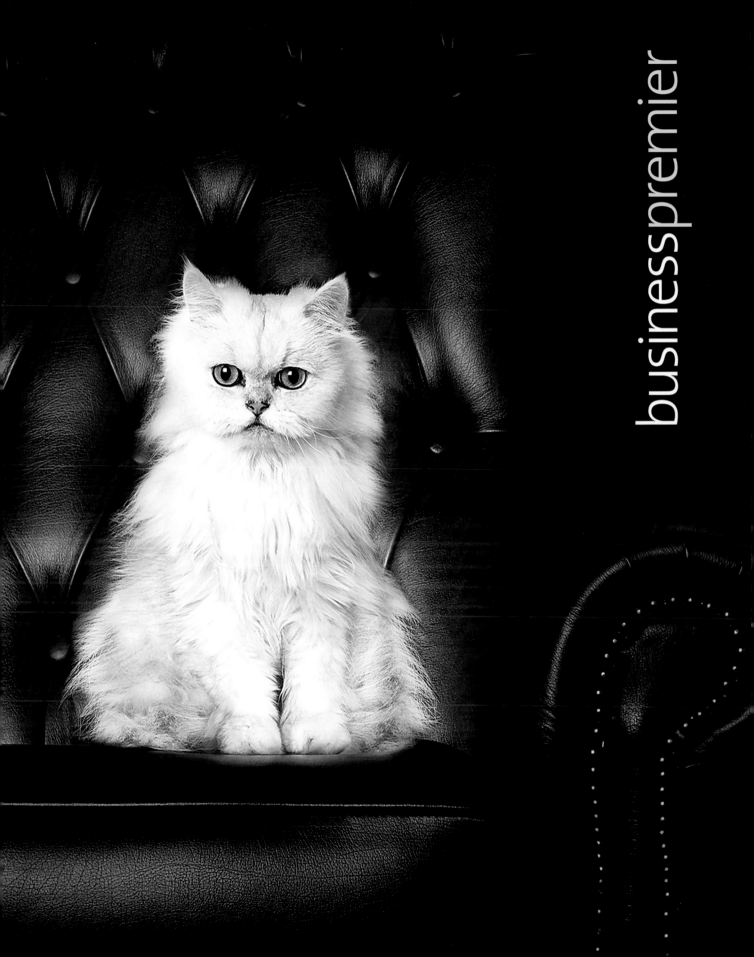

businesspremier

Parrot Pot
Promotional Films

A startling new device that looks after your plants for you whilst you are away or busy doing something else, all controlled from a mobile app.

The use of science and electronic know-how was developed by gardening boffins to create a system more in tune with commercial growing techniques than your average garden centre. We were asked to create a promotional film for the new product. In order to be non-alienating and in keeping with the natural world we had animated animal characters present the irrefutable advantages of this clever product in a very direct and enthusiastic fashion straight to the camera whilst playing the parts of three very different types of gardener.

We were delighted by the on-screen presentations from the busy busy bee who doesn't have five minutes to stand still, he's always on the go; the unforgettable British lady orangutan, who's been "caring for plants for 25 years" and the wonderfully clueless young billy goat who sounds almost exactly like Joey Essex, explaining why it's perfect for someone like him.

In a seen-it-all world of insane competition and talented opponents, this is how we gain the upper hand. The difference between great and brilliant is so small yet so significant and so difficult to achieve. How can we be that elusive little bit better than the best? Is it possible to win the game without playing the game? By not trying to fit in, by not playing to the crowd we can be out on our own, we can see things with perspective and fresh eyes unclouded by convention or inherited rituals. It's the perfect start if you want to do something out-of-the-ordinary.

It's easy to blend in and hide your eccentricities, but it's also the easiest way to lose the best parts of who you really are. The special indefinable uniqueness of you. This deserves to be seen. You deserve to be known for the real deal that you are. After all, how many people that you admire are admired for the way they fit neatly into the world? Exactly. You admire them for their one-of-a-kind qualities—so why do you keep taking the easy way out? Want to do something unique? Just stop trying to fit in.

Outside The Circle is absolutely where it's at. Let's leap before we look. Forget the rules. Forget ourselves and mix it up. Why don't you join us as we hop from circle-to-circle (oh yes, there's many, many circles out there) free from fear, free from worrying about exclusion for bad behaviour or being laughed at for being ridiculous.

Business-wise we try and impart this concept to the companies we work with. We have the honour and privilege to be able to look into any of these circles that we are not ourselves inside. We can see where we have no right to see. It's a little like peering into one of those ant nests inside a glazed frame.

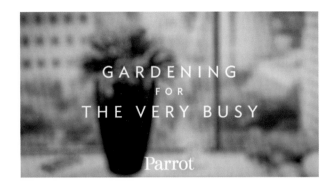

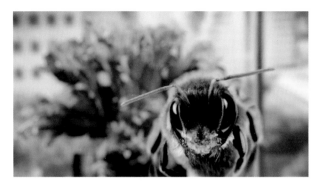

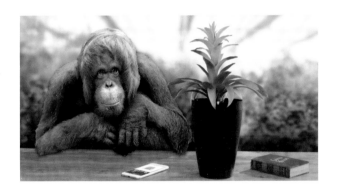

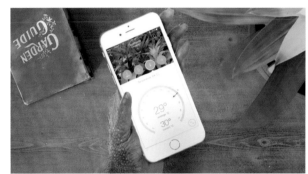

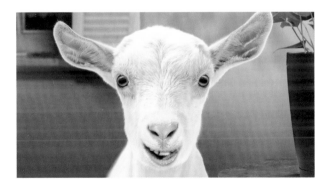

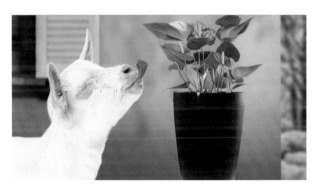

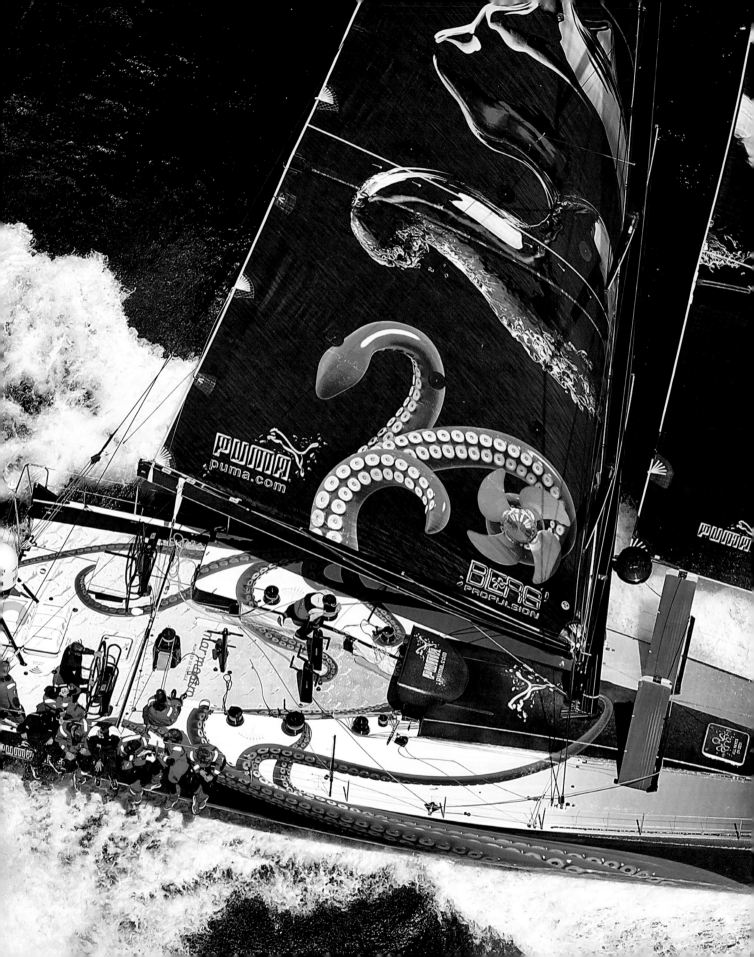

We can see them in there, scurrying around, but they don't see us. When we first met our friend Thierry Gaugain he commented wonderfully on this phenomenon by saying "You point to the moon—but they look at your finger."

To avoid ourselves and our clients being trapped in conventions, we must be free to borrow ideas, customs, technologies and languages from any of these sealed little worlds and share from one to the other. We can see how two unremarkable things from different circles can be combined to create something amazing for someone else, somewhere else. We have seen first-hand how different organisations are all similar in certain ways (fashion industry excluded— those guys are another story entirely) and we simply make a demonstration to a client of what their version of getting out of their circle will look like for them.

We try to introduce them to our belief that whilst it's safe to fit in, it's quite stupid to do so if you can stand out magnificently by becoming the most interesting, attractive and desirable version of yourself. We know that people tend to think of rebranding as a new coat of paint, whilst we believe it's more akin to a surgery that cuts away anything that is masking inherent truth and beauty. Let's forget what the others are doing or have always done. This is the position we like to take and it's the beginning of why we are nearly always able to make work that really works harder, better and faster, by proudly starting from outside The Circle.

So here's the best bit. This also means we end up being able to work in almost any sector as we no longer need to be experts in the business but simply be an independent and impartial observer.

PUMA Mar Mostro
Boat Livery, Campaign & Apparel

Inclusiveness is inherent to PUMA, so what would they do in the exclusive world of sailing? PUMA formed an ocean racing team and entered the Volvo Ocean Race. To make it truly accessible required a Kraken, a sea monster to be reckoned with.

Turning traditional sailing on its head and polarising opinion, PUMA's vessel, Mar Mostro, referenced one of their biggest selling shoes, The Mostro (Italian for 'monster'), created a stir in the sailing community and opened up sailing to a younger audience as an eco-friendly team sport.

PUMA's entry into the competition, became the centre of their campaign as a proud salute to the team that conquered the seven seas. Truly a one off, the boat and the graphics were designed from scratch. We used pencil and paper then 3D modelling programmes to create the monster which was then painstakingly painted onto the carbon fibre shell by hand.

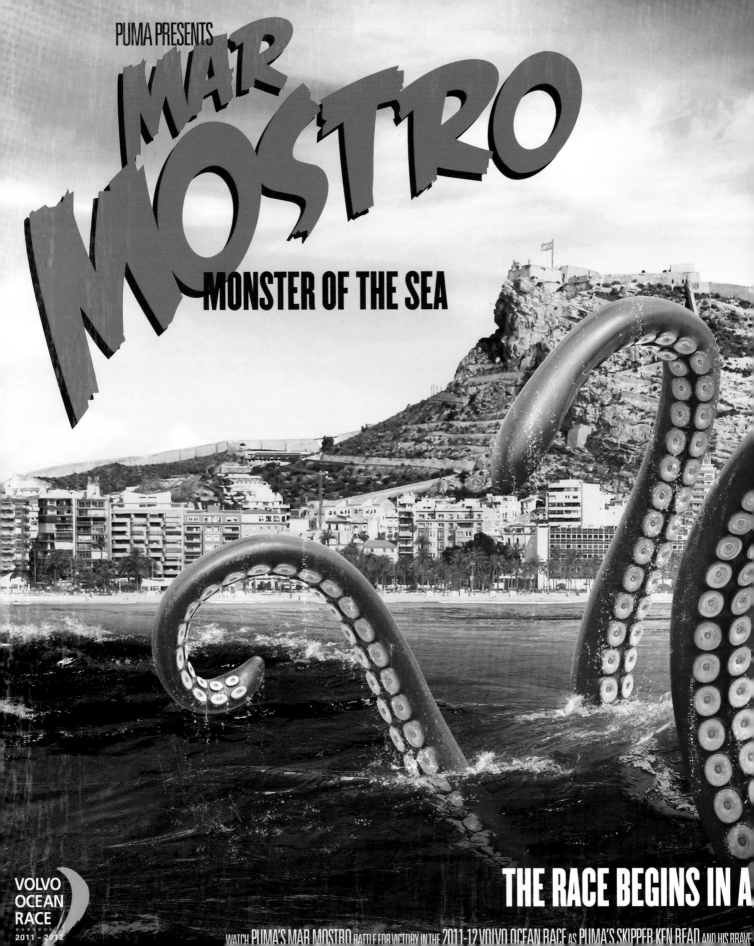

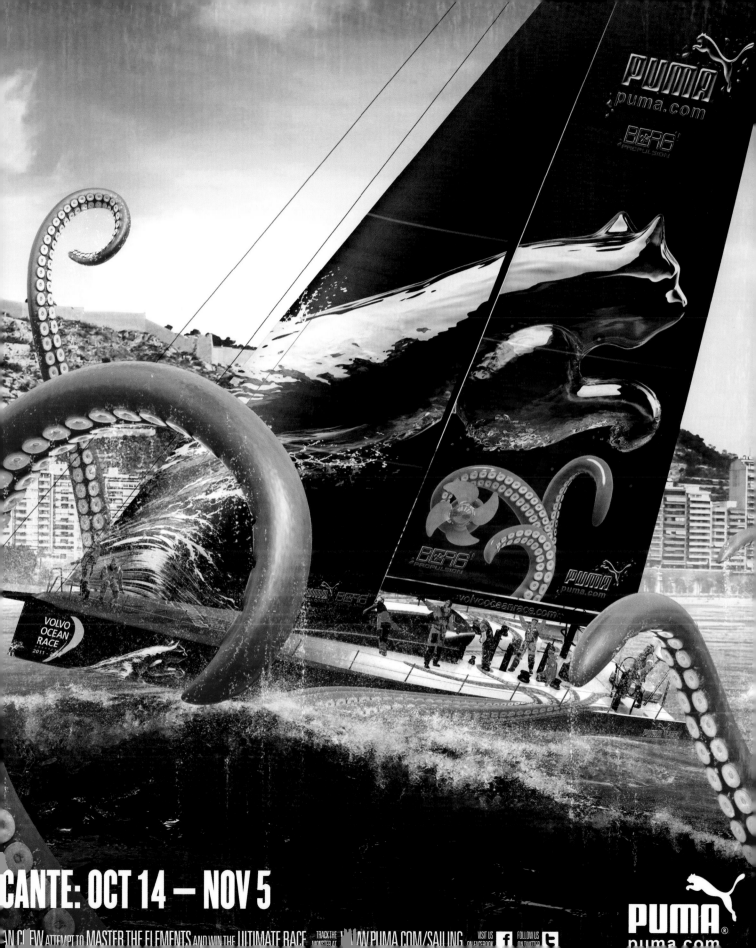

This library of knowledge and outside experience straddles all disciplines and is seems strangely desirable to others. It's quite usual to find that something commonplace in one circle will be received like the Second Coming by someone in another. People always think the grass is greener and here we are standing at the door with grass stains on our knees. We nearly always get asked inside. From here on in, who knows, it's down to chemistry, timing, the angle of the moon or perhaps even having your lucky pants on!

So that all sounds pretty good right? Is there a downside to any of this we hear you ask? YOU BET YOUR ASS there's a downside! You know that feeling you get when you're leaning back on a chair and it nearly topples over backwards but you just catch it at the last minute? Well, it pretty much feels like that the whole time! You've exposed yourself, you've turned your back on the acceptance, status, support and values of being in a circle. You've effectively sold your soul to be able to look into other circles, you've gained unique insights and brought together the best elements from all sorts of different places and maybe even created some new ones.

By some strange alchemy you have imagined the future for an organisation that's invited you in. You've done your job, you have this big idea and it's a beauty. But wait, here's the biggie: this is all very well back in the studio, in your own circle, but here's how you've well and truly set yourself up for that feeling all over again....

It is you, not someone else, but just YOU who now has to step right back into someone else's

Our 'monster of the sea' theme continued into apparel with these first ever GBH-designed sneakers that gave exceptional grip in the wet and were sold in mobile stores that followed the Volvo Ocean Race around the globe.

When the racing is over, the celebrating or drowning the sorrows can begin; and what better place to do that than Bar Mostro (see what we did there?) PUMA's hospitality offering for the dockside at the Volvo Ocean Race. By zigging whilst the others zagged, PUMA was embraced by spectators as the most lovable brand in the race.

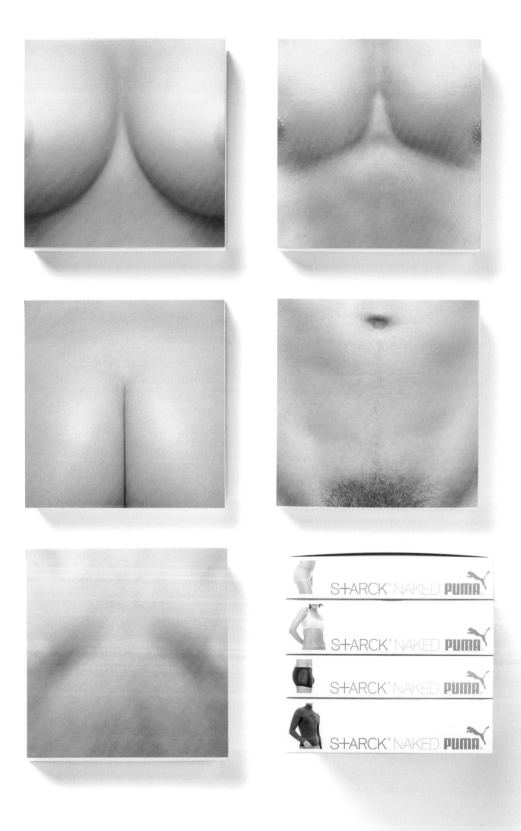

circle as an outsider. You will be surrounded by people well and truly in The Circle. They are all around you. Wherever you look they are staring back at you with disillusioned eyes and slightly slack jaws. You're actually having to 'go sell your crazy' to these people in this boardroom, right here, right now as AN OUTSIDER. One who knows nothing of The Circle. What were you thinking? This was all well and good and very interesting for both parties when you first met each other, when it was all about "possibilities" and "figuring out" and "working smartly". But now you're back a few weeks later and about to start telling these people what they should be doing. How they should be looking. How they should be thinking. And in your mind, every fibre of your being is telling you that you just DON'T FIT IN HERE. And of course, because you don't fit in, in your head you sound all wrong, you are telling them they need to be different and yet you really shouldn't know what you are talking about, and indeed you are suggesting something that in their eyes actually PROVES you don't really know what you're talking about. What can you possibly do to gain the trust of these people? Will you fold under questioning? Can you prove that what you are suggesting will work brilliantly, or even at all? That's the $64,000 question. What to do in this situation? This endlessly recurring living nightmare. Well the jury is out on this one. This is where we freeze-frame, turn to camera and bite your top lip. This is where you sink or swim.

 There's two schools of thought on this one. No right or wrong, just different strokes for different... needs (as David Brent of *The Office* once said).

STARCK Naked
Underwear Packaging

Showing (but not quite showing) the unshowable. We turn our back on convention by naming and packaging a range of sporting undergarments by showing no product whatsoever and yet somehow managing to avoid causing offence.

 This casting session was one of our most interesting of all time. Due to budget restraints and model fees we had to find one male and one female model who had the perfect front, back top and bottom for the packs. Our studio was full of beautiful naked people for the best part of three never-to-be-forgotten days.

PUMA UN-Smart Phone
Branding and UI Design

In the wake of the App Store and the rise of smartphones we quietly launched the PUMA UN-Smart Phone in all PUMA retail stores.

Returning to analogue gave us the opportunity to attract shoppers with this 'old-fashioned' device perhaps never seen by some of the younger customers. Once answered, the phone delivered a randomised message as if left on an old-fashioned 'answering machine' from a huge library we recorded in 15 different languages (to cover all worldwide regions).

The beauty of this initiative was it was all about raising smiles and brand awareness rather than straining to sell product, which left us free to play, to charm and sometimes just be downright random. There were thoughts for the day in various amusing voices. A message from a jilted date gone wrong. Another was from a vet's telling you your pet ant was ready for collection and a variety of hardcore German techno music. Best of all, they all ended with an abrupt cut-off followed by the loud constant tone that used to play when someone hung up on you. Ahh analogue, we miss you. x

Firstly there's the exciting and, let's not deny it, high-risk option that is to simply carry on what you're doing and do it harder. Whatever you are doing, TURN UP THE HEAT. If you're being strange, get stranger. If you are being funny, segue into hilarious. Being geeky? Get geekier. Punch through. Don't doubt yourself. Never falter. Show no fear. It is incredibly important to continue to act as if this insane idea you are presenting is the most natural thing in the world. If you simply carry on being the most out-there outsider they've ever seen, then if you're very lucky, your behaviour and ideas could well be treated in the same polite and smiling way as an unusual foreign custom might be treated.

Secondly there is a more cunning play. You carry on the Presentation of the Outsider, no change there. But there's a twist this time—you now wear the mask of Professional Outsider. And look out! This outsider has an ace up the sleeve. They've done their homework. They bring not only revelations from outside The Circle, along with some challenging and slightly scary ideas, but they pepper the presentation with some choice references and INSIDER information on the company they are presenting to.

A little goes a long way, as most Circle people enjoy the opportunity to talk about themselves and their world. Listening becomes the key here. The more homework, the less risk. You be the judge here.

Finally we must learn from the swan. Not by making a loud honking noise and breaking a man's arm with our beak, but by mating for life.

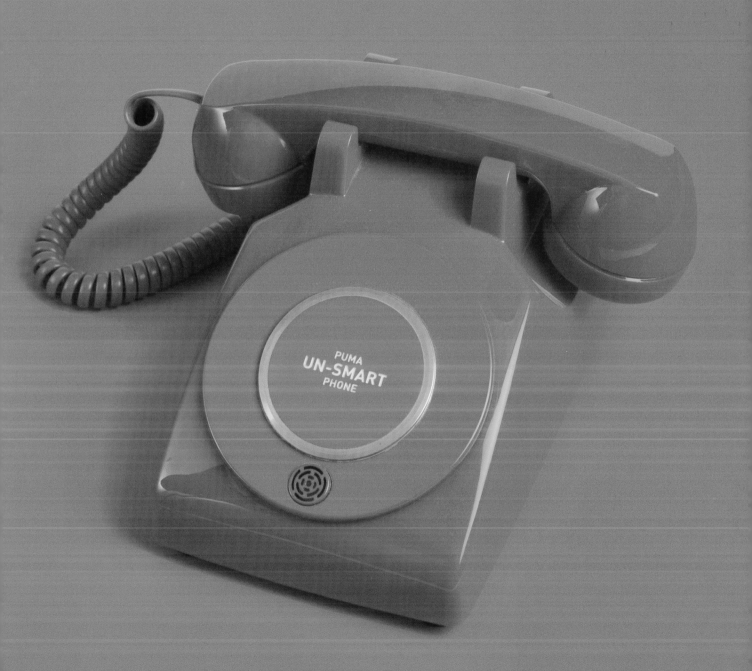

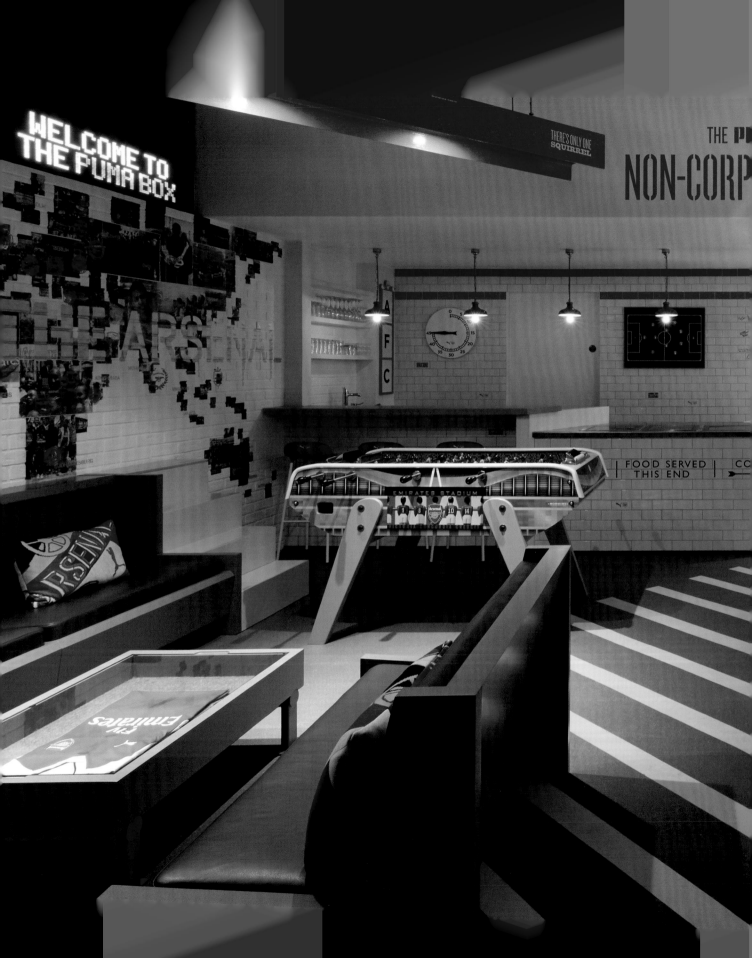

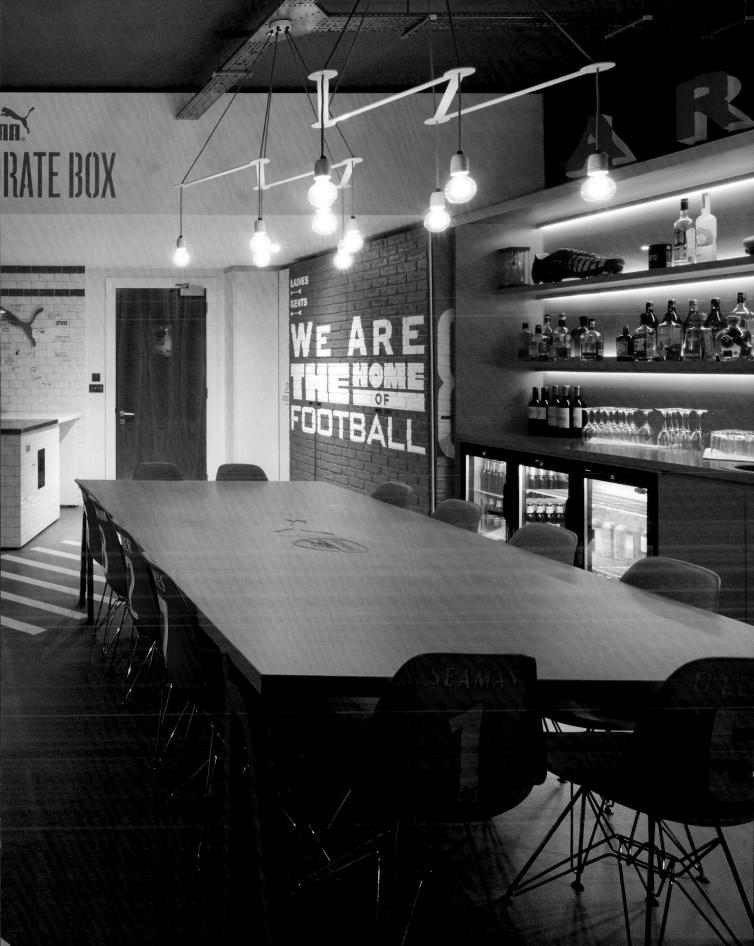

PUMA Non-Corporate Box
Emirates Stadium, Arsenal FC

Traditionally an exclusive domain, this executive box seeks to redress that balance by elevating the iconic football terraces to this upper tier. The hospitality space is packed with details celebrating the Red and White Army; steel and concrete seating references the terraces of old, and tiles inspired by the Highbury dressing rooms adorn the walls, complete with graffiti chants fit for a Gooner. At the PUMA Non-Corporate Box, prawn sandwiches are definitely not on the menu and it's fan culture that is the real hero.

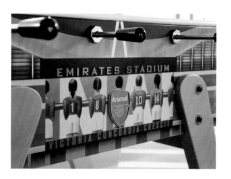

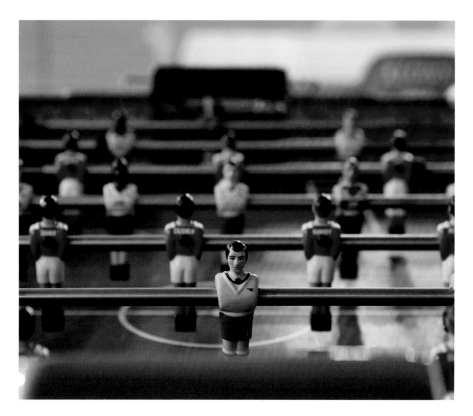

That is to say, once you find someone to work with who understands you, values you and is likely smarter than you, then you must hang on to them. Keep them close and keep in touch. Don't just contact them about their stuff, keep them posted about what you're doing for others too. Show them well-judged secrets. Make them gently jealous, it keeps them keen. When you are back working with them, make sure you over-deliver. Always, always, give more than they could ever expect. Bring on the magic. Show them the love every single time and never, ever let them go. Because the longer the long-term friendships, the stronger the trust, the better the work. And that, our dear friends, is what we are talking about.

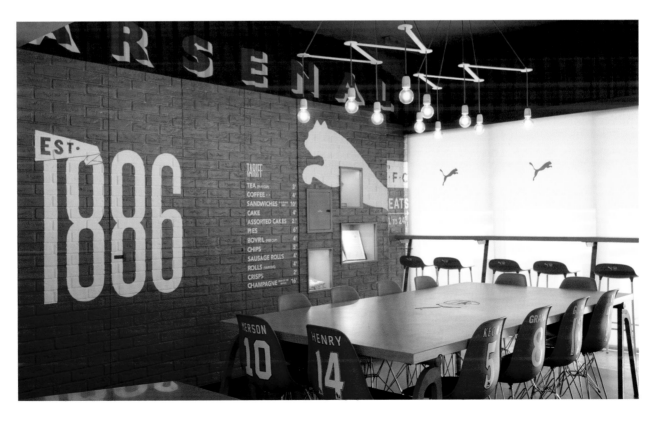

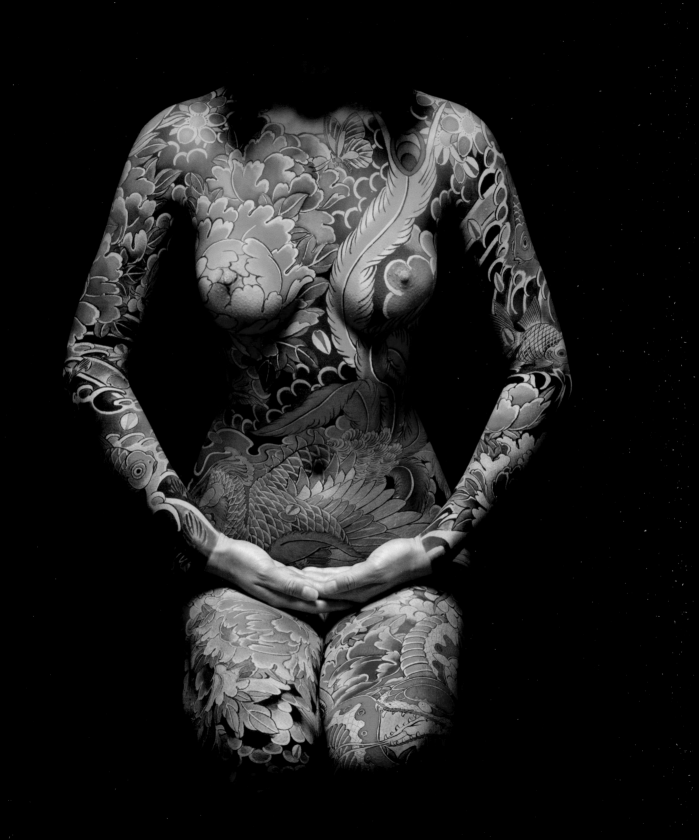

The Kamikaze Within.

There's a distinct flip side to the quivering little bunny who lives in fear of failure. The polar opposite in fact of that cute, soft, sweet-smelling creature that you'd want to take home to the kids. This flip side has big teeth and great big claws, crazed eyes and a wicked mind. It gets off on deliberately placing itself in peril just to taste danger, has a compulsion to over-promise in the face of insurmountable odds, like small budgets and even smaller timelines. Let's discuss....

Kamikaze | adjective. A person willing to take impossible risks and behave in a wildly reckless or destructive manner, with no regard for personal safety or the safety of others. The kind of character that really shouldn't be allowed to take on client projects.

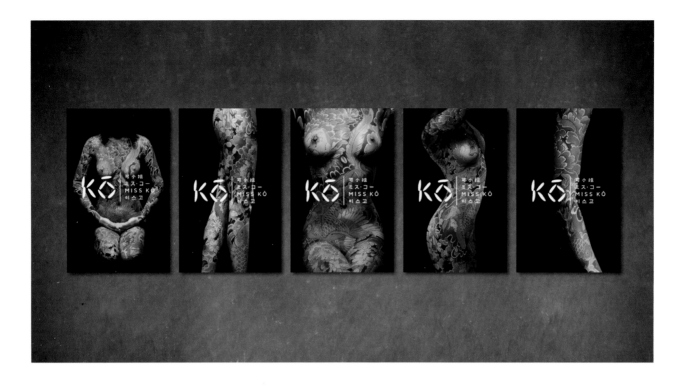

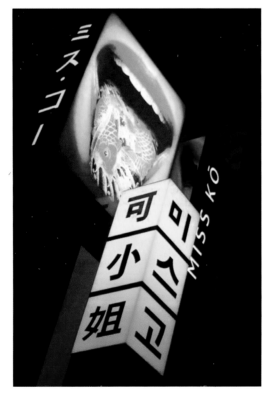

This flip side can be charming, persuasive, larger than life and barely resists its exhibitionist tendencies to run around exposing its naked body screaming "This is the greatest thing ever, this will show them all, it's going to win big this time."

A less melodramatic type (or someone not trying to write a book) might simply call this flip side the designer's ego, blind ambition or the basic human desire to show off. A flexing of the creative muscle to win respect from the elders or over-deliver to the delight and heaped praise of clients. But whatever you call it, for better or for worse, it's a mental condition experienced, we imagine, by many designers and creatives. A kind of self-destructive desire that lives within, that rises seemingly from nowhere and carries you off into unknown territory which often means finding yourself in high-risk situations where there's a good chance you'll come out of the job looking very, very bad indeed.

But what's interesting is that this mental state more often than not leads to very interesting results. That sense of invincibility and bravado is capable, if used with a little perspective, of taking you to dizzying heights and into uncharted graphic waters that you wouldn't normally be brave or stupid enough to dive in to. And in all honesty it's been a pretty important characteristic in helping GBH come up with and follow through with some of our biggest graphic stunts. The kind of things that on the face of it were overly ambitious or often a knife-edge away from failure. In fact, it's one of the defining psychological features at GBH, rearing its ugly little head in every other project we undertake.

Miss Ko
Branding & Restaurant Installations

Miss Ko is an Asian fusion restaurant located in the heart of Paris' most prestigious arrondissement. Exotic, luxurious, a touch of the traditional mixed with the futuristic, a place where street food, cocktails, art and music meet. Inside it's like an Asian street of the future—*Blade Runner* only happier. The subject matter presented us all kinds of lovely creative opportunities and, for a brief period, all seemed fine.

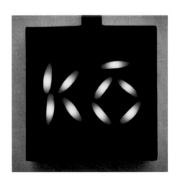

Then we chose to turn Miss Ko into a real girl adorned with real Japanese body tattoos (*Irezumi*) made by a real artist trained by a real Grand Master. What were we thinking? We descended into the underground den of tattoo art and from that point our world went into a dark spin. Photography, nudity, tattoo design, Triads and CGI body mapping conspired to test our resolve, budget and schedule.

Miss Ko's body is seen across all restaurant applications, printed, illuminated and projected. Meanwhile we fabricated her innocent past by forging childhood passports for her that also doubled as menus, showing Miss Ko as a young girl enjoying her favourite food and desserts. The logo in the end was the simplest part of the project. Nine pieces of rice, laid out to spell 'Ko'. A small illuminated sign at waist height flickers on and off, only occasionally revealing the logo.

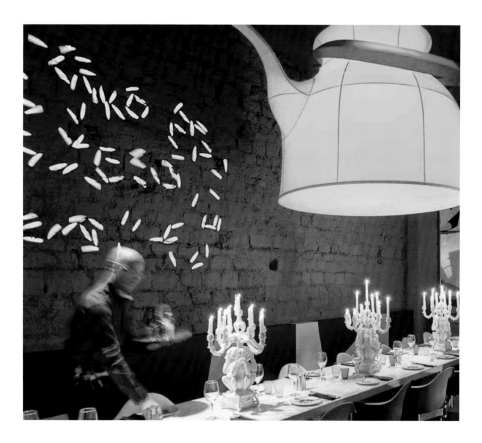

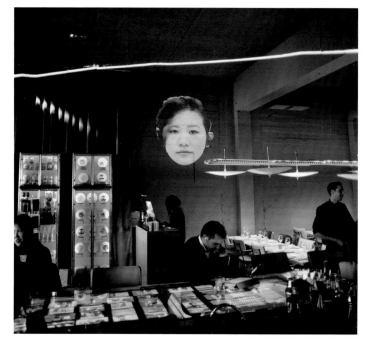

DESSERTS TO SHARE

Rice Pudding
Chocolate, pistachio, praline,
ask for the flavour of the week
19.0

Miss Kō's Shu-Shu
Mini doughnuts served with
coconut, caramel coffee and
caramel-passion fruit sauces
21.0

Himalayan Emperors
Light chocolate mousse
with fluffy meringue
24.0

2-3 people

ICE CREAM

Chocolate-Nougat-Sesame

Vanilla-Ginger

Matcha Green Tea

SORBETS

Raspberry-Yuzu Coulis

Mango

Lychee-Grapefruit

One Flavour
4.0

Three Flavours
9.0

SPIRITS

Yuzu no Kimochi
Yuzu liqueur
6cl / 8.0

Momo no Kuchidoke
Peach liqueur
6cl / 8.0

Choya Umeshu Original
Japanese prune liqueur
6cl / 8.0

Eurostar
Frequent Traveller Branding

Loyalty schemes, especially in the travel sector, are one of the last bastions of old school elitism. Our approach to naming and branding Eurostar's scheme was to do away with their conventional gold, silver and bronze system in favour of just two levels. In the new order, the entry level was a gateway to the upper level, Carte Blanche, which as the name suggests, unlocks doors to all the VIP goodies Eurostar has to offer. But regardless of how important you are, we had the blind ambition to try and surprise, make an experience.

With branding centred around black-and-white tiers, we had the idea that your black card could somehow turn into the white card the more you used it, kind of reminding you that the more you travelled the closer you'd get to Carte Blanche status. A simple idea that at first seemed easy to do. Using thermochromatic ink, we were able to print black cards that turned white the warmer they got. We could even reveal pictures beneath. But controlling the temperature the cards changed colour at was another matter entirely.

In tests we had them coming off the printing presses already white. We had to stock them in a fridge in our studio to keep them black. Then we found people with particularly hot hands (or hot pockets) would have an adverse effect. It took weeks, a lot of tests and some weird science to find and fix the optimum temperature point for the black to start fading and the speed at which we wanted it to. We were pretty close to the wire on all fronts. Mind you, if that sounds extreme, the Carte Blanche card was made from sheet steel. Now that really was madness.

A Hyde to the Jekyll if you will, but a Hyde that, once the adrenalin has subsided, you realise was a useful fellow to have around.

So what is this mental switch that is suddenly flipped in the creative mind, making one want to attempt the impossible? What are the triggers that make the fear-of-failure guy (whose favourite statements are "How can we possibly get it done? What if they find out this isn't actually our specialist subject?" or "Seriously, I could actually lose my house over this") get all pumped up and say things like "We'll find a Japanese lady covered from head-to-toe in traditional tattoos and photograph her naked," or "Of course we can write and produce an eight-episode film campaign over the summer"? And who controls the switch? Can we choose to flip that switch at the point we know it'll count the most or are we at its mercy, hoping for the best?

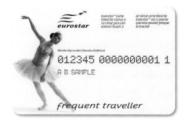

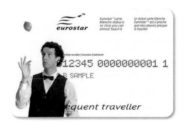

Well, there are definitely triggers that seem to tap into the beast buried deep within even the most mild-mannered designer, making him or her sit up like Pavlov's rabid dog, reacting with instinct, desire and excitement to high-risk tasks. Sometimes that trigger is a brief flash of an image or concept that you can't get out of your head. An idea that's utterly impossible or so stupid that you casually mention it in a brainstorm for a laugh, joking about what an unrealistic thing it would be to propose. "Oooh, but it would be so funny/cool/weird to try and do that wouldn't it?" And at some point during the mirth, it begins to take hold, the designer's grey mist clouds the left and right brain and the team of designers you're working with get whipped up in the frenzy, all contributing to the upwardly spiralling vision.

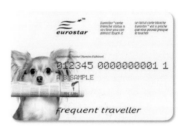

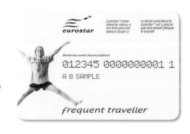

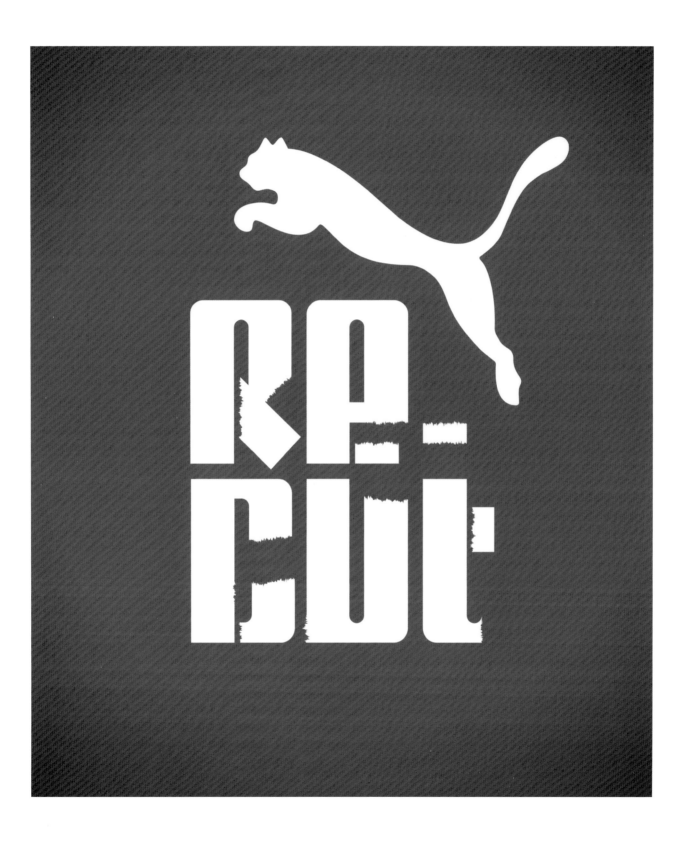

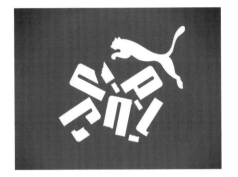

PUMA Re-Cut
Recycled Product Branding

The brand logo. King of all graphic elements. That untouchable jewel that you respect, use carefully and never take risks with. Unless you have a very, very good excuse. That excuse came when PUMA launched a sneaker collection made entirely from the off-cuts left over during the manufacture of jeans. Denim re-cut and remixed. How cool would it be then if the logo for that collection was a re-cut and remixed version of the PUMA logo?

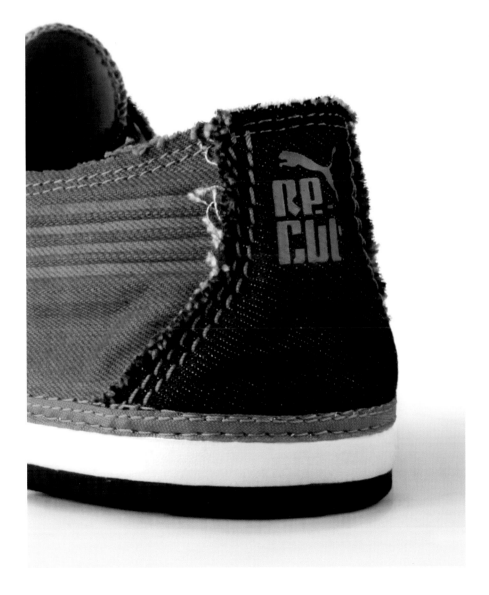

GBH Christmas Card, 2001
Close-to-the-wire message

Sometimes an idea makes you laugh enough that you're fired up and ready to go with it, even though you know it's a risk. Our second Christmas card way back at the start of the millennium was one of those. We were bored with convention and expectation and wanted to provoke, to stick two fingers up. It was a simple bit of thinking that we just couldn't let go of. The printed inscription inside the card went some way to try and appease the more sensitive recipients: "For God's sake, it's just a joke".

Maybe it's to do with safety in numbers but an idea can escalate really quickly and before you know it that stupid suggestion has taken hold, the idea has sunken in its claws and bingo... the switch has been flipped. Sanity goes out the window (a modicum of sanity generally prevails); the laws of space, time and physics are forgotten because that stuff's for smooth jazz listeners and this is for 'death metal on acid' fans.

Sometimes, the triggers don't come from within at all, but from fee-paying clients. That's right, clients. They lay down a gauntlet that's dressed up in any one of the following ways:

1. "We've already had a bunch of other well-known agencies present us their ideas and to be honest, we weren't that impressed by them. Then we heard about you guys. They say you're the best. Do you think you can possibly help?" The veil of flattery is so seductive (and in stark contrast to the berating tone one more usually expects) that although you're simultaneously hearing the phrases "Obviously we've now spent the budget" and "Because of the problems with the other guys we only have three weeks until the launch", it's barely registering in your mind. Those words are evaporating into a cloud as you picture yourself clinking wine glasses with the CEO at his summer residence in Venice. The switch is flipped.

2. Next up there's a variation on the above, where your recently finished project has gone down so well and the praise been heaped so high, that despite your rational brain screaming at you to remember just how traumatic meeting that deadline was, how many times you killed yourself

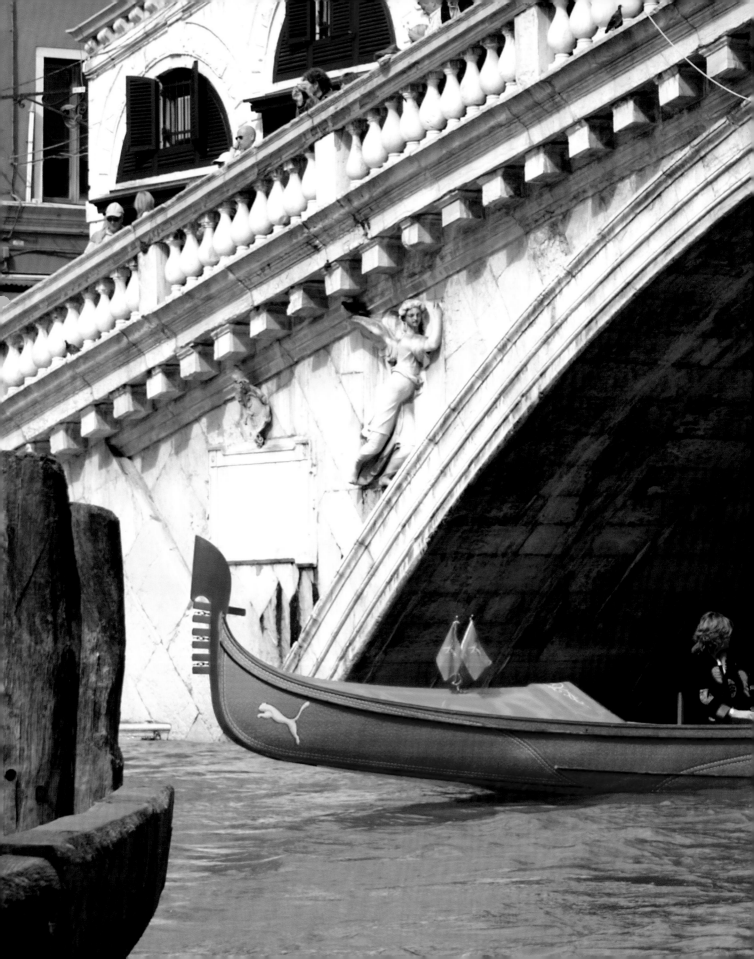

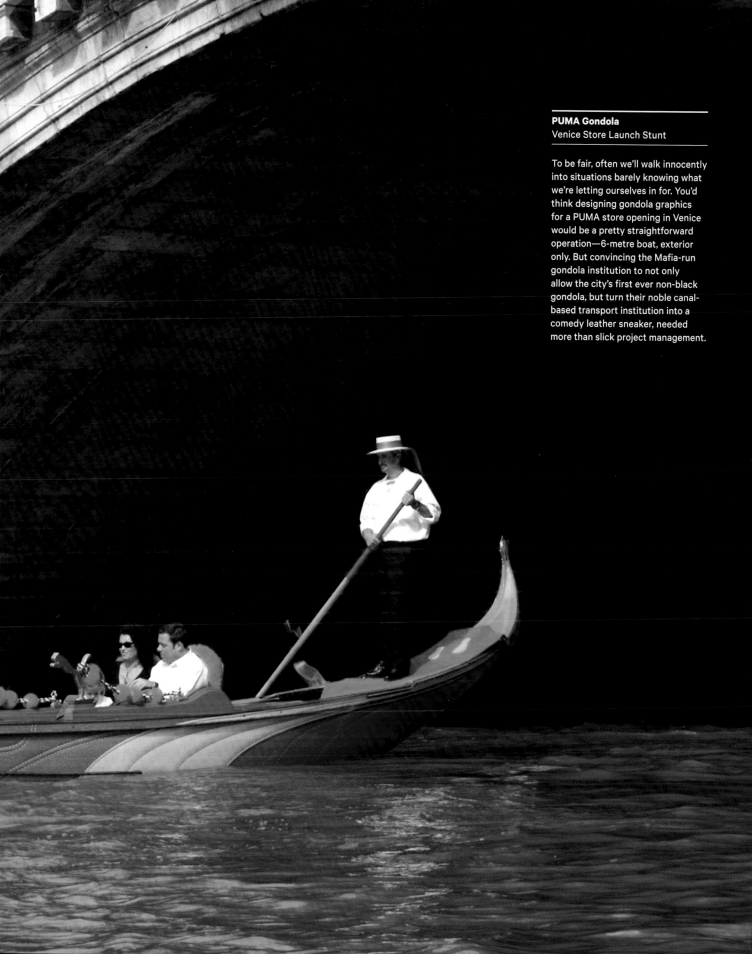

PUMA Gondola
Venice Store Launch Stunt

To be fair, often we'll walk innocently
into situations barely knowing what
we're letting ourselves in for. You'd
think designing gondola graphics
for a PUMA store opening in Venice
would be a pretty straightforward
operation—6-metre boat, exterior
only. But convincing the Mafia-run
gondola institution to not only
allow the city's first ever non-black
gondola, but turn their noble canal-
based transport institution into a
comedy leather sneaker, needed
more than slick project management.

After weeks of backhander deals, agreements and stress that we'd miss the opening, we made our way to Venice, armed with violin cases. There we worked with a master craftsman in a traditional authentic workshop, cutting a pattern from traditional cheese paper so that we could apply our design to the specific gondola we'd been allocated.

To see a red leather sport shoe morphed into a gondola, cruising the canals of Venice and ferrying Italy goalkeeper Gianluigi Buffon no less, was a sight for LSD-tainted eyes. Our design was allowed precisely six hours on the canal, after which time it would presumably have been blown out of the water.

trying to invent more concepts before they were finally accepted and how much money your agency lost in the process, you're starting to get more and more revved up, your blood pumping. "This time it won't be so difficult", you're telling yourself, "This time I can probably do it quicker and better. This time they know what we're like and they'll probably sign off the first idea we show." Before you know it, the switch is flipped and you're up for doing it all over again. That crazed inner voice has drowned all else out.

3. The opposite to the above, of course, is the client threat. Somehow (through no fault of your own, naturally) you find yourself in a position where your integrity is challenged, your creative honour put at stake, your abilities questioned. You remember the phrase "You're only as good as your last job" and for just a second you start to doubt yourself. Your insight, experience, your ability to channel the absurd. You're backed into a psychological corner. It's fight or flight. Which do you choose? That's right. You come out fighting and absolutely nothing's going to stop you. You won't be beaten. The switch is well and truly flipped.

Now at this point we should probably go back to the thing about ego because let's face it, that's really at the heart of all this. Looking at the examples above, it's easy to dismiss the condition as something bad. But the thing is, to be a half-decent creative person, and this is true at least for GBH, we think you need to have a side to you that wants to do some crazy stuff. A side that wants to provoke, make people laugh or simply gasp at the scale/audacity/shock factor of your idea.

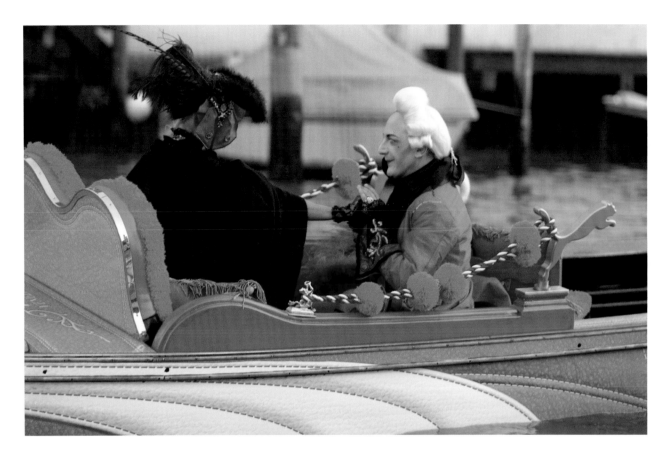

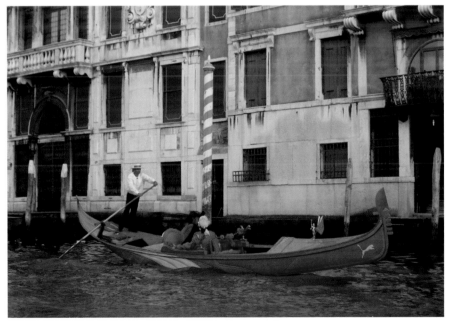

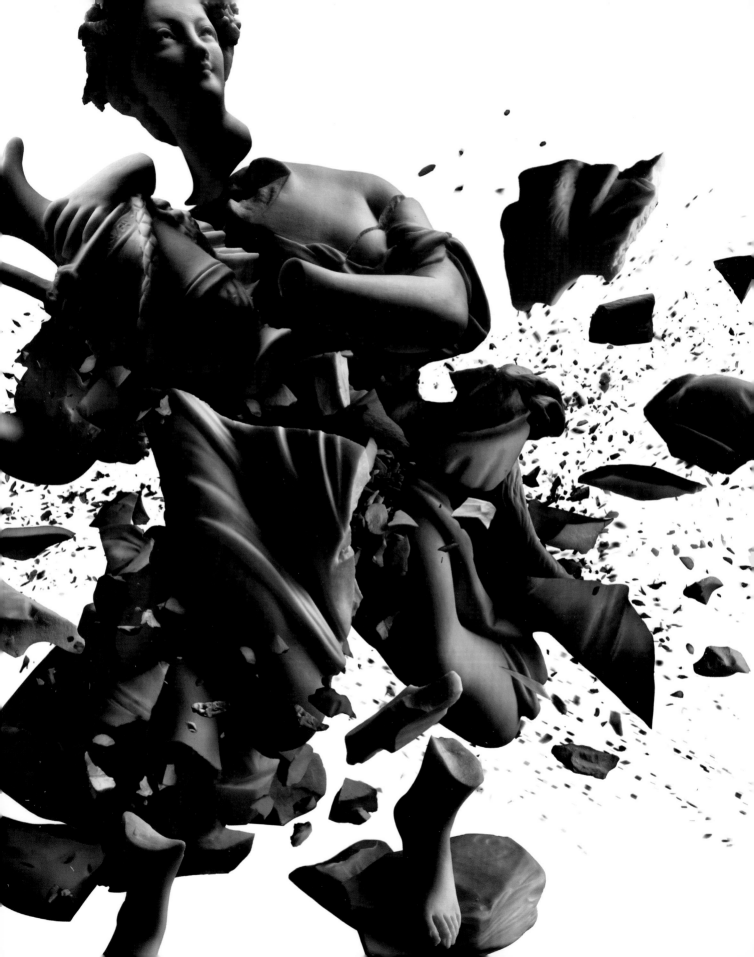

It's kind of the reason we do it. Yes yes, of course we want to add value to our client's business and help communicate valuable brand messages to their audiences and all that grown-up stuff, but we'd be lying if we said we didn't want to really, seriously impress people. We think anyone in the creative biz that is any good is probably susceptible to this mental state too.

To a degree you could even say that we've also come to rely on this quality and now use it as a secret weapon—whether we like it or not it's become an essential part of how we go about getting things done. But what's so compelling and vital about the kamikaze within is that it's utterly honest, unmalicious and pure in its motives. It's the opposite of a business mind, instead fired up by the desire to do really exciting, attention-grabbing stuff. You have to marvel at how it is utterly oblivious to finances and budgets, how it scowls at schedules, chews up timesheets and never, ever tries to second-guess what the client might want. If our bank manager is reading this, of course these things are hugely important to keeping a design agency ticking along nicely, but they don't help you to come up with that intangible magic that you need to grab an audience, charm them, make them laugh.

The kamikaze gives us license to indulge and take delight in those surprise results that come from just letting yourself go, giving in to your silly side and not giving a shit about rules, conventions or dreaded expectations. How you make the most of these results, turn them into polished nuggets, is of course the important trick and maybe one for another chapter.

Groupe Allard
Explosive Branding

The business of Groupe Allard is to seek out grand and historic buildings that have long fallen into disrepair, breathing new life into them by remodelling and re-appropriating. "With great energy we will resurrect the forgotten palaces of the world, keeping the best of the old and merging it with the best of the new, afterwards presenting something unexpected and beautiful that did not before exist." From this often brutal, sometimes architecturally controversial vision, hotels, shopping malls and piazzas have all grown.

At some point during our creative brainstorm, somebody suggested the idea that we put our money where our mouth is and make our own brutal statement, a piece of art almost, that could become the identity for the group. It seemed debauched at first but we were soon gripped by the idea of blowing up a precious antique. Eventually we found a beautiful, 200-year-old marble carving and set about trying to convince the client to 1. Buy it and 2. Let us destroy it.

Having been given the go-ahead, the statue was shipped to the photographer's. With great anxiety, we set about breaking it up with a hammer. To create the final piece, each element was painstakingly arranged, shot and reassembled into a composition which shows the split-second moment of detonation.

The result is an energetic piece of brutal elegance and a lovely example of re-appropriation. The statue not only lives on, it is an icon for Groupe Allard. At once old, yet utterly shocking and new.

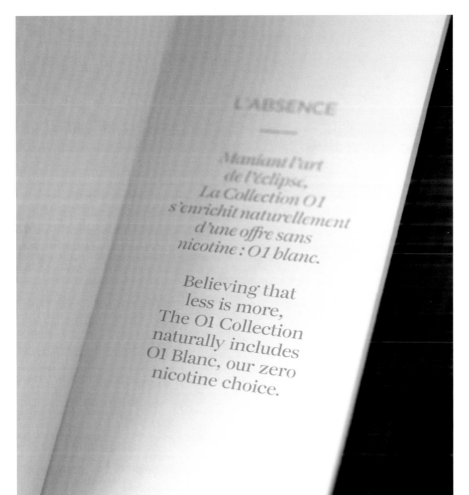

Only One Paris
E-Cigarette Branding

Whichever way you look at it, smoking is a provocative and emotional subject, guaranteed to inflame, disgust and polarise most folk. That's probably why we were so drawn to the ethically dubious fug of the e-cigarette.

Seen by some as a gateway drug to get your kids hooked and argued by others as the twenty-first century's risk-free alternative, our challenge was to name and create a brand both desirable (reimagining the glamour of 50s Hollywood) yet stripped-back and straightforward, making clear the options of normal, low and no nicotine content. The result is simple and controversial.

The name Only One is abbreviated to O1. We designed the illuminated end of the product to be a glowing letter O. The packaging has a gradient across the individual boxes from black to white, encouraging a path of decreasing nicotine usage. An elegant lifestyle product that's provocative, but an innovation we feel is made for the greater good.

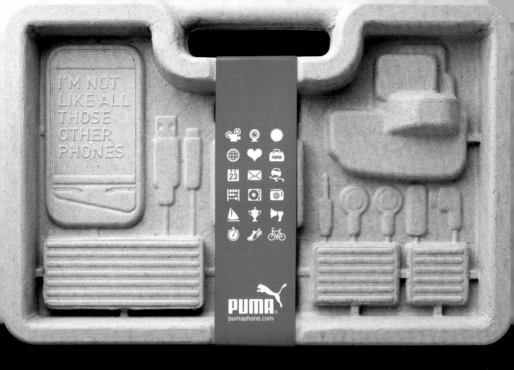

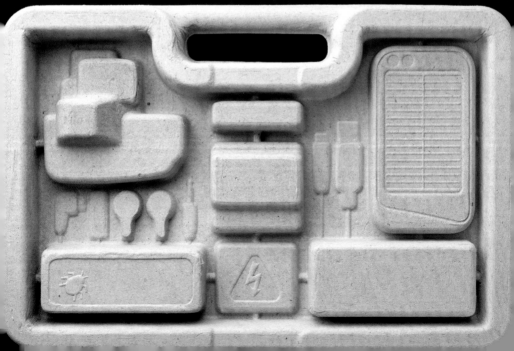

After all, you can't operate in a frenzy of adrenalin and blind ambition forever. You need to find a moment of down-time to sit back and reflect, look at where your inner self has taken you to, calmly assess those free-form ideas you've been left with. After that, get ready to do it all over again though, to encourage and immerse yourself in the conditions that will unleash your inner demon.

So to the creatives of the world, we say don't fear it; enjoy it, nurture it and above all, embrace the kamikaze within!

PUMA Phone
One Piece Pulp Packaging

It seemed so simple at first. Most electronic items you buy come in a fancy outer box which houses the ugly, beige, pulp-moulded tray inside. Our brief was to package PUMA's new phone and its assorted contents of adaptor, headphones, battery, booklet etc. So we had a neat idea to make that ugly inner tray, with all its humps and bumps and ridges which hug the components, the outside of the packaging. A kind of inside-out idea that was paired down and efficient but that looked weird and cool.

Should be easy right? Wrong. Not only did we want the shape to hold the pieces, but we became obsessed with moulding text and icons too. We nailed it eventually but only after driving our manufacturer crazy making and re-making what became the world's most complicated air-dried, single-piece pulp mould ever. And that's official.

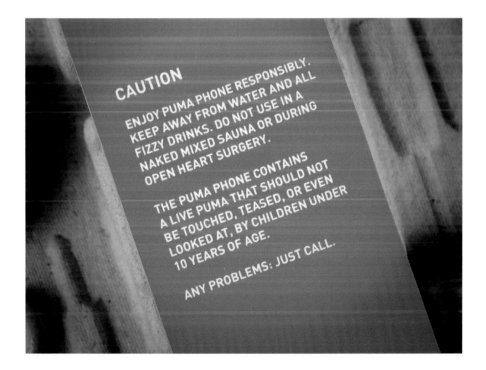

The God Complex.

1. In the beginning there was nothing. Our world was formless and a darkness hovered over us all.

2. Then GBH said *Let there be light,* and there was light. This was the light of all lights and it shone brightly with hope and truth and with purity and the laughter of children.

3. It was in this light that GBH crossed the oceans and the deserts, they were fruitful and multiplied in their numbers.

4. GBH saw the work they had made and, behold, they saw that it was good.

5. Pretty good for a first attempt.

God Complex / noun. An unshakable belief characterised, amongst other things, by refusal to admit the possibility of defeat. GBH spent 40 days (and nights) documenting thousands of lights and fittings in an architectural lighting range to create the FLOS 'City of Light'.

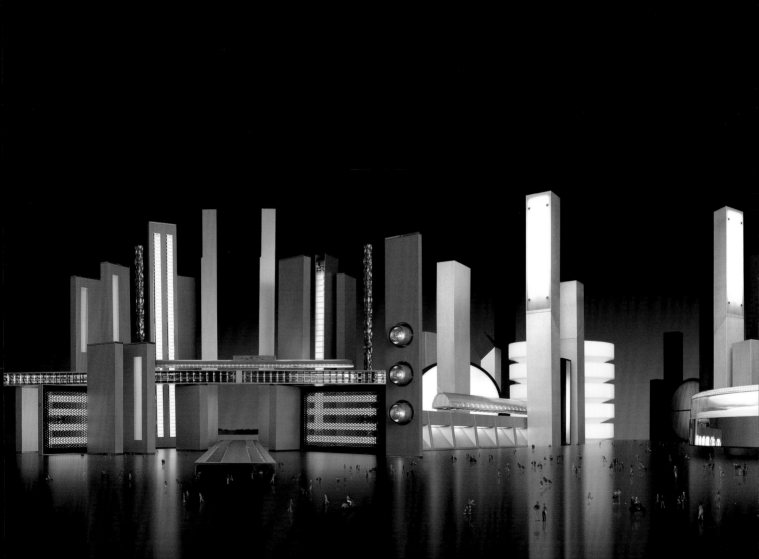

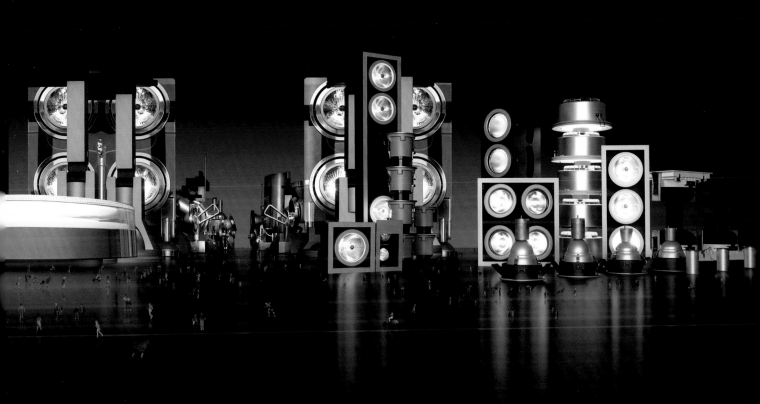

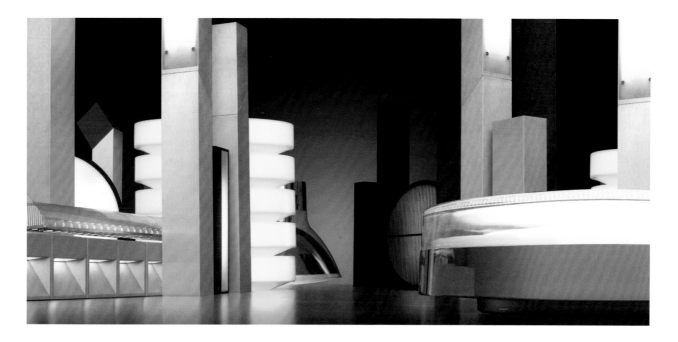

 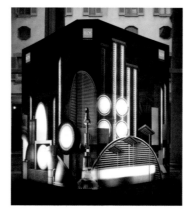 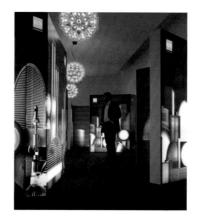

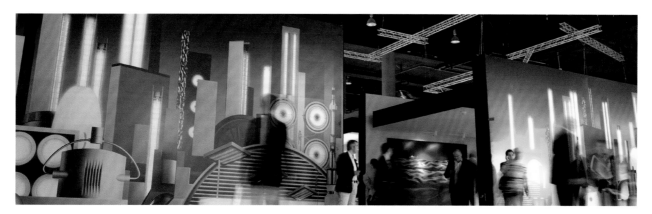

But seriously, did God have a brief or did he make it up as he went along? Usually a great start to a great project is a great brief. A document written by caring and intelligent individuals that sets out to explain what a client wants. A good one manages to strike the balance between informing and inspiring the creative mind that's reading it. In older times briefing was simpler. King Julius II briefing Michelangelo on the ceiling of the Sistine Chapel might well have said something like "Bring the awe of God creating the world into the Chapel." What we are pretty sure he didn't say was "I'm looking for something very progressive but with its feet firmly planted in tradition, we don't want to scare off the traditional churchgoer. We need 20–30 cherubs dotted around. We need gold. Lots of gold. We need to show Adam as the first man, he should be African really but the Vatican are keen he looks Italian. Oh and God, we need to show him. Or do we? Could he be implied? Anyway, you're the artist...."

The truth at GBH is, great brief or no brief at all, we've never really been happy to just get our heads down and do the thing we've been asked to do. That has always seemed a bit too easy.

We always want to do more than we've been asked to do. It's something innate within our make-up. Something we came into this world with. We tend to take the brief as a jumping-off point, something to be done not as an end in itself but as the first step on a much longer journey. It's not something we've planned or cultivated, but thinking about it now it all seems to stem from one simple approach. A start point that is the opposite of heads down. And that's heads up.

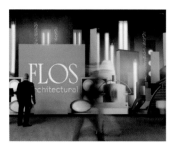

FLOS
'City of Light' Branding & Campaign

The Italian lighting manufacturer FLOS had decided to expand its business into the architectural sector. These are the lights architects specify for use in their buildings so we felt compelled to think big, really big. What if we could build something architectural ourselves using these beautiful products—not just a building, what about an entire city?

This simple and pure thought required some serious organisation. And so it came to pass that there was a photo shoot of epic proportions where each and every light they made in the huge collection was captured in every detail. And finally after 40 days and 40 nights (yes, that really happened!) we began to see the FLOS 'City of Light' appear before us in all its glory.

It was a fantastic creation to behold and as you looked closer you could see different districts of the city had been formed by groups of the same type of lights. There was a district of downlights, a district formed solely of spotlights, one district of outdoor lighting—and each product became a single building in the district. And so the city flourished and expanded until all of the lights had found a place. The city informed everything the company did that year: it was the advertising campaign; it formed the structure of a massive product catalogue with a book launch in Milan; and it was the 60,000-square-foot exhibition space at the Light+Building show in Frankfurt.

Just look up. Look to the heavens, look to the horizon. At least look forward to see where you are going so you don't trip up. It's not a secret and it's not a complex point we are making here but it seems to us that by raising your eyes a little higher than your desk and computer monitor you can see so much further, so much more clearly into the future.

Sure, there's a time to dream and a time to get things done but if you always begin by looking beyond what you are doing from the very start and understanding that nothing exists in a void then this difference of approach is the difference between the creation of individual things and the creation of worlds.

By having a bigger, broader vision you gain a better sense of what you are doing and why you are doing it. You are better able to see problems coming and better equipped to answer your own questions about what is right and what is wrong about your own creations. As your own lord and master you get to write the future. It's a future in the here and now. We believe it already exists. It's real but also unreal at the same time and to us this is its most exciting state, because anything is still possible. So, having got ourselves into this frame of mind, we ask "Why restrict ourselves to just doing what we've been asked to do? Why not think bigger, think longer, go further? Why stop now?"

Years ago a client told us not to "think poor", by which he meant we weren't seizing the day, or reaching far enough. This had quite a profound effect on us all, so much so that today if you ask us for a magazine cover, we'll design you a coffee table to put it on.

PUMA Raw Football
Teamsport Brandbook

By 2008, PUMA had built an enviable array of African International Football assets, with the hosts of the 2010 FIFA World Cup, South Africa, added shortly after the tournament's completion. It was our job to seize this highly visible brand opportunity for PUMA, which resulted in the Unity Third Kit worn by all nations (see overleaf).

To lay the foundations for that work, a strategic phase delivering a new attitude for PUMA Football for that tournament product cycle was produced, tying key footwear product stories (Speed and Power) into 'fight or flight' within PUMA's 'Raw Football'.

To convey the positioning internally, a unique book was designed using a section from the official FIFA laws of the game. This was further subverted with linocut illustrations and messaging overprinted directly onto the rulebook's hallowed pages.

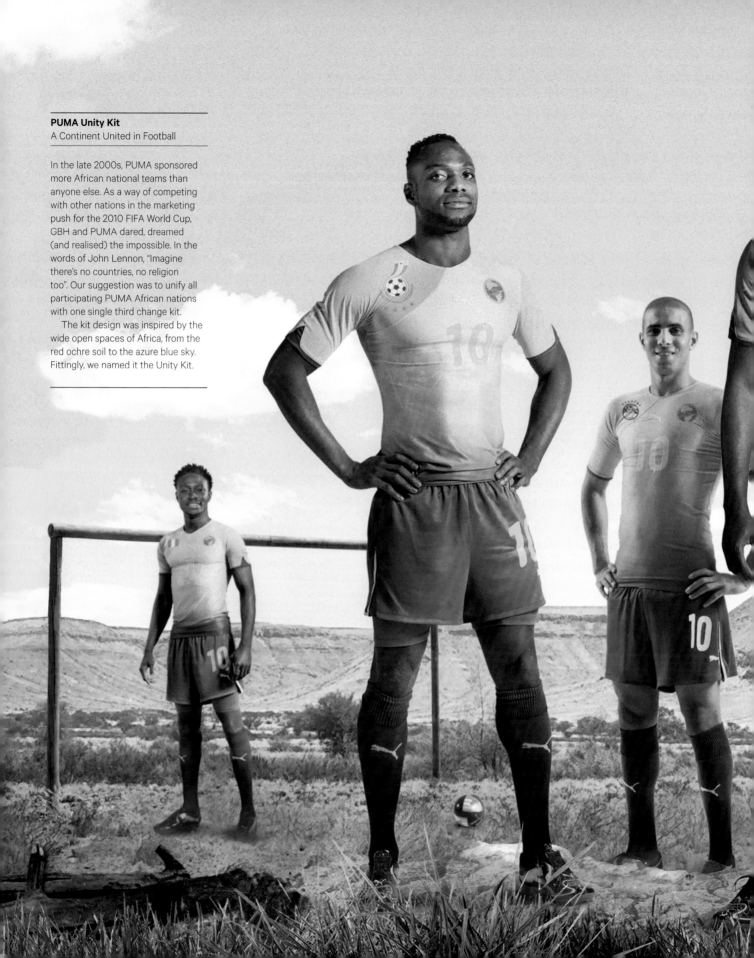

PUMA Unity Kit
A Continent United in Football

In the late 2000s, PUMA sponsored more African national teams than anyone else. As a way of competing with other nations in the marketing push for the 2010 FIFA World Cup, GBH and PUMA dared, dreamed (and realised) the impossible. In the words of John Lennon, "Imagine there's no countries, no religion too". Our suggestion was to unify all participating PUMA African nations with one single third change kit.

The kit design was inspired by the wide open spaces of Africa, from the red ochre soil to the azure blue sky. Fittingly, we named it the Unity Kit.

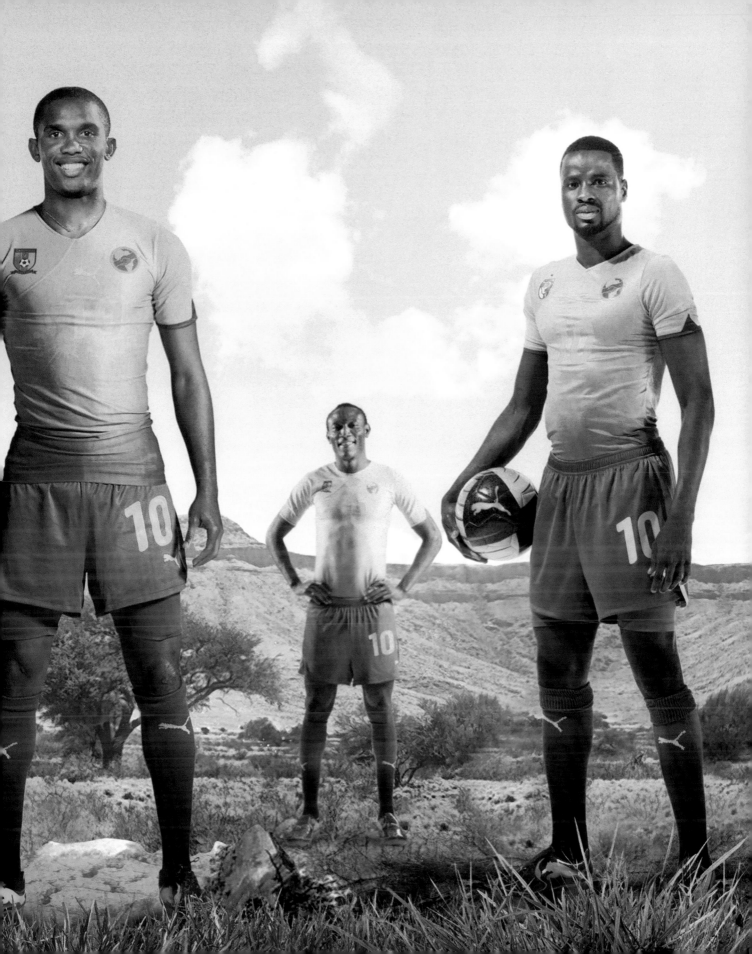

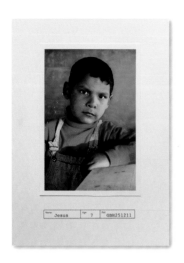

GBH Christmas Card, 2011
Jesus Saves Initiative

This is charitable giving with a whole new spin. It all started with GBH sponsoring a child in Mexico. We had no ulterior motive, certainly not to create a company Christmas card, but when we got the paperwork through and saw the name of the young boy we had sponsored was Jesus; well you can only imagine our delight!

It seemed at first like a gift from God, until we discovered that Jesus is a relatively common name in Mexico, but still we couldn't let this one slip by. Perhaps we could get others to support the charity and have a little fun in the process. So in good faith we set about inventing a life story for our boy. We wanted him to be smart, resourceful and kind. We wanted him to do well. So aping the charity's paperwork, we made a card with a photo and a handwritten note (written by a real six-year-old) which we sent to all our friends and clients.

So what happened? Nothing happened! No one responded, not a soul. Had we offended, did no one get the joke? We just didn't know. Others would have given up at this point. But not GBH, we continued on for a second, and finally, a third year bringing news of the rise and fall of Jesus, the young entrepreneur.

If you ask us for a book jacket, we'll want to rewrite the book. Ask us to design a planet, we'd probably try to change the solar system. We think you get the point! Please realise that unless we impose them on ourselves, there are no barriers in this parallel universe. There are no planning restrictions, no traffic policemen in white cotton gloves. So let's not limit ourselves and just have some fun whilst we're here. What's the worst that can happen?

The desire to influence not just one thing but to try and shoot for everything is both a blessing and a curse. The idea that we can surround one iteration of an idea with many others is appealing in a number of ways. Firstly, it's more work, it's good for business. Secondly, it preserves the purity of vision against outside forces. And thirdly it's spreading the gospel. The more things that share the same idea or philosophy means a stronger, more enjoyable experience for all concerned.

On the negative side: we just can't stop! This sort of behaviour is like a biblical plague. It's extremely infectious and we sometimes just can't help ourselves from going one step too far. From the top to the bottom, macro to the micro, and everything in between, we really do just want to design it all.

Is this some sort of mental illness? Do we have a God complex, we wondered? We discovered that a God complex isn't a diagnosable disorder and doesn't appear in any journal of mental disorders, which is nice to know. However we did learn that "someone with a God complex may exhibit no regard for the conventions and demands of society,

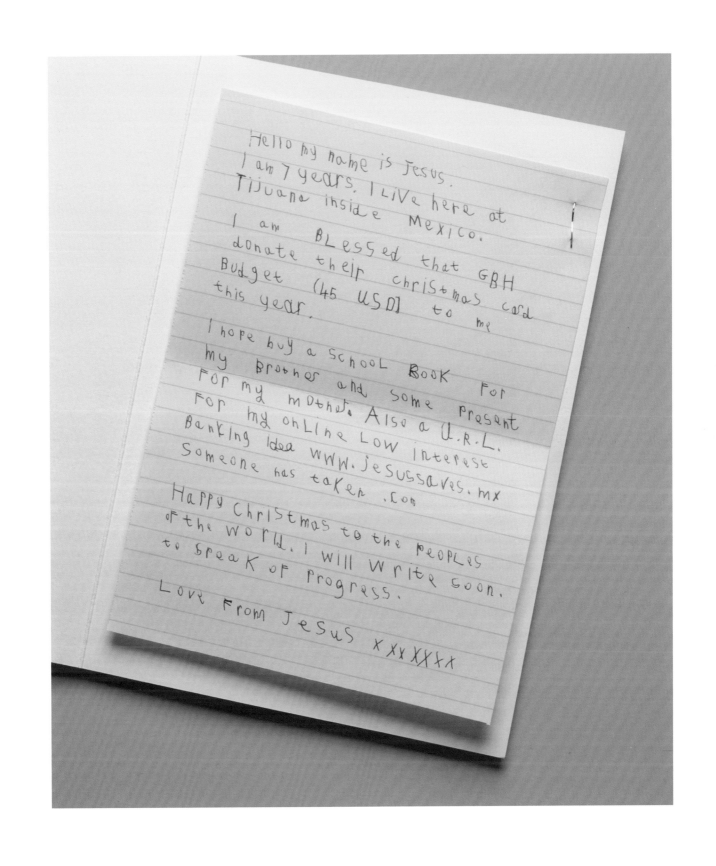

Hello my name is Jesus.
I am 7 years. I Live here at
Tijuana inside Mexico.
I am Blessed that GBH
donate their christmas card
Budget (45 USD) to me
this year.
I hope buy a school Book For
my Brother and some present
For my mother. Also a U.R.L.
For my onLine Low interest
Banking idea www.jesussaves.mx
Someone has taken .com
Happy christmas to the peoples
of the world. I will write soon.
to speak of progress.
Love From Jesus xxxxxx

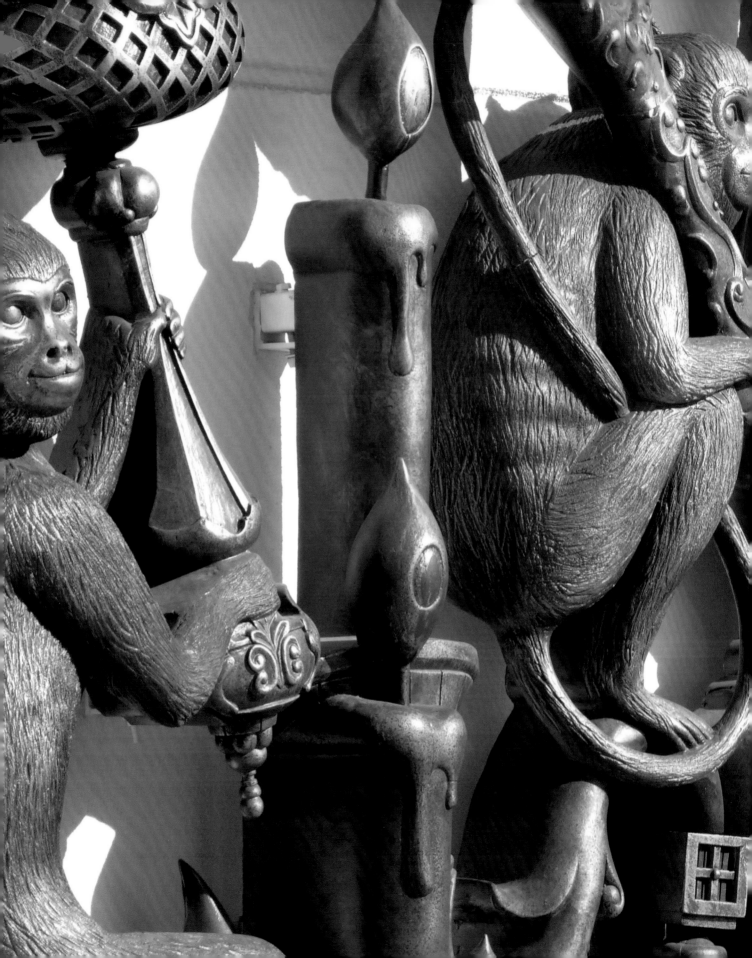

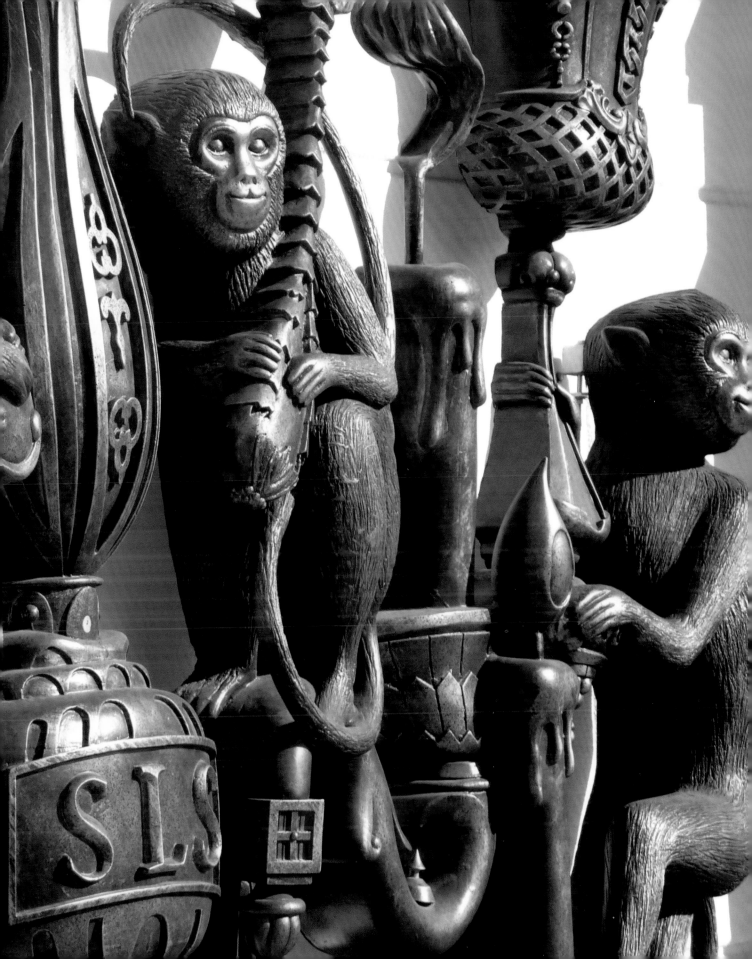

SLS HOTELS
BEVERLY HILLS

SLS Hotels
Branding in Beverly Hills

Luxury comes in many forms as the identity for SLS, a five-star Hollywood hotel, demonstrates. Combining the "historic grandeur of Europe" with a sense of Beverly Hills after-hours party spirit required a delicate balance. Our vision was to create a whole new species of party animal that would flirt with scandal one minute and then blend right in with polite society the next. This required us to walk a tonal tightrope whilst keeping a straight face in the process.

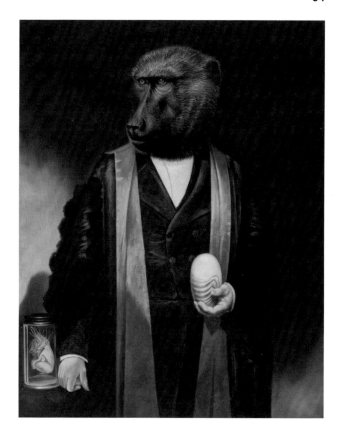

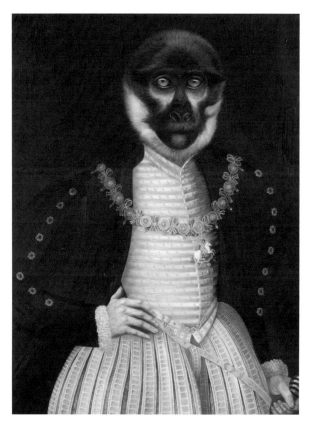

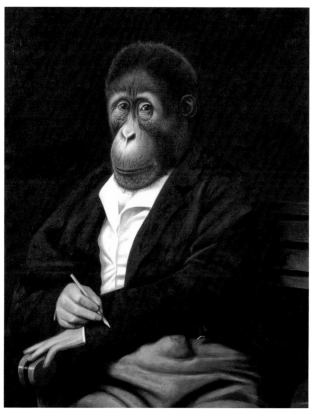

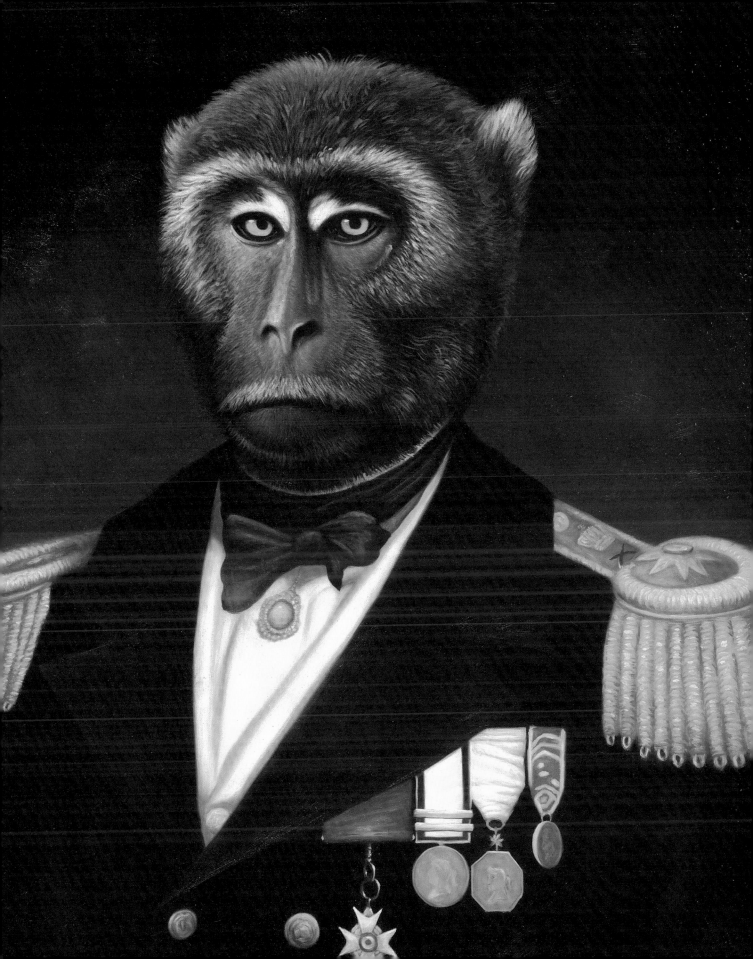

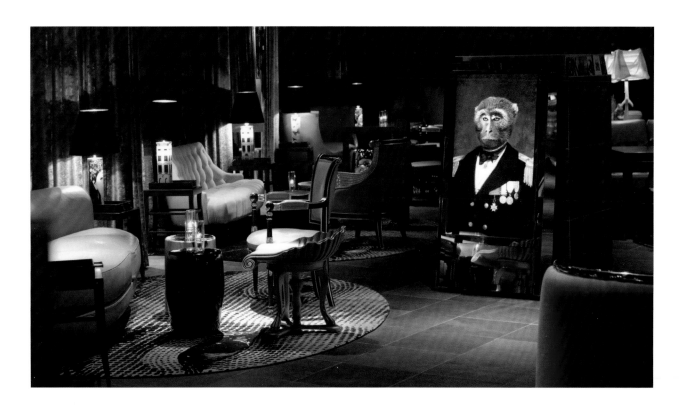

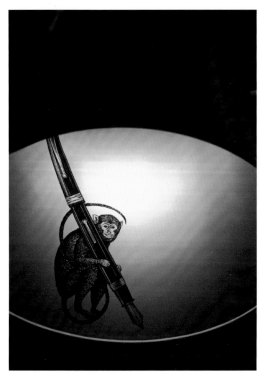

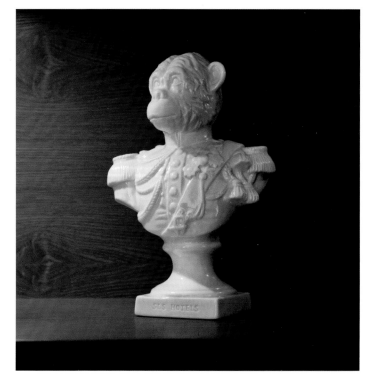

and will refuse to admit the possibility of defeat, even in the face of irrefutable evidence, intractable problems or impossible tasks", which does start to sound a little bit familiar to us if we're honest with ourselves.

This relentless behaviour can be taxing on us mortal human beings and sometimes when things get too much for us, on rainy days when the clouds cover the sun, sometimes a little heresy can creep in. We sometimes wonder what it might be like if we didn't have to reimagine the world again. What if we didn't have to start over every time? Why can't it be a bit easier after all these years? After all, a really great piece of work is really a great piece of you, and sometimes it can feel as if there's not too many pieces left to give.

Suddenly doing something simple, something a bit repetitive, perhaps making bird boxes in a workshop or bottling beers seems like a soothing alternative to what we do with our lives. Why, we've even talked about having a GBH garage, not one that fixes cars that have broken down (too much like problem-solving), but one that only does MOT tests. Pass or Fail. Just the two outcomes—how soothing and simple that would be! A place where the tired creative brain could heal and regroup by concentrating on doing just the one thing for a while.

But we were quick to say a firm NO to that one, that's not the life for us, that is but a foolish and unattainable daydream. We must go on. Carry on the good work. The creation of worlds is where it's at with us. It's in our blood, and after all if we don't do it they're not going to create themselves, are they?

The troop of capuchin monkeys that we released into a Baroque playground create a double take that is one part elegance, one part mischief. They seem to mock those that fail to notice them and offer a promise of adventure and delight to those that do.

Once conceived we let our beloved creations run wild and free. We watched over them with pride as they flourished and adapted to the high life in every conceivable corner of the hotel. We commissioned original oil paintings of the elders, we created on-screen morphing art pieces which very slowly changed from monkey portrait back into a portrait of a human. A sort of reverse evolution that took place over half an hour. We named public rooms in the hotel after famous monkeys, made enormous sculptural signs of the logo and honoured monkey war heroes by creating a ceramic bust that featured in the hotel suites.

And today, some years later, the descendants of this tribe now inhabit hotels all over the USA. Some have recently been sighted in Asia.

We relentlessly pushed for excellence in the creation of the hotel materials. Everything was bespoke and made with great seriousness and attention to detail: we used the best sculptors, printers and craftspeople we could find. The room directory was fine embossed hide, the insides written as a fully functioning dictionary which became a huge project in its own right. The carrier bag is even modelled on the iconic Hermes Birkin bag so beloved by the celebrity set. The project was a labour of love and took two years to complete.

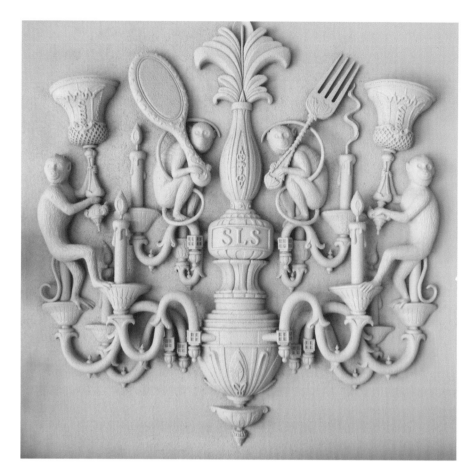

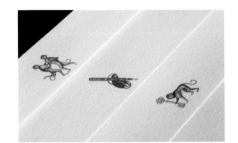

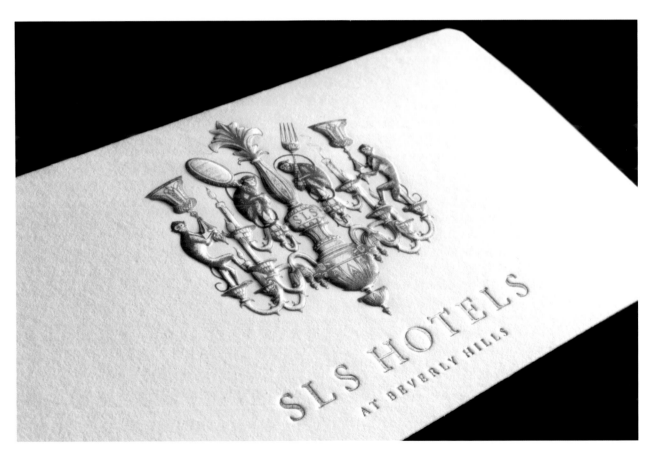

STARCK Network
Branding & Website Design

What do you give a man who has everything? What do you give a man who has designed almost everything? 10,000 individual things and rising every day. The design legacy of Philippe Starck is legendary. On a website it's almost overwhelming. So what we give the visitor to starck.com is the simple and refreshing option of selecting LESS.

The site contains everything designed by Starck in his lifetime, in chronological order—on just one page! That's right, the homepage contains everything Starck has ever done, every project, in a never-ending scrolling page. However, as a way to tame and curate this universe of creation, we give the visitor the option to select LESS which instigates an intelligent search, from individual projects to whole categories. It's a powerful and pre-emptive tool to help navigate and also explore his world.

Select MORE and you get a traditional category site navigation which also features a press area and topical news and views curated by the man himself. The intention for development is to build that side of the site so visitors come for Starck but stay for more.

Virgin Galactic
The World's First Spaceline

Humans have looked to the heavens with awe and wonder since time began and our species is driven by a deep desire to explore.

Virgin Galactic is determined to provide civilian astronauts with the opportunity to look back down at earth from a new, life-changing perspective and the mission's aim is for their effect back on earth to be profound.

The blue iris is Branson's own, but the beauty and depth of this democratic, dynamic identity grows as each new astronaut has their own iris photographed as part of the process of going into space. In time, this scheme will curate a unique colony of real identities from across all cultures and nationalities.

The graphic silhouette is referred to as 'The DNA of Flight' and expresses Virgin Galactic's place amongst a rich history of aviation pioneers. The device is used in conjunction with the iris to deliver a flexible and meaningful system. The Virgin Galactic brand identity needs to communicate universally, without language, across political and geographic boundaries and we work with this requirement uppermost in our minds.

A New Vision
The curiosity and adventure of the human spirit exist in the vision of a human eye, from today through millions of years of evolution, right back to the beginning of mankind.

The nebulous arc – represents the infinite possibilities of this endeavour and signifies our opportunity to look back at earth from space with our own eyes for the first time.

The eyes pupil incorporates an eclipse, the dawning of something new, something unique but accessible. Something far, but near.

PHILIPPE STARCK

Why am I going to space?

Space travel offers perhaps the ultimate opportunity for those seeking to rise above the triviality of material wealth and who recognise the riches to be found from personal experience. Our early astronauts will be pioneers for a new industry, making the dream possible for the many others who will follow and provide the foundations for a new space age. The experience will be intense, thrilling and magical. It will change the way you think and give a perspective that has remained out of reach to all but the very privileged few.

That perspective has much to do with the fragility and beauty of Earth that can only be truly appreciated by seeing it, at a distance, first hand. Many astronauts of the past have returned to earth as confirmed environmentalists, having seen for themselves the narrow layer of atmospheric protection and the visible effects of man's activities. To extend that insight to a new generation of private astronauts could have a powerful impact on the way we choose to manage our planet in the coming years.

How do I get ready?

As a Virgin Galactic astronaut you will embark on 3 days of space training in preparation for you for your flight. The Virgin Galactic suborbital syllabus will prepare you mentally and physically for something you have never experienced before.

Virgin Galactic training will help you prepare for near instantaneous 4G on launch, achieving supersonic flight in under 8 seconds and accelerating to speeds of up to Mach 4. You will be prepared for the extremes of sound and silence you will hear, and also be taught the etiquette of floating freely in weightlessness. You will also be fully trained with communication and recording systems, to help you record the event, so your moments will stay with you forever.

Our medical program will be driven solely to ensure your safety and enjoyment in space. We are working with the best medical minds in the industry and Virgin Galactic is fully committed to making sure you have the right level of health and fitness for your spaceflight.

What will it be like?

Your journey to space will be one of incredible contrast and sensory overload. From the spaceport to 50,000ft, you will be in the spacecraft attached to the mothership, a specially designed jet carrier aircraft. It will be a time of anticipation and perhaps contemplation of what's ahead.

Then the countdown to release, a brief moment of quiet before a wave of unimaginable but controlled power, surges through the craft. You are instantly pinned back into your seat, overwhelmed but enthralled by the howl of the rocket motor and the eye-watering acceleration which, as you watch the read-out, has you travelling in a matter of seconds, at almost 3000mph - 4 times the speed of sound.

As you hurtle through the edges of the atmosphere, the large windows show the cobalt blue sky turning to mauve and indigo and finally to black.

The rocket motor has been switched off and it is quiet. But it's not just quiet, it's QUIET. The silence of space is awe inspiring. What's really getting your senses screaming now though, is that the gravity which has dominated every movement you've made since the day you were born is not there any more.

There is no up and no down and you're out of your seat experiencing the freedom that even your dreams under-estimated. After a graceful mid-space somersault you find yourself at a large window and what you see would make your hair stand on end if the zero gravity hadn't already achieved that effect. Below you (or is it above you?) is a view that you've seen in countless images but the reality is so much more beautiful, so much more vivid and produces emotions that are strong but hard to define. The blue map, curving into the black distance is familiar but has none of the usual marked boundaries. The incredibly narrow ribbon of atmosphere looks worryingly fragile. What you are looking at is the source of everything it means to be human, and it is home. You see that your fellow astronauts are equally spellbound, all lost in their own thoughts and storing away the memories.

Sir Richard Branson

founded Virgin in 1970, and not long after he opened a record shop in Oxford Street, London.

The Virgin Group has now expanded into international music Megastores, air travel, mobile, financial services, retail, internet, drinks, rail, hotels and leisure, with around 200 companies in over 30 countries.

Virgin Atlantic Airways, formed in 1984, is now the second largest British long haul international airline and has won many major awards.

Richard has been involved in a number of world record-breaking attempts since 1985. In 1986 his boat, 'Virgin Atlantic Challenger II' crossed the Atlantic Ocean in the fastest ever recorded time. This was followed a year later by the epic hot air balloon crossing of the same ocean in 'Virgin Atlantic Flyer'.

After the ultimate adventure, in January 1991 Richard crossed the Pacific Ocean from Japan to Arctic Canada, the furthest distance of 6,700 miles. Again, he broke all existing records. Between 1995 and 1998 Richard Branson, Per Lindstrand and Steve Fossett, made a number of attempts to circumnavigate the globe by balloon. In late 1998 they made a record breaking flight from Morocco to Hawaii but their dream of a global flight was shattered by bad weather.

27.07.05
Sir Richard Branson and Burt Rutan announced their signing of an agreement to form a new aerospace production company to build a fleet of commercial suborbital spaceships and launch aircraft.

The new company will own designs of the new SpaceShipTwo and WhiteKnightTwo launch systems that are now in development at Scaled Composites.

Burt Rutan

was born in Estacada, Oregon, and raised in Dinuba, California. By the time he was eight years old he was designing and building model aircraft. His first solo flight in a real plane was an Aeronca Champ in 1959, when he was sixteen.

After working for the U.S. Air Force at Edwards Air Force Base, he became director of the Bede Test Centre for Bede Aircraft, in Kansas, a position he held until 1974.

In June of 1974 Rutan formed Rutan Aircraft Factory in the Mojave Desert. His first design was the Rutan VariViggen, a two-seat pusher with a canard in front. In April 1982, Burt Rutan founded Scaled Composites, LLC, which has become one of the world's pre-eminent aircraft design and prototyping facilities.

Over the years Burt Rutan has designed hundreds of aircraft, including the now famous Voyager, which flew a record-breaking nine-day non-stop flight around the world.

In 2004 Rutan's SpaceShipOne became the first privately funded craft to reach space in June of that year and win the Ansari X Prize a few months later on October 4.

Some of his other designs include the Raytheon Beechcraft Starship, the remarkably asymmetrical Boomerang, as well as small, light, general-aviation aircraft such as the VariEze, Long-EZ, Quickie, Quickie 2, and Defiant.

On March 3, 2005, the Virgin Atlantic GlobalFlyer, an aircraft similar to the Voyager design, completed the first solo non-stop, non-refueled flight around the world

State Officials Sign Agreement For New Spaceport Site

At press conferences in London and New Mexico, officials from Virgin Galactic and from the State of New Mexico announced that they had reached an historic December 2005 agreement, which will see the building of a $225m spaceport in the southern part of the State, on a 27 square mile area of State Land.

"We are truly on the ground floor of a new industry"

Virgin Galactic's spaceflights will initially operate from the Mojave Spaceport, a stunning location in the Californian desert, which will afford spectacular views of the Pacific Coast. It is also the home of Burt Rutan's Scaled Composites, the birthplace of SpaceShipTwo and where SpaceShipTwo is now being built. It will provide a fitting launch site for this amazing venture.

Virgin Galactic will then establish its headquarters and operate its space flights from the world's first purpose built commercial spaceport in New Mexico. Funded by the New Mexico state government, it will provide cutting edge facilities and a wonderful location for fledgling astronauts to realise their dreams.

Virgin Galactic is already looking seriously at other potential spaceport locations around the world, with a view to expanding the enterprise and making the wonder of space travel accessible to as many people as possible.

An ideal operations base: good climate, free airspace, high altitude, and stunning scenery.

"Safety is the North Star of this project"

"Individually, each of those technologies increased safety by a factor of ten... I think everybody will understand that fifteen to twenty years from now"

BURT RUTAN
CEO, SCALED COMPOSITES

STRONG COMPOSITE MATERIALS

SS2 uses a high grade of composite materials designed to give the craft a huge amount of strength while remaining lightweight.

SAFE HYBRID ROCKET

Powered by rubber and nitrous oxide the hybrid rocket motor is noncombustible, and completely controllable.

50,000ft AIR LAUNCH

An airlaunch means that SS2 does not need to carry large quantities of fuel compared to a ground launch vehical. Secondly, because SS2 has wings, it can at any point during the flight, simply glide back to Earth

"We are truly on the ground floor of a new industry"

PRESIDENT, VIRGIN GALACTIC

SPACE TOURISM

SPACE TOURISM

SPACE TOURISM

Virgin Territory

200,000 ft

100,000 ft

VIRGIN GALACTIC

Virgin

Creating these little worlds is like creating a walled garden, where we can consider all the elements and have control of all that is seen, touched, smelt and heard. Some of the best examples we have of this are in the hospitality sector. In a hotel, a restaurant, a lounge, a changing room or even a toilet cubicle, indeed anywhere people seek refuge from the bustle of the world, our work is able to flourish most vibrantly. Like the Galapagos Islands for Darwin's finches, they are protected environments where things can evolve and grow in all sorts of unique ways that would be so much more unlikely out in the rough and tumble of the real world.

Creating branded environments is a delight because we can with some certainty predict the path and behaviour of the people who will be using them. We know when they will be seated, when they will be relaxing, often when they will be leaving. This gives us key points to work with, certain places where we know we can have their undivided attention which allows us to make an experience that builds upon itself to create a richer, more memorable experience.

It means that each element, each incidence of an idea can be considered separately and become more specialised, more ornate, more appealing in its own right. We can make better surprises, more intricate languages and in general be a bit more indulgent in delighting our audience. The plan as always is to convert the congregation, getting them to remember, compelling them to take away and pass on to others their new-found devotion.

We believe without question. We are the faithful. For the Power. And the Glory.

Amen.

A ticket holder's support of the project's ambition is rewarded via a 1-metre-high book which contrasts the noise of the global media conversation on the covers with the uninterrupted silence of images detailing the preparation, launch, weightlessness and views of earth inside its oversize pages.

The publication is exclusive to full ticket holders, and three versions were produced originally, awarded depending on the level of deposit: a broadsheet version which unfolds to reveal the spaceship's view of earth taken by test pilot Brian Binnie; a gatefold brochure offering substantial detail (selected spreads are shown below); and the A0 monolith, the front cover of which is shown opposite.

The identity has been created with the importance of its livery in mind, and a custom typeface was created in five weights, the lightest named 'Zero G'.

After mid-air launch, VSS Unity will travel at mach 4 speed to the edge of sub-orbital space with a precise fuel load. Once expired, the craft's wings move to an upright position and a period of weightlessness can be experienced by its passengers. The brand identity is now at its apex, with the giant iris literally looking back at the fragility of earth, before the spaceship spirals in a controlled, gradual and gliding descent back to Spaceport.

The livery is a work in progress in collaboration with Virgin Galactic's design team, but a partial chrome finish will reflect the changing environments of its context as it travels from desert, through the stratosphere's indigo blues to the black edge of space and back.

Zero G
abcdefghijklmnopqrstuvwxyz
ABCDEFGHIJKLMNOPQRSTUVWXYZ
1234567890[]!/?-:;"" ''..

One G
abcdefghijklmnopqrstuvwxyz
ABCDEFGHIJKLMNOPQRSTUVWXYZ
1234567890[]!/?-:;"" ''..

Two G
abcdefghijklmnopqrstuvwxyz
ABCDEFGHIJKLMNOPQRSTUVWXYZ
1234567890[]!/?-:;"" ''..

Three G
abcdefghijklmnopqrstuvwxyz
ABCDEFGHIJKLMNOPQRSTUVWXYZ
1234567890[]!/?-:;"" ''..

Four G
abcdefghijklmnopqrstuvwxyz
ABCDEFGHIJKLMNOPQRSTUVWXYZ
1234567890[]!/?-:;"" ''..

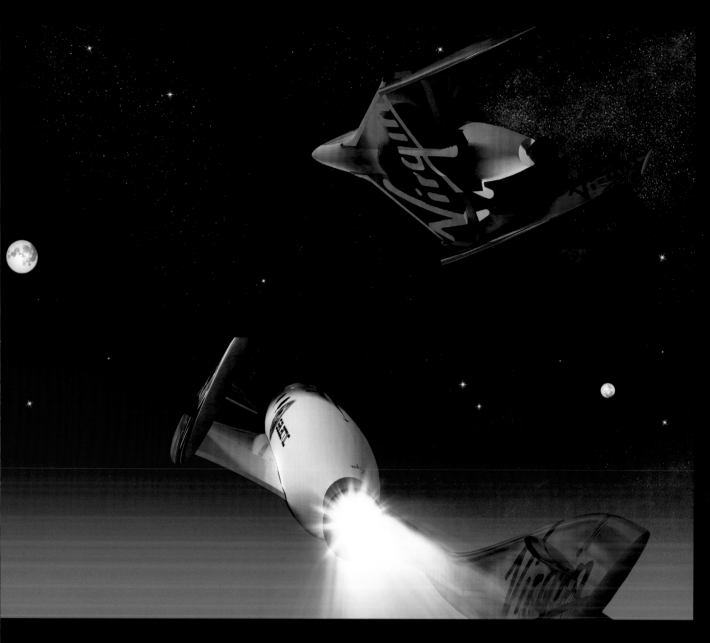
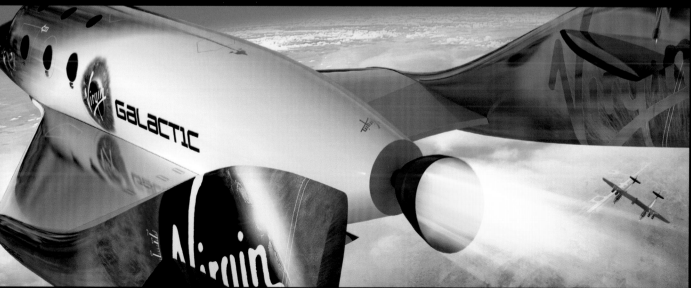

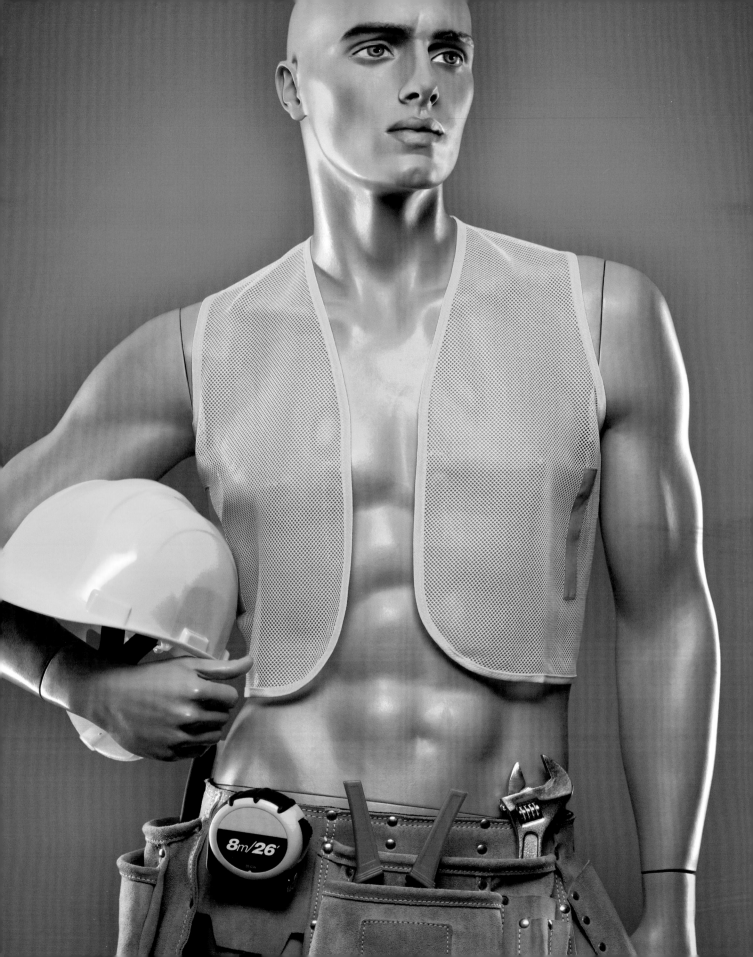

People, not Projects.

Designers have this fantasy that we'll end up with only artisan projects in a brick-lined, parquet-floored, whitewashed loft, with achingly cool, obscure Blue Note Jazz on 180 gram vinyl. We'll collect design-classic furniture that we never actually sit on, with a lovingly curated mix of career memories: distressed signs, rare books and papier mâché animals on the shelves (thanks for everything, Alan), all alongside our regularly polished awards, of course. A stainless Gaggia is always on the go, natural sunlight and birdsong pours in and there's not a phone call in sight. Sound like a designer's dream? Well, good luck with that utopian vision—each to his own—for that's not Design as we know it.

'Brooks' Law' | noun. The rule that "adding manpower to a project running late will make it even later, as each new person's 'ramp-up' to productivity takes incrementally more, not less time".
Happily, 'The Bermuda Plan' reassures: "if 90 per cent of the people working on a project were removed, (send them to Bermuda), then the remaining 10 per cent will always get the job done quicker".

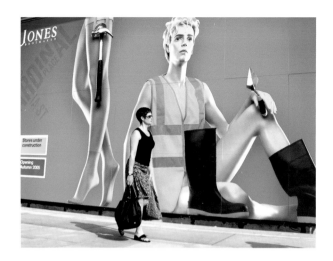

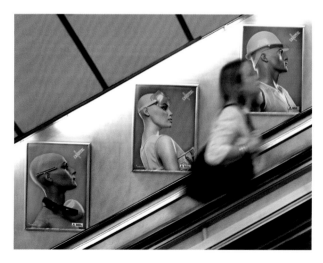

We work in an organised chaos. We're often fresh out of tea bags, with 6 Music on a brain-numbing loop. Constantly caught somewhere between finishing and starting new things, each and every day. A new schedule and to-do list every 48 hours, moving goal posts, 15–20 overlapping projects, one unrelenting standard of excellence and what feels like hundreds of people appearing to do their damnedest to derail it... that's the Design we know and love.

To tame this beast, we need a process. A way of working that allows us to feel the tranquillity of the sunlit white room, within the reality of what seems like Grand Central Terminal. Is it a complex set of behaviours, paperwork or a chain of command? No. Everything distils down to one, simple, unarguable need: communication.

Ironically, this elusive art is exactly what we're supposed to be really good at.

We're communicators first and foremost, but there's an interesting irony here, as the average Joe Designer is more than a little introverted. All the extroverts at art school seem to end up in advertising, while we designers all aspire to a whitewashed solitude. Why is that?

Even a designer working alone is actually working in a team of two when you really think about it. Three, if you count the client AND the problem they're trying to solve. So right away, it's best for everyone that you realise you're working in a team and it's the team that makes the work great, not just you. Design doesn't work in solitary confinement, the magic only happens when you collaborate with your client and with the project itself.

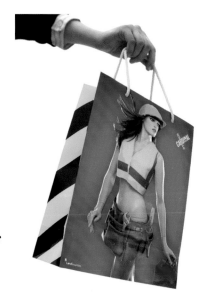

Land Securities
'Built For Fashion' Campaign

Humanity can appear in the least likely of places—for instance, a mannequin warehouse. A campaign to promote the soon-to-open retail shopping centre Cardinal Place featured a range of hand-picked fashion mannequins who we dressed up as construction site builders to create a light-hearted series of images to inform shoppers that a fashion paradise was being built.

The interesting thing was the strange effect working with all those fake, unclothed humans had on us and how quickly we projected personalities on to them. Mind you, some of them really were very lovely.

Design doesn't grow without information, conversation, discussion, questions, answers, suggestions and rejections. You can directly correlate good work with good communication. The projects that rise are the projects where no one hides. You'll need a thick skin. A good connection between designer and client, between product and audience. Writer, illustrator or photographer, printer, digital designer, web developer, filmmaker, interior designer, courier company and even the sandwich shop are the intertwined strands in the DNA of great work. Think of it as a kind of electrical circuit: for the current to flow, it needs clean contacts and every working part functioning at its best, relaying the energy that lights the light bulb, turns the wheels and sets the plan in motion.

Work on your own in psychological isolation, and you'll become paranoid, conceited and precious. Play for a team with focused skills with a clear sight of goal, and watch it sail right into the top corner.

To communicate, you need to understand people; not typography, coding or Creative Cloud. That's the hardest part of being a designer right there, but it's also the most important insight of all. Here's the good news: the sensitive, introverted stereotype has an advantage here, because he or she has a finely tuned antenna to what people are thinking. A person like this wants to be liked, to people-please. To achieve this, he or she has become very, very good at listening, at reading between the lines. A designer like this develops a sixth sense for what's next: like a chess grandmaster,

Land Securities
'Famous Faces' Campaign

We've had particular ideas in the past that have relied 100 per cent on convincing others to join our madness. 'Famous Faces', a campaign to promote London Victoria's Cardinal Place retail centre, is a shining example.

Realising that celebrity endorsements are the best way to grab audience attention, we dreamed up a campaign that relied on well-known UK personalities making headline statements about the merits of the centre. Except they weren't the 'real' celebrities. In fact we placed an ad in the *Metro* newspaper asking for people with a famous name to get in touch if they wanted to appear in our campaign.

For the next few weeks we took calls from the likes of Michael Jackson and Julia Roberts, all wanting to take part in our stunt— having spent years being the butt of jokes it was their chance to finally be the stars. As long as we confirmed them to be real on the posters, we were free to flaunt those names as much as we wanted. Thank you again to our 'stars'—we wouldn't be here today without you.

TOM JONES FOUND THE PERFECT PANTS AT CARDINAL PLACE

TOM JONES, 37
HOME: MARYLEBONE
LOVES: CRICKET
HATES: BUSES

MEET TOM AT CARDINALPLACE.CO.UK SHOPS/RESTAURANTS/GALLERY/GARDEN

CARDINAL PLACE
VICTORIA ST

PUMA
'DuoCell' Campaign

We've had a little experience over the years making technology seem more human, more loveable. DuoCell is PUMA's sole technology—two hexagon-shaped air pockets fused together that take cushioning in running shoes to the next level. Smart science but not particularly thrilling or easy to explain.

Shunning the usual testosterone-pumped sport approach, we gave our two cells human characters and cast them in their own 'action movie' so they could show off their extra special skills. George and Oscar (together they are 'GO'!) are the dynamic duo that runners love, so much so they even got their own collectible toy line. Smart tech made simple because at the end of the day, sport is nothing without a little humanity.

they are always several moves ahead. Running the math on the myriad permutations of potential outcomes in their head, they can assess and decide upon a course of action that is best set to achieve their goal. They have an innate understanding of the human condition, of how the recipient will react. They think about the catch as well as the throw. This informs their choices and gives their work a higher likelihood of success. Let's take this step by step.

There's this curious first hurdle in creativity called the 'Chemistry Meeting'. These are those annoying diary dates where convention says you must slave over a finely curated greatest hits presentation—you put far too much work in it only to find that the clients you meet don't choose projects, they choose people. Once, we were psychoanalysed by a client to see which of the three of us would 'fit' best. We took it in turns to sit on a white chair in a white room, with white shagpile carpet, answering questions testing our openness, defence mechanisms and temperaments. On reflection, this psychiatrist's lair felt just like the clichéd design studio. How odd.

Time and time again, clients watch politely as creative people try to pummel them into a visual stupor with unarguable greatness, when they already know you are good at what you do. After all, they asked you there, right?

They don't need you to prove that to them, what they want to know is what you think about their business, their project and their future. How dare you take 50 minutes of the hour rambling on about what you did for others (or worse, for yourselves),

and then hand over to them with 10 minutes to go to discuss 'the brief'. Show them their problem in your work, use it as a muse to get them talking about themselves. The best advice we ever had was to realise that you need to say things that allow them to talk about their project—not you. Be aware of how what you say makes people feel. Master that, and that'll cause a chemical reaction of trust, and they'll add that empathy, experience and understanding to the high regard of your work that they already had.

Once you've left, you need to keep talking. Keep in touch, find ways to sustain the conversation you just had. Share knowledge, continue to be helpful. The last thing you should do is go back to your white room of jazz music, and wait for a call that will never come. In fact, do that and you'll get an email, telling you, "You came a close second". We both know there's no such thing. Email is your enemy.

There it is, four simple little words of undeniable truth. If you take just one thing from this book, take that. Email is communication for the Middle Ages, a backward step towards carrier pigeons and smoke signals of yore. Surprised? Don't be. What's so technologically advanced about asking a question and then waiting a couple of days for the answer? Pointlessly clicking that 'Get Mail' button like spinning the one-arm bandit in a casino of bad communication.

If you really need to know, use the phone. Two cups tied by string will do. The phone is still far superior to email for one simple, human reason: you don't hang up until you achieve an outcome. There's another bonus too... you can unmistakably

PUMA
'Hello' Campaign

'Hello' was a PUMA brand positioning campaign that was all about people. From the collaborative teams at GBH and PUMA, to photographer Juergen Teller and his troupe of models, to the community of PUMA devotees already out there and flying the flag of the brand. We were all in it together and it was all about one simple message: forget selling. Forget fancy product shots. Let's just gently remind people we're still here, getting on with our thing, in our own way with a polite "Hello" to all.

It was a reminder to us of how important close client and team relationships are. That some of the best work comes not from locking yourself away in isolation to thrash out some razor-sharp concept, but from getting together and talking things through as a like-minded team.

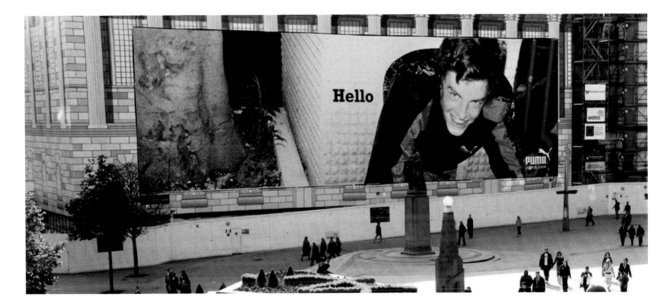

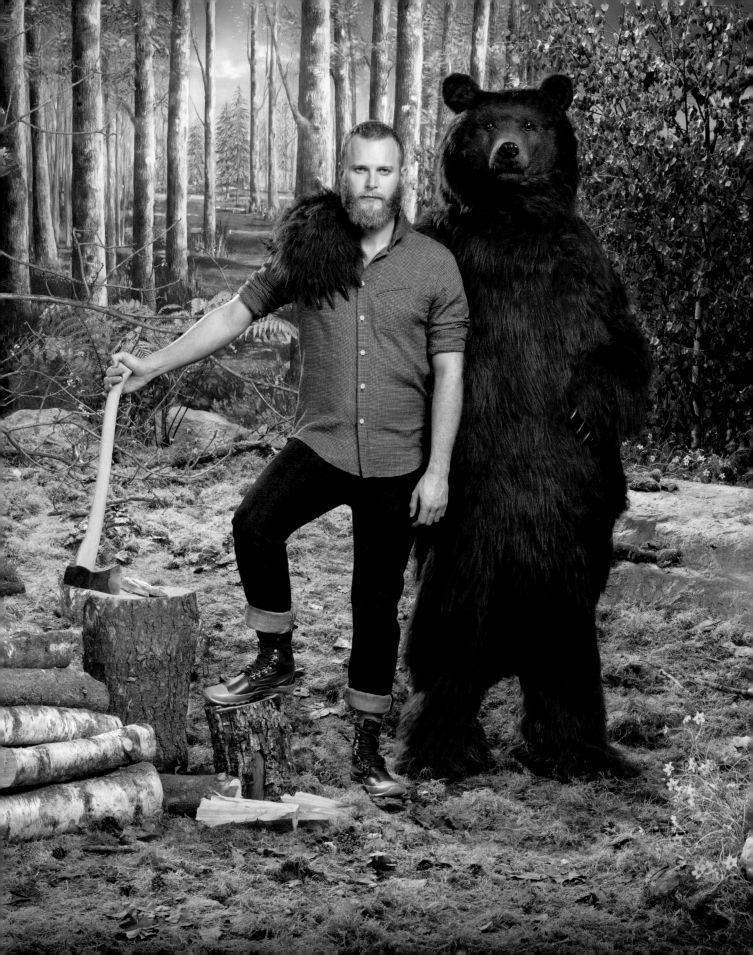

hear uncertainty, impatience, anger, confidence and even discern wit from sarcasm. You can read the reactions with your ears and you can respond with your own words, in real time. If you want to persuade or cajole a client, NEVER use email. Definitely don't chase payments with it. It's the hardest thing in the world to turn someone down on the telephone, but in an email its done within seconds, with no guilt. Worse still, it can be ignored. Email is the business equivalent of asking a friend to dump your girlfriend. It's the single biggest reason for poor communication and low productivity in creativity. Some idiots even send emails to communicate to their colleagues sitting just opposite them—perhaps via a satellite orbiting Mars—cc'ing them in on endless strings of unresolved procrastination. If you really want to put something in writing to save your ass, get a lawyer to write a letter. One last thing. Don't ever start a phone call by asking, "Did you get my email?" That's for the clinically insane.

So, now we've got that out of the way, and you got the call (not the email), how do you keep the iron hot? You keep talking, that's how. Don't disappear behind a toweringly precious three-week concept stage, making another greatest hits presentation of blind ideas. Watch, listen, learn. Repeat.

So easy to write, so hard to do. Even now, we have projects where we're not talking nearly enough to our clients and collaborators. Convincing ourselves that juggling multiple projects justifies the odd email for 'speed' or so they have it 'in writing'. The more you feel you are shrinking back into that white room with the rare jazz music, the more you need to pick up that phone. Fact.

Tretorn
'Swedish Goodness' Campaign

Tretorn is a Swedish brand that's been around for 120 years. Today they make stylish outdoor wear and promote a happier, healthier way of living. Our campaign was wrapped in 'Swedish Goodness' which nicely encapsulates not just their manufacturing process but the brand's philosophy: reconnect with nature and things will be better!
 Of course, it looks easy. To bring a bear and moose to life took a lot of people, love and late nights, but you can sense this in the finished work: images that make you want to reach out and hug the nearest person.

ZA Café Literaire
Paris Restaurant Branding

ZA is on a mission to bring health and culture to locals living in the redeveloped area of Les Halles, Paris. Serving healthy organic dishes that encourage a sense of well being, ZA allows diners to order literary novels from its menu, encouraging all to 'feed the mind' as well as the body.

The identity plays with two metro-chic characters, each a collage of graphic features snipped from real book jackets. Both are built around the typewritten name 'ZA', inverting the beginning and end of our alphabet.

Via a smart app, guests can choose from a range of novels which are printed on demand within ten minutes and delivered, with or without food and drink, by conveyor, right to your seat via iBeacon technology.

The brand identity was created to strongly reflect this unique story with a graphic scheme that represents the active lifestyles of guests, combined with a strong sense of literary iconography.

Throughout the brand scheme there are countless references to books and words, none more so than in animations which play on huge overhead screens inside the restaurant and which build to the sounds and rhythm of an old typewriter being tapped away at while our characters interact within a literary landscape.

```
            ZA
          Feeds
        the mind
      as well as
       the body.
       Read from
     our library of
    curated books;
    classic, modern,
    facts, fiction,
    crime,   rhyme,
    thriller,  killers,
    heroes,   heroines,
    lovers,   haters,
    polemic,   poetry,
   biography and biology.
   Printed on demand at ZA,
   our librarian will choose
  a magnificent seven new books
    e a c h         month
    for you         to try,
    taste,          sample,
    like or         l o v e.
  A place to eat fresh.   A place to eat fast.
  ZA is a machine for eating.  for learning, for living.
  Use your phone, Download   our App and Feed Your Mind.
```

ZA uses Xerox's digital 'Print on Demand' technology to allow its guests to choose from a database of books in multiple languages which can be ordered, printed, bound and delivered within five minutes. Perfectly bound, square-spine paperbacks, with full colour covers, literally hot off the press.

The effect of an environment busy with imagery of characters and literature is that ZA feels like more than a restaurant—there's a sense that you're partaking in a social event, that mind as well as body are being nourished and that by reading, discovering and sharing ideas, we're reconnecting with people around us.

From the app's user interface right through to a ZA Bike-Fix outside, every single opportunity to celebrate this unique combination of food and words has been utilised.

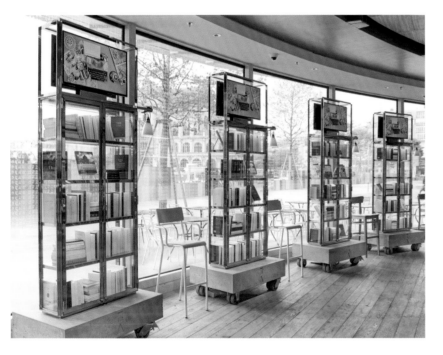

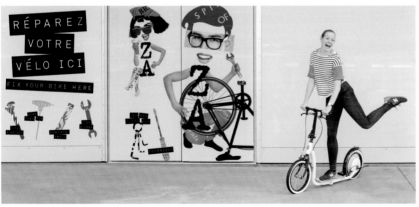

ZA is a new kind of restaurant for people that love to live and work in the city. ZA exists for urban, mobile types who like to laugh, think, drink, dance, dream, skate, cycle, argue, charm, snack, learn, flirt, sleep, read, eat or shop. Zoilettes, ZAlades, Zoupes, ZArtines and DeZZerts are all chopped, sliced, diced, flipped, dipped, grilled, grated, melted, simmered, stirred, cooked, juiced, mashed, blended, mixed, pulped from only fresh, organic and 100% natural ingredients, sourced from the very best suppliers, so we can serve super food for a super city.

5\5

........................

(ENG)

Dear Readers,

Every month, I'll propose 7
books; something for everyone,
from across the genres.

Here is this months selection:

1. PARIS VS NEW YORK 23€

2. LE GARÇON INCASSABLE 6.30€

3. ALEXANDRE GROTHENDIECK 18.90€

4. DE L'ART D'ENNUYER EN
RACONTANT SES VOYAGES 10€

5. CE QUI NOUS RELIE 18.90€

6. 3 AMIS QUETE DE SAGESSE 22.90€

7. JOURS TRANQUILLES À CLICHY 5.10€

All the books I've selected
are enjoyable to read, and all
are written by authors with
a unique view of the world.

By printing on demand, we'll
never run out of copies.
In fact (or fiction), your
order will be delivered
within 5 minutes!

Feed Your Mind.

Guillaume Allary

The ZA Press

Z
A

The ZA Press is curated by leading
French publisher Guillaume Allary
of Allary Editions. Guillaume selects
seven new books for the menu each
month from a diverse mix of genres.

To announce this changing feast
of both classic and new writing,
a 60-second film plays on a loop
within glass bookcases which house
ZA Press' growing collection of
selections. The film shows a character
representing Guillaume drifting
in and out of literary genres as he
types a personal promise to choose
"something for everyone" each and
every month at ZA.

This delicate art of constant communication is only beginning. Just you wait until you have momentum; an idea that went down well. Feedback starts and one conversation can become several, all of which need your time and skill to stay on track. Once you've lit the torch with an approved idea, you realise that in carrying it, you'll need to lead an army. Each and every person involved needs to know the plan. Include them in ownership, as they'll need to care for it as if they had the idea themselves. They'll become so acquainted, they'll be card-carrying ambassadors of your own vision.

Each and every person added on the creative side needs to be as excited and motivated as you are. If they're not, then move on to someone who is. You need the very best people, and you'll need to be in constant touch. Clear roles and responsibilities. Clear timings too. Be kind, be nice, be thorough but above all else, be clear. Make sure each collaborator knows the whole story so they can think and do in context.

On the client side, work to know the beast. If they're layered and you're dealing with middle management, then understand their rock strata. Be aware that if you're questioning the ask, or their process, they'll need to check back. It's Chinese whispers with all the agony that entails. Your message will be passed up, and their response passed down. Offer to do it for them and cut out the pain, making new relationships as you go. If you're lucky enough to be dealing with the decision-maker, then thank your lucky stars. Understand who they have to lead and help them to light their own torch.

Even the toilet signs at ZA embrace their literary inspiration. The main entrance zooms out and deals with literary archetypes and the individual booths have fun with some of the most well-known characters of all.

Turtons Protective Clothing
Brand Identity

Turtons holds a special place in our history—a reminder to us that clients really do make all the difference to your success. It was in the early years of GBH and we were looking to make a name for ourselves (and make a living). The husband and wife directors of a family-run protective clothing company, took a leap of faith with us and our ideas and helped kick-start what was to be a very fruitful relationship. It saw us rebrand their company with a symbol that was as friendly and charming as they were and help to position them above a multitude of faceless, industrial looking competitors.

In our experience, clients become friends, given time and the trust that great work provides. You'll make each other look good. There is no such thing as a bad client, just clients that need your expertise. Some need more than others, but look for the clients that enjoy the creative process. Don't run a mile if they "have an idea", or "have come up with some names". Embrace it, discuss it and build on it with your skill. Show them some love, walk with them, talk with them. Email pictures of your kids, your motorbike or whatever gets them talking. That's what email is good for.

Once upon a time, we did a project with a husband and wife team who ran a tiny protective clothing company in Birmingham, England. They'd never commissioned design in their lives. They knew very little about it, or what it could do for them. We feared the worst, in that arrogant way only designers can. What did they know? What they did know is that their business didn't stand out. They felt they worked hard and that their staff should be proud of where they worked. Luckily for us, despite our uncertainties, we passed the chemistry exam and won the project. What followed was one of the most rewarding design processes you could imagine. Their open-mindedness was the foundation for the perfect creative opportunity; we carefully explained what design could do, and we led them to a brave new identity, which remains one of the most human projects in our archive. Their seamstresses hand-sewed their own brochure covers and, in the end, they became evangelists for design. Its simplicity, wit and relevance were more than matched by their rising sense of pride.

Turtons

The Butcher, the Baker, the Candlestick Maker

and other stories.

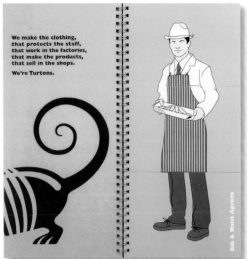

We make the clothing, that protects the staff, that work in the factories, that make the products, that sell in the shops.

We're Turtons.

Bib & Waist Aprons

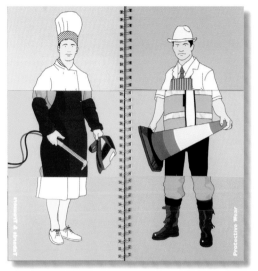

Tabard & Smocks

Protective Wear

Products can be printed, perfectly embroidered or left plain to show the worker's toil with pride.

Tabards fit for a king, made to a medieval tradition. Today, modern knights in armour cut tying tapes with steel.

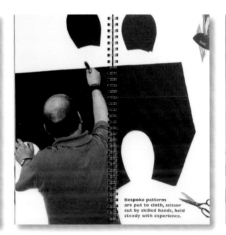

Bespoke patterns are put to cloth, scissor cut by skilled hands, held steady with experience.

Special fabrics cut, seams stitched tight, hems overlocked, eyelets threaded. Every process made by hand, aided by machine.

Turtons High Visibility

Samuels & Associates
The Verb Hotel, Boston Fenway

In many respects The Verb Hotel was a community project as much as a branding one. The hotel, a 1959 modernist motel located in the Fenway neighbourhood of Boston had in more recent years been a rundown 'Howard Johnson'. To the proud locals though, the building was a much-loved landmark that had always been at the centre of the action. A bustling backdrop with a finger-on-the-cultural-pulse, urban charm and sense of community. It had always played a big part in the neighbourhood's personality, its cast of unconventional characters, electrifying music scene, burgeoning arts scene and indie edge all shaping the events and stories that played out there.

 The ambition was to return the site to its rightful place as the home of the Fenway's legends and good times while injecting it with all the things modern guests could want. Tasked with branding the redeveloped site, our initial role was to write a new narrative to reinstate its place at the centre of the local scene. With such a rich heritage to trade off we began resurrecting the spirit of the music and attitude that pervaded. With a name derived from 'Reverb' and interiors designed around music quotes and ephemera, we instilled a respect for the past, a little irreverence for the present and a big invitation to guests to write the future.

They were amazed, and so were we. Not by how good the work we had done was, but by how great it felt making work that mattered to them. It changed their working lives. They weren't one of the world's alpha brands, but why couldn't their small family business benefit from design? It's about the people, not the projects. We remember that lesson and try to feel that good about every single project we do, regardless of who we do it for, David or Goliath.

Some of our clients are even more creative than we are. Driven, strategic, entrepreneurial, visionary; the very best know how to enjoy their dreams. They love to make new things and to get stuff done. They love solving problems. They're addicted to launching things, to seeing how people react to their stuff. They love being first. Just like we do. Working in tandem with people like that is why we do what we do.

It's more important than ever to communicate well when you're working internationally. We are, and have been since day one. Expert in Franglais, intermediate in Italian and surprisingly inarticulate in English, we've become experts in managing crackly conference calls. We Powwownow at the drop of a hat and have the soundproofing to prove it. It's common for us to present remotely—often thousands of miles away—using just our work and our voices. It's been good training as it keeps us all talking. It might even be our secret (not actually meeting our clients too often, face-to-face).

So, open the door, come out of that ivory tower and bring your voice with you. A phone call a day keeps clients happy. Watch, listen and never, ever stop learning.

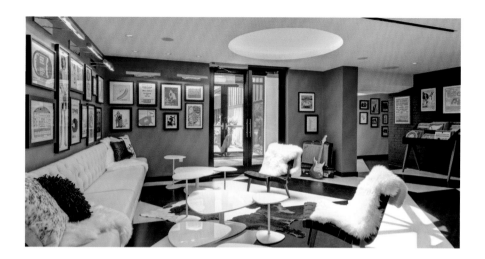

Design was unashamedly 1950s-inspired to help take the hotel back to its authentic roots. To ensure our story was as authentic as possible, we connected with Steve Mindich and David Bieber, founders of the once famed local music paper, the *Boston Phoenix*; a promoter of local music, champion of counter-culture, independent and provocative. Delving into their archives, Stephen and David curated authentic events, classic moments and many super-rare pop artefacts to adorn the bedroom and foyer walls, summoning up stories and memories of Fenway's rich music and arts scene.

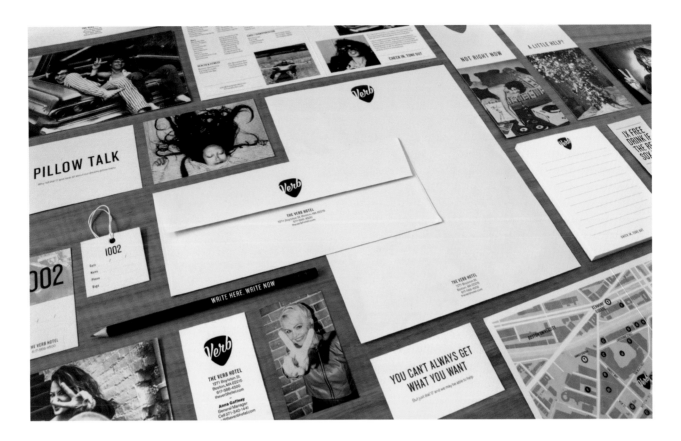

The result of everybody's passion and enthusiasm is not only an inspiring brand project, but the resurrection of a local icon. Proof that property developers really do know how to party and have the neighbourhood at heart. Rich in detail and history, it's restored, reloaded and ready to welcome its proud community back through its doors to let the music play and the good times roll.

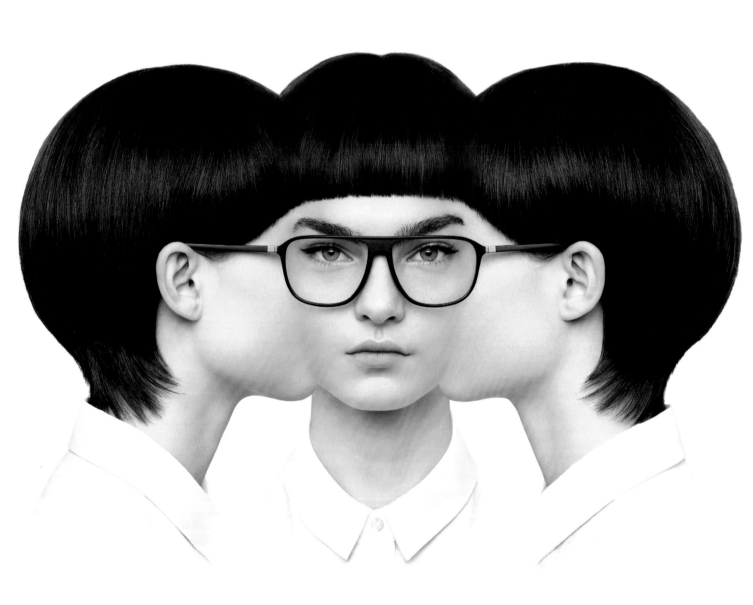

A Child of Six Could Not Do This.

Let's be completely honest about the point of this chapter. It's 10 per cent moaning (because if we're spending coin making a book about ourselves we might as well offload some stuff that's been buried deep for a while), and it's 90 per cent a pep talk to anyone starting out in this wonderful business called 'Design'. Because although the trick is to always make things look as effortless as possible, in reality it's anything but this. So let's begin with the moan...

Child | noun. A young human being below the age of majority. Lacking experience, insight, skill, sophistication or the capacity for applying any intellectual rigour whatsoever. They wouldn't even know what the hell branding is.

STARCK Eyes
Campaign and Retail Store POP

Sometimes the most beautiful and direct things come from difficult briefs and thinking laterally about the problem. When you take a look at the advertising of eyewear, there's often not much to tell campaigns apart. Fashion photography and pretty faces designed to sell to a style-conscious audience. What made the brief for the STARCK Eyes campaign particularly challenging was that it required us to tell a technological product story to a fashion audience.

STARCK Eyes frames are very sophisticated pieces of tech that use a patented 360-degree micro articulation hinge, allowing the arms to rotate in almost any direction. It makes them extremely durable and allows a snug fit on the face. For 15 years the frames had been designed in traditional styles for a mature, tech-loving audience. Looking to expand into a younger, style-oriented market with a range of chic new frames, STARCK Eyes suddenly needed to look great within the pages of fashion magazines and somehow communicate the technology without turning people off.

While there was an expectation to show technical diagrams, we had a hunch this wouldn't fit and were sure there'd be a way to create striking images that could demonstrate its USP. The solution was surreal and very simple. Just as the arms of the frames open up flat, why not open the faces so they're flat too? A simple brief that proved surprisingly hard to execute! Some faces ended up with strange hamster-cheeks while others came off as plain scary. But eventually we had a set of six that, placed alongside rival campaigns, cut through. Uncompromising and beautiful images that manage to talk tech in a very cool way.

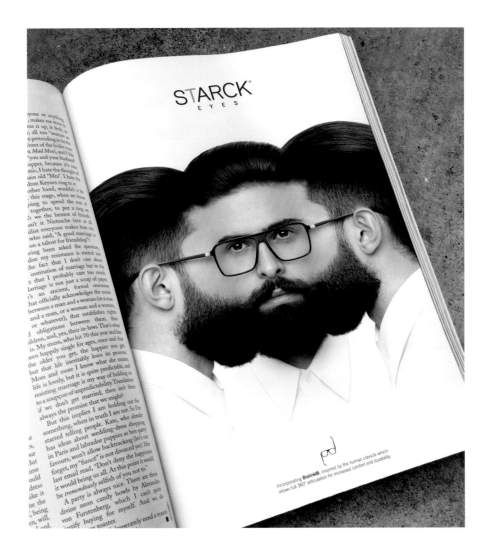

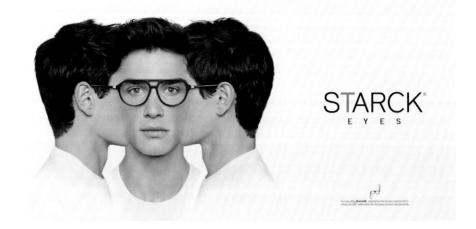

There comes a point in the life of an art college student when you have to make that big decision. Do you want to be an artist, a sculptor, a fashion designer, a filmmaker, a photographer or, gulp, a graphic designer? If you choose the last option then get ready to embrace your new life on the lowest rung of the creative ladder because in our experience, that's where our profession slots in. We'd like to say that the more experienced and successful you become, the more respect you earn, the more clients value your opinions, even take your advice. But it doesn't seem to work that way.

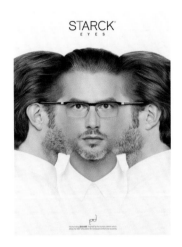

No, from your early college days when you make that difficult choice, you opt to become the creative janitor of the art world; the least glamorous of the creative professions, the one you're statistically least likely to get exciting projects doing, the one you're likely to earn the least amount of money doing and the only one where most people tend to think they can do a better job of it themselves (or if not them, then at least their mate's younger brother who knows how to use Photoshop).

After 15 years of graft and toil, doing our best to prove to clients that our work makes a real difference to them, it still feels as if we're ranked on a par with domestic call-out services. Guys you call in an emergency, a bit stressed, knowing you'll probably have to drop money on the problem and are already a little peeved thinking about it. That's us. Toilet backed up? Call that plumber again, he was a bit moody but OK. Key snapped off in the lock? Get a quote from those local guys, they were quick and pretty cheap. Urgently need a brand identity for a new product concept? You get the idea.

Royal Mail
Doctor Who Anniversary Stamps

You might imagine that working on the iconic theme of *Doctor Who*, a cultural institution that all generations in the UK have grown up with and know personally, would be child's play. But in fact, being given the prestigious 50th anniversary stamp set from Royal Mail was the start of an epic journey of research, understanding and detail. In short, we had to out-geek the geeks. For Royal Mail's blockbuster stamp collection of the year, a multitude of mouth-watering products were planned to get collectors, both of stamps and the TV show, salivating.

All 11 doctors are honoured with a regenerating stamp each. Archive images were painstakingly pored over to find the definitive images of each Doctor. Details such as the evolution of the iconic logo and credit sequence graphics were packed into each tiny canvas to ensure a richness and authenticity to delight the legion of aficionados.

26.3.2013

26.3.2013

And it's not just clients who hold this view (note to GBH clients, we don't mean you, just the other ones). While we're sailing the good ship paranoia, here's another observation from the deck: graphic design, or perhaps just GBH, is a strange misfit of a profession. Business people tend not to take us seriously because they picture us as all being a bit sensitive and banging on about the importance of 'the big idea' while having our heads up our asses when it comes to how to drive up profits.

But conversely, we're forever the poor cousin inside the wider creative industries because here we're basically viewed as one of the following: the guys who stick the logo on, the guys who choose the background colour, the guys who choose the font, the guys who make the business cards, the guys who do the website. Basically, the more perfunctory and practical applications that are needed at the end of a process, once all the proper and much grander work has been done by others, the decisions made and the budgets spent. Somehow we just don't quite fit in to any camp, we drift in between, working hard to uphold our creative integrity while earnestly helping to add sparkle to our clients' businesses.

Sounds a little bleak we know (and we're exaggerating 22 per cent for dramatic effect) but here's the positive in all this. It doesn't matter what 'the world' thinks because we're here to declare that the humble graphic designer is in fact, the unsung hero of the creative industry. There, we said it. Ballsy huh? You see, when you get into the wonderful world of graphic design, you need a whole lot more going on than the ability to come up with good ideas. Or let's put it another way.

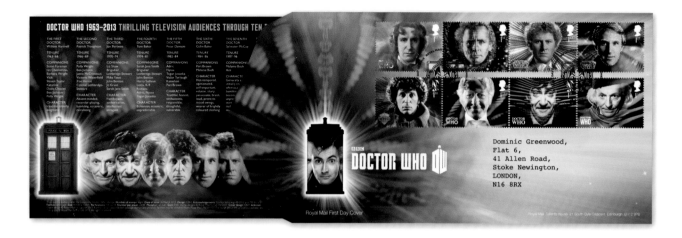

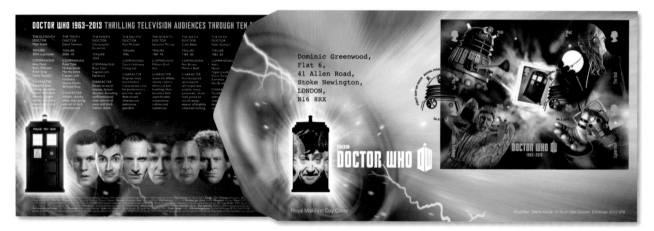

Of course, a celebration of *Doctor Who* is really a celebration of British TV itself, that tiny portal in our living rooms that lets us glimpse into other worlds once a week, igniting our imaginations and scaring us silly.

With 50 years of history in the bag, there was a daunting amount of ground to cover and a treasure trove of heroes, villains and stories to feature. The epic story of struggle and discovery that *Doctor Who* continues to explore was lovingly squeezed into an epic series of collectable materials, literally out of this world in their scope and ambition.

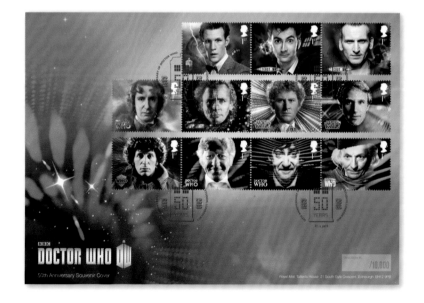

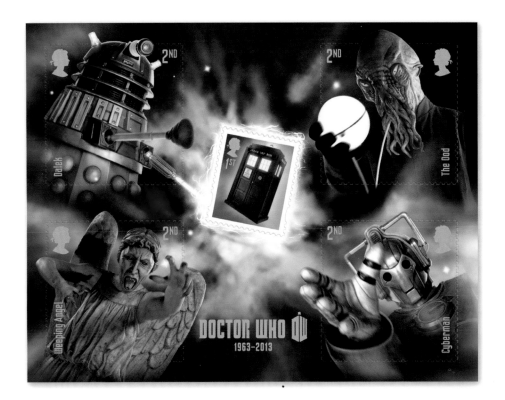

PUMA Clever Little World
Environmental Branding Scheme

Shoeboxes account for millions of waste tonnes every year and PUMA worked to change this with a creative team of FuseProject and GBH. Together, we investigated language, branding, production, manufacturing and logistical concepts, working relentlessly to reduce and communicate PUMA's environmental 'pawprint'.

Creating the 'Clever Little Bag' reduced cardboard consumption by 65 per cent as well as cutting tissue paper and assembly, saving 8,500 tonnes of paper, 21 mega joules of electricity and a million litres of water.

The CLB was a central part of PUMA's brand initiative 'Clever Little World', made up of a number of innovations which would endorse PUMA's growing sustainability credentials. Our simple, universal brand language included naming, the graphic design of the new CLB, sustainable customer bags, tags and the 'PUMA Eco-Table', a periodic table of materials and production methods carried by all products and packaging in PUMA's new 'Clever Little World'.

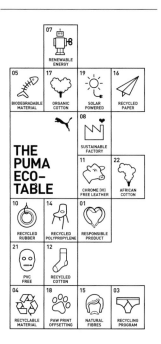

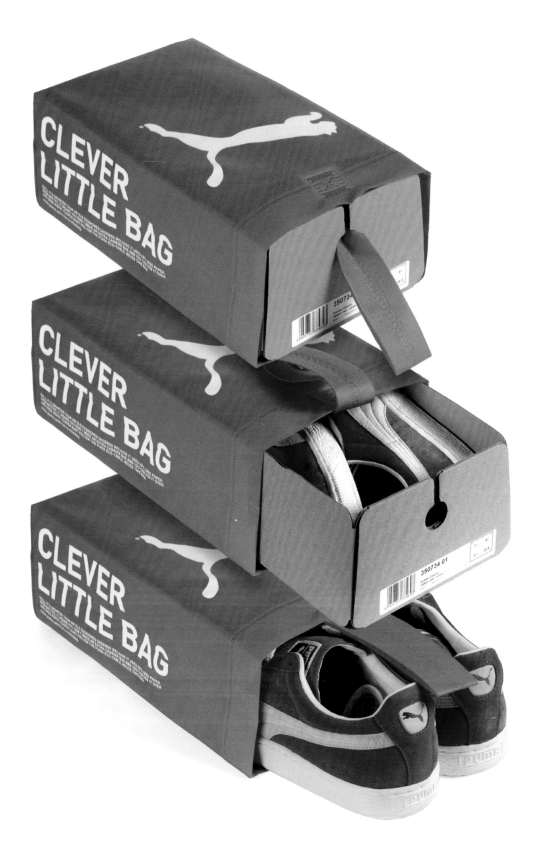

You'll need to come up with good creative ideas despite all the stuff that'll be going on. We're the guys who are expected to deliver artful wonder but go at it like a team of Polish labourers. You pretty quickly find that to be a successful designer (for a definition of 'success' see our later chapter) you actually need a whole bunch of strings stuffed into your bow.

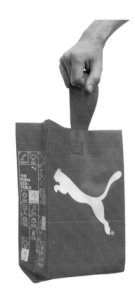

For example, who else has to balance being highly creative and playful one minute with getting your head round overly complicated briefs the next (or trying to squeeze information out of the near-non-existent briefs), or reassure pressurised clients that "It'll be amazing" (while trying to reassure the scared voice inside your head saying it might not)? Or deal with clients who constantly dispute you (or worse still, disagree amongst themselves)? Or manage myriad environmental and ethical expectations while navigating the contradictions and paradoxes surrounding them (is something that looks green and sends a green message but isn't green better than the thing that is green but looks toxic? Is an e-cigarette an anti-smoking wonder or a gateway to addiction and doom?), or try to be culturally relevant or harder still, creative, in a foreign culture that you've not had time to understand? And all the while you're likely to be trying to resist the emotional pressures of flattery/berating/physical abuse (delete as appropriate) while being asked to 'tweak' your ideas to the point where you feel useless and want to cry? OK, let's pause to breathe.

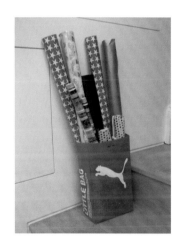

Now if you're skilled enough to navigate through that creative meteor storm unscathed and, better still, able to come out the other side with a beautiful

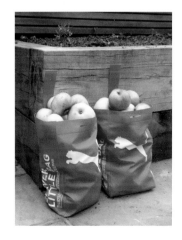

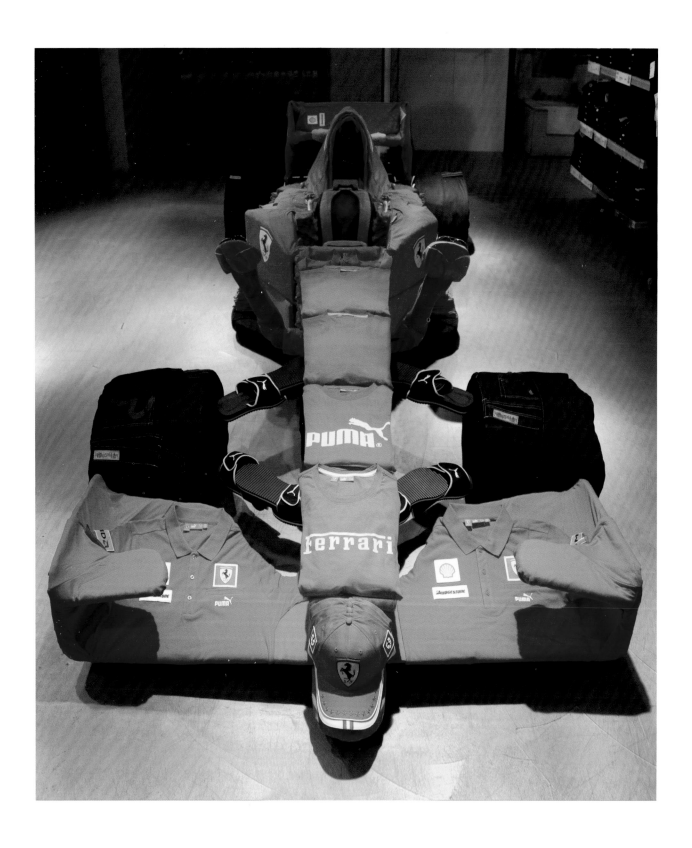

piece of work (well done to you by the way) you'll then be expected to do it all over again next time. But no, not like that last piece of work you did, we mean something completely different. You see, because you're not an artist you don't get the luxury of exploring the same idea over and over for a few years, developing it, honing it, indulging it. No, if you do a fabulous job, you've just raised the stakes for yourself and are now expected to reinvent the whole damn wheel for the next one. And frankly anything less good will be met with the dreaded question "Where's the GBH magic gone guys?", whilst work bearing the merest whiff of similarity to your last is met with "Are you trying to charge us money for the same idea again?" Make no mistake, to produce top-level creative work takes a number of skills, only one of which is creative skill. Indeed, the unsung heroes of the creative industry.

Now this isn't a 'me too' thing or a complaint at the maltreatment of designers. Far from it really. It's a gentle wake-up call (and here comes the pep talk) that as a community we could do with believing in ourselves a little more and positioning 'graphic design' as something a little more magical, unexpected, dare we say it, artistic. Because we do have a tendency to be our own worst enemies when it comes to reinforcing that perception of being the exterior decorators. Unlike the bravado and larger-than-life characters of the other arts, the graphic designer has always been a low-key, slightly geeky character. Humble to a fault, (overly) accommodating and extremely pleasant. But that doesn't always help you stand up to the outside forces that are trying to pick holes in your work.

PUMA Ferrari
Retail Store Installation

Sometimes the challenge is less about coming up with an idea and more about convincing a client to go with it, as was the case with a stunt to promote PUMA's sponsorship of the Ferrari F1 team.

The idea, to build a life-size Ferrari F1 car entirely from PUMA products, was a window concept rejected on size and cost. Undefeated, we looked at how to make it viable; how much product and space it would need and who'd help us fold all those T-shirts! With a fully formed plan for how to pull it off we went back to PUMA, who liked it and even agreed to supply the 1,500 products we worked out we'd need. Built in a PUMA store overnight, it took pride of place before going on a European tour of PUMA's flagship stores. A happy example of what a little persistence can achieve.

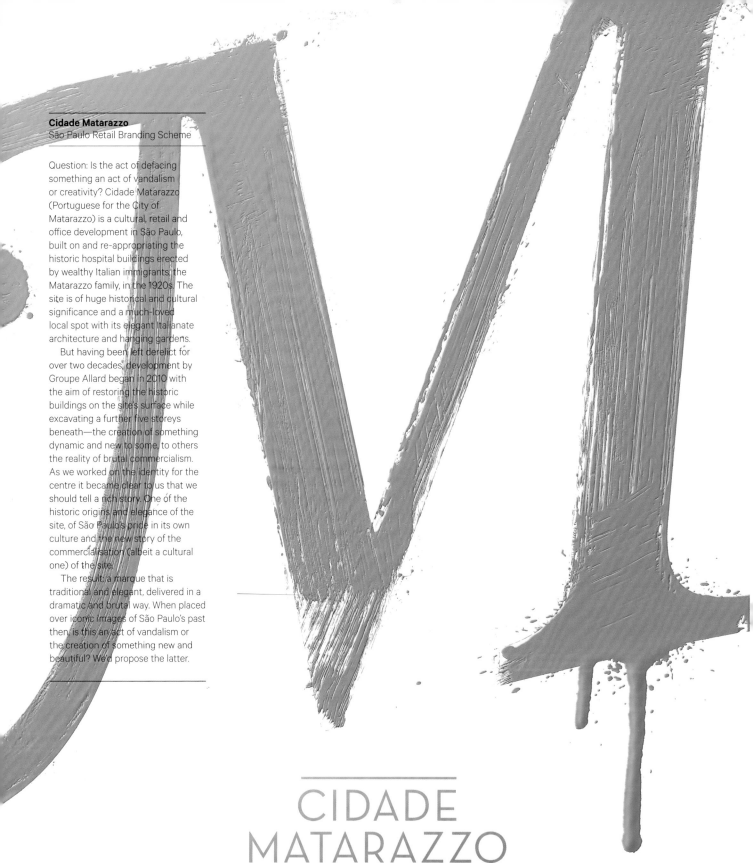

Cidade Matarazzo
São Paulo Retail Branding Scheme

Question: Is the act of defacing something an act of vandalism or creativity? Cidade Matarazzo (Portuguese for the City of Matarazzo) is a cultural, retail and office development in São Paulo, built on and re-appropriating the historic hospital buildings erected by wealthy Italian immigrants, the Matarazzo family, in the 1920s. The site is of huge historical and cultural significance and a much-loved local spot with its elegant Italianate architecture and hanging gardens.

But having been left derelict for over two decades, development by Groupe Allard began in 2010 with the aim of restoring the historic buildings on the site's surface while excavating a further five storeys beneath—the creation of something dynamic and new to some, to others the reality of brutal commercialism. As we worked on the identity for the centre it became clear to us that we should tell a rich story. One of the historic origins and elegance of the site, of São Paulo's pride in its own culture and the new story of the commercialisation (albeit a cultural one) of the site.

The result: a marque that is traditional and elegant, delivered in a dramatic and brutal way. When placed over iconic images of São Paulo's past then, is this an act of vandalism or the creation of something new and beautiful? We'd propose the latter.

CIDADE
MATARAZZO

Perhaps it's down to the origins of the graphic industry. Before graphic designers, there were only printers and printing houses. Graphic design was a service that was thrown in as part of the process of getting your advert/poster/message into print. Since then of course, layout and compositing have given over to more advanced ways to engage audiences—a sophisticated vocabulary of graphic language has evolved and it takes a sharp mind to be fluent in it. But there's an element of the 'free service' that seems to pervade even today and graphic designers are guilty of perpetuating it. Getting back to the point, if we see our business as merely a service, that's what it'll be.

Perhaps that's why we've always shunned wanting to be a conventional design agency and ignored the parameters that we were meant to stick within. We always took a view that our role didn't have to be defined as 'design' or 'campaign' or 'digital'. We could use those tools to help contribute to something larger, more entertaining, more theatrical, more surprising and more artful than that of your normal outfit. We certainly didn't set out to be glorified suppliers or the guys who stick the logos on. It's an attitude that's allowed us to flourish—to build up a reputation for doing smart and surprising work, to collaborate with like-minded creatives who want to push the envelope and with super-smart clients who understand that good design makes a big difference.

Not bad going really but it's not been plain sailing to get there. It's the result of a huge force of creative will that, to be honest, isn't always for the faint-hearted; the late-night discussions about the

MOB Hotel Of The People
Branding and Hotel Touchpoints

Some of our work can look as though a child of six has made it, but in reality a lot of sophisticated thought goes into the simplest things. MOB is a hotel that helps its guests return to a simpler way of living in the city.

A modern concept that puts people and the community first, offers a more social way to live, a healthier way to eat, makes art and literature available, grow-your-own allotments accessible and, above all, strips down the things that we need to the essentials that make us happy. That's why we positioned MOB as "the hotel of the people" and made an identity that celebrates nurturing and social interaction. The sophisticated bit was in having the restraint to use the logo simply and sparingly.

Britain in miniature
Abolition of the Slave Trade
22 March 2007

Britain in miniature
Celebrating England
23 April 2007

Britain in miniature
Christmas
6 November 2007

Britain in miniature
Scouts
1 June 2007

Britain in miniature
British Army Uniforms
20 September 2007

Britain in miniature
British Grand Prix
15 May 2007

Britain in miniature
Birds
4 September 2007

Britain in miniature
Beside the Seaside
15 May 2007

Britain in miniature
60th Royal Wedding Anniversary
16 October 2007

Royal Mail
Britain In Miniature Part-work

With most of us immersed in digital pastimes, not least children and young adults, it's a big ask to try and convince them to put down their devices and start collecting stamps. But that was the task set by Royal Mail who saw an opportunity to build on the 14 collectible stamp sets they issue each year and win over a new generation of budding philatelists.

The wonderful thing about the special edition collectible stamps is their rich and varied themes; artful and educational and always a fascinating glimpse into the culture and history of the United Kingdom. The concept was simple: design a collector's folder which children can add to every month as each new stamp is issued. But of course, the stamps themselves were just a small part of the pack as each month's theme allowed us to expand, tell stories and bring to life with colourful visuals themes as diverse as the Beatles, the Scouts and the Crimean War. A rich and engaging experience for children and, in the end, an opportunity for us to unleash our inner child at GBH!

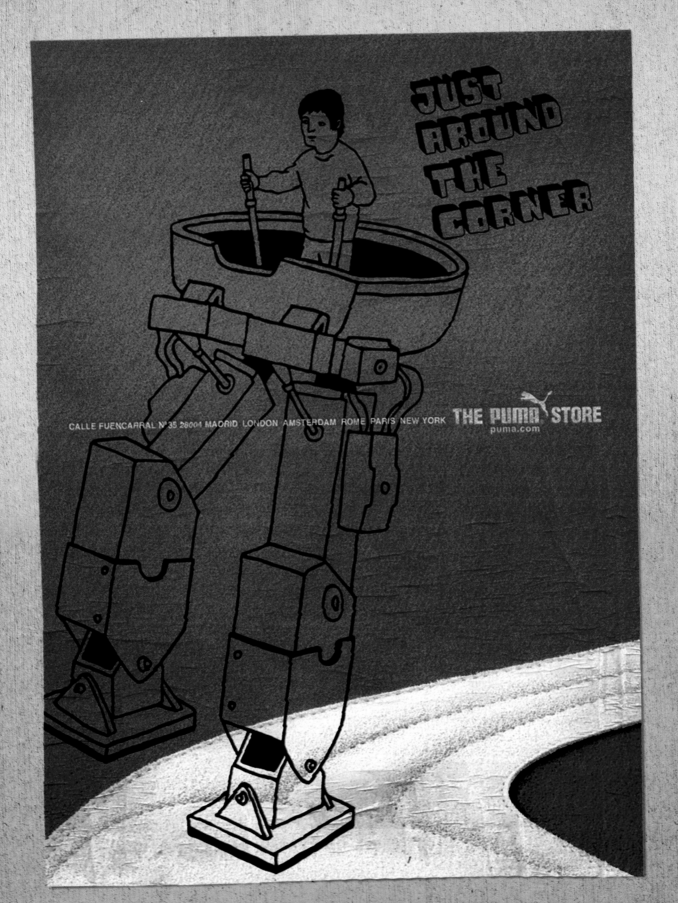

merits of a particular hue of teal, arguments over which cut of that German font carries the most gravitas mixed with kooky charm, the hours spent in rooms busting our brains, holding out to see if there's an elusive and better sixth idea just round the corner, something that "will really blow the client away", and of course fights over whether an idea works or not.

Question: Is it easy to keep your enthusiasm and energy levels up for each challenge ahead? No not really. Can you ever really satisfy your personal creative needs with those of the client? It's doable but the planets need to align. Are we just a bunch of frustrated artists trying to get out? Quite possibly. Have we fallen into the trap of believing what we do is art rather than commerce? Definitely not. The joy is in the fact we get to hear real client problems, fix them and try to inject a little magic along the way.

At the end of the day we think, we make, we craft, we agonise and intellectualise the hell out of things, then tear it all down and redo it at the last moment. We put ourselves through it and anyone that works, or has worked at GBH will testify to that. But it's a rollercoaster of our own making and one that we really rather enjoy. By the way, if you're wondering about the slightly odd title of this chapter, it's based on an old cartoon about modern art where a lady in a gallery points to an abstract painting declaring, "A child of six could do that". Well maybe you can say that about art, but never about graphic design!

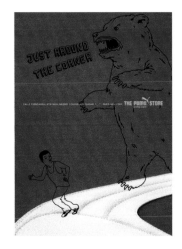

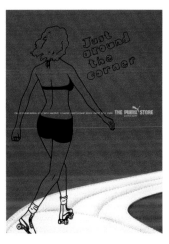

PUMA Stores
Local Advertising Campaign

A little while back we were tasked with making a campaign to promote PUMA stores as they opened. Media was limited to local billboards and buses around the vicinity of each store (like a golf sale placard but with more wit), so the emphasis was on simplicity and memorability.

The solution, 16 characters making their way to a store "just around the corner", was a celebration of diversity and PUMA's "room for everyone" attitude. We even reappropriated the untouchable Formstrip and turned it into PUMA's own yellow brick road.

CHEER UP IT
MIGHT NEVER
HAPPEN

The Art of Simple Joy.

There is one thing that keeps us getting up in the morning and coming back to work. It's our reason for living. Yet it's something so simple, that once recognised is so obvious, it seems almost nothing. Yet if you try to analyse it, you'll realise you don't really understand it. If you reach out to touch it, you'll see it dissolve before your eyes. Try to recreate it again on demand, well that's when things become really tricky. What is this ethereal, elusive and wonderful thing that we will chase to the ends of the earth to enjoy? Well, we call it simple joy.

Joy | noun. Is it 1. A state of happiness or bliss? 2. A source or cause of delight and discovery?
3. Absolutely guaranteed to cause disappointment and a lasting sense of gloom when trying
to include it in a communications project?

 ALL HANDS ON DECK

 AVOID HOLD UPS

 BE BRAVE

 BE GENTLE WITH ME

 BEG FOR IT

 BE GREEDY SOMETIMES

 BE MORE CHARMING

 BE A HERO

BEAT 9.58

 BITE ME

 BOUNCE BACK

BREAK IN AN EMERGENCY

BRING A FRIEND

 BRING YOUR FRIENDS

COOK UP A STORM

 CREATE A SCENE

 CREATE OPENINGS

CUT IT OUT

 CUT YOUR HAIR

 DANCE LIKE NO-ONE'S WATCHING

DARE TO BE DIFFERENT

 DON'T BE A SQUARE

 DON'T BE A STRANGER

 DON'T BE CHEEKY

 DON'T BE LATE

 DON'T BE MAD

DON'T BE SCARED

DON'T BE SHALLOW

 DON'T DRIBBLE

 DON'T EAT RUBBISH

 DON'T EVEN GO THERE

 DON'T FEED THE ANIMALS

 DON'T FORGET YOUR TOOTHBRUSH

 DON'T GET CAUGHT

 DON'T GET COLD FEET

 DON'T PLAY WITH FIRE

 DON'T PUSH IT

 DON'T RUB IT IN

 DON'T RUN OUT OF STEAM

 DON'T SHOOT THE MESSENGER

 DON'T STOP

 DON'T STOP NOW

 EXPECT THE UNEXPECTED

 EXPECT THE WORST

 FEED A DONKEY

 FEEL THE BREEZE

 FEEL THE LOVE

FIND OUT MORE

FIND YOUR FEET

 GET A MOVE ON

GET A TATTOO

 GET JAPANESE

 GET LOST

GET MOBILE

 GET MOTIVATED

 GET ORGANISED

 GET WELL SOON

 GIVE IT UP

 GIVE IT YOUR BEST SHOT

 KISS ME

 KNOW WHEN TO STOP

 LISTEN TO THE BIRDS

 LOOK ON THE BRIGHT SIDE

 BE MORE GREEN

 BE PATIENT

 BE PREPARED

 BE PRODUCTIVE

 BE SMART

 BE THERE

 BE YOURSELF

 BUST SOME MOVES

 CALL ME

 CATCH ME IF YOU CAN

 CHANGE YOUR LIFE

 CHEER UP

 CLOSE THE WINDOW

 COME BACK TO REALITY

 DIG FOR VICTORY

 DO IT WITH STYLE

 DO IT YOURSELF

 DO NOTHING

 DON'T BE A DRAMA QUEEN

 DON'T BE A LIGHTWEIGHT

 DON'T BE A QUITTER

 DON'T BE SHY

 DON'T BLAME YOUR TOOLS

 DON'T BLOW IT

 DON'T COUNT ON IT

 DON'T CRY ABOUT IT

 DON'T CUT CORNERS

 DON'T PANIC

 DON'T GET STUCK

 DON'T GIVE UP

 DON'T HIDE AWAY

 DON'T HOLD YOUR BREATH

 DON'T KNOCK IT

DON'T LAUGH

DON'T LEAVE HOME WITHOUT THEM

 DON'T SWEAT THE SMALL STUFF

 DON'T TALK TO STRANGERS

 DON'T THROW IT ALL AWAY

DROP BY SOMETIME

 EAT MORE FRUIT

 EAT MORE GREENS

ENJOY YOUR TRIP

 FINISH WHAT YOU STARTED

FORGET ABOUT IT

 GET A DOG

GET A GRIP

FUEL YOURSELF

GET A BARGAIN

 GET AHEAD

 GET OUT MORE

GET OVER IT

GET OVER YOURSELF

GET STUFFED

GET THE LATEST

GET OUT OF HERE!

GET THERE EARLY

 LOOK ON THE SUNNY SIDE

 HAVE A NICE DAY

 POWER UP

 POWER DOWN

 SEE YOU LATER

 TAKE A VACATION

 WISE UP

PUMA Icons (previous page)
Branding System

We created 850 of these icons for PUMA as a part of their corporate identity. Some call them lifestyle motivators, some call them cheeky, someone even once called one a haiku. These little creations would be hidden away on labels, boxes, bags, almost anywhere they might bring a little sunshine. At ten years in the making, they were our longest-running single project.

Eurostar
Business Lounge Installations

This was our first project working with Philippe Starck. We created installations in the Eurostar Business Lounges in London, Paris and Brussels. His brief to us was that travellers may only stay in the lounge for ten minutes, but we must make sure they were a magical and memorable ten minutes. Our first task was a cupboard used to store travellers' luggage situated at the entrance to the lounge. We used a hospital X-ray machine and 250 sheets of X-ray film to shoot a whole vanload of cases and parcels to give passengers a chance to have a cheeky peek into other people's business while waiting for the train.

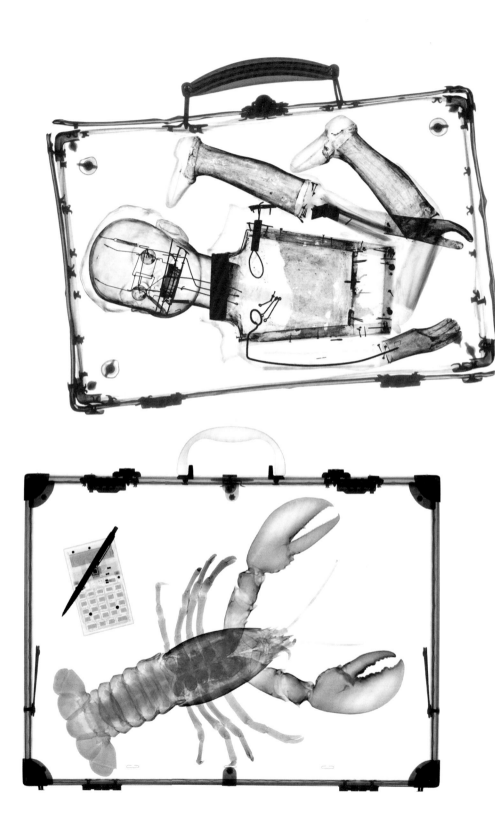

Good old plain and simple joy. In our world of communication, she's the sister of smiling, the cousin of rapture and can be found in many other guises such as the stupidity of slapstick, the base humour of the buffoon, the knowing wink of wit or the intelligence of satire. Call it what you will, it's a feeling before it has a name. And it's anywhere on the humorous scale from a smile, a tiny whimper barely perceptible outside your own head to a full-on, pant-wetting hysterical outburst.

Joy is a moment of magic in a been-there, done-that, bought-the-T-shirt world. More commonly experienced in fine art than in design, it elevates, illuminates and reminds us what it is to be human again. Joy is strangely most conspicuous in design by its absence. There's a lot of good design. There's an awful lot of nice design. But nice is nothing when compared to joy. It's a completely different ballpark. It's not even the same sport. It's a timeless act that removes us from our life, however briefly, and delights us with its audacity, its unexpected beauty or violence against normality. Joy makes the good excellent and the excellent sublime. Why then, is this quality so universally enjoyed, so challenging to create?

John Cleese, one of our heroes whom we have turned to for inspiration over the years, mentions in his 2014 book *So Anyway…*, "Comedy is extraordinarily difficult. It's much, much harder than drama. You only have to think of the number of great dramatic films and then compare that with the number of great comic films… and realise that there's very, very few great comedies and there are lots and lots of very great tragedies, or dramas. That tells you, really, which is the hard one to do."

Out of many other ideas in the lounges our favourite came from a mistake: a newspaper stand had been made too tall for passengers to reach the top pigeonholes, so we got to make these charming characters who welcome passengers instead.

PUMA Phone
User Interface Design

Before the iPhone became a legend
and Android was still a baby we
created the world's most adventurous
feature phone for PUMA. The user
interface was built from scratch
from our design, which revelled
in the simplicity of flat graphics
and expressing PUMA personality
through language.

Built around a sport or lifestyle
mode, joy was built into every detail
from the battery levels (Full, Happy,
Hungry or Dying) to the brightness
setting (push the cloud over the
sun to dim the display). The phone
featured groundbreaking features
such as solar charging, PUMA Icon
messaging, an early version of Skype
and an in-phone puma named Dylan.

But most joyful of all for an
electronic device was that the phone
was always the first to take the blame
when something went wrong, which
was proved to reduce phone rage by
up to 85 per cent.

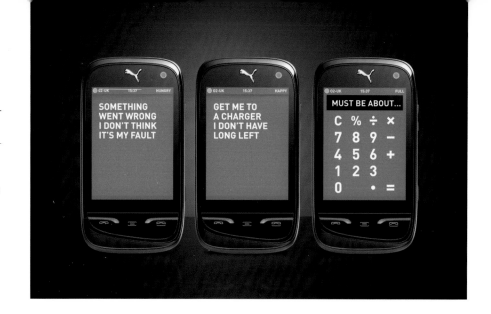

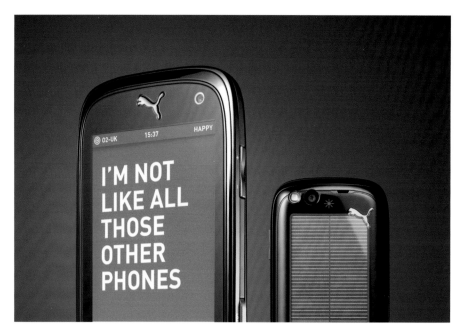

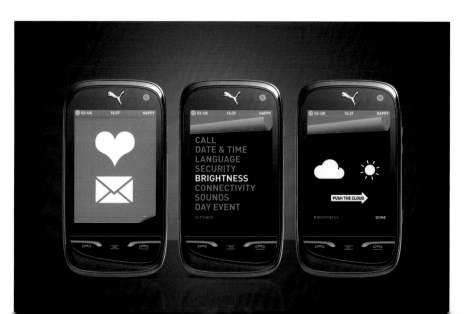

US Women | 4 ½ 5 ½ 6 ½

France | 18 19 20 21 22 23 24 25 26 27 28 29 30 31 32 ½ 33 34 ½ 35 ½ 36 37 ½

Japan | 12 ½ 13 ½ 14 ½ 15 ½ 16 ½ 17 ½ 18 ½ 19 ½ 20 ½ 21 ½ 22 ½ 23

Your foot is as long as...

a 50 euro note

a standard house brick

a blues harmonica

a ball point pen

a wooden clothes peg

Average contents 2

CAUTION: THIS IS NOT A TOY
Obviously it's just a bag. OK, we didn't really
think you would mistake it for a games console.
All we mean is don't fool around and put it
on your head, you'll just look silly.

PUMA Redworld
Branding System

One of the first things we did for PUMA was simplify and declutter the brand identity. We went big on cat. And we went very big on red—a happy and prosperous colour.

Then hidden away in the corners of boxes and on the bottom of bags, anywhere the dedicated follower of PUMA might search them out, we put almost the opposite of what you'd expect to find there. Sometimes icons, often texts that belie their humble appearance by giving a blast of PUMA's irreverent spirit their followers would come to expect. This look and feel and way of thinking we named 'Redworld'.

WASH THIS
WHEN DIRTY

USP TECHNOLOGY

Outside, it's not always nice.
You get wet, cold and hot.
You fall down. There's bees.
You're liable to get hit by
a car, possibly a minivan.
Our technology can help.

COME AND SAY HELLO

LONDON
NEW YORK
PARIS
WHEREVER

Miss Ko
Cocktail Menu

As well as signage and identity for this Asian fusion restaurant in Paris, GBH also designed the cocktails and this rather special menu. In one of our most enjoyable naming sessions ever, French, Asian and English designers imagined the life of the enigmatic Miss Ko. Who were her friends and those important people in her life?

Like the food in the restaurant we took influences from France and Asia and collided them to create names for these people that in turn became the names of cocktails.

We briefed a mixologist on the type of drink we wanted for each name and the illustrations were created by Yeji Yun, a friend who had moved back to her native Korea. If you're ever in Paris, go for a couple of Ginza Boys and you'll never look back.

MRS LI
레몬 리

TCHIN TCHIN
친친

CRAZY MO FO
미친 모 포

GINZA BOY
긴자 보이

CHEF JIN SU
요리사 진수

Well, for a start, try to convince another person that you are funny using a rational argument. That's a tough one. It's really much simpler to just make them laugh, isn't it? It's often said that humour is "the shortest distance between two people". In other words, the best and quickest way to break down barriers between individuals. And so it is with joy. It cannot be conceived of via logic or formula. It simply is, or is not.

This joy is like a drug which sadly does not come in a pill or a powder, it really can't be preserved for later. Joy stems from the pure, innocent and delightful experiences of childhood, it's all about the power of surprise, it's permission for a moment of silliness. It dodges cynicism and leapfrogs intellect to create an enlightening and never-to-be-forgotten memory. It's not an easy thing to connect with one person like this, let alone a whole audience, but it is for GBH the Holy Grail of communication and the reason we spend most of our time searching for this catalyst to success. Why? Because simple joy is a shortcut directly and emotionally to our very core.

So now we know the value of this wonderful thing, how do we go about using it in our work? Well, the short answer is it's all about timing. (And the slightly longer answer is it's all about timing, intensity, delivery, colour, the time of the month, the angle of the sun and the fact that terms and conditions do apply and your job may be at risk if you do not keep up the good work. Past performance is no guarantee of future success, as they say in the small print of financial documents.)

Parrot
A Branding Story

When GBH was briefed by founder of the French wireless products company Henri Seydoux to redesign their corporate identity, he began with a story about their logo, which was, perhaps not unsurprisingly, a parrot.

"I love him because he is the colours of the Caribbean, he is not drawn well, but I like this naivety precisely because it is not cold and slick like everyone else in the industry. There are about 800 employees at Parrot right now and I think if you ask everyone then 799 of them will say that they hate the parrot!"

GBH arranged a makeover for the bird and relaunched him as a company ambassador: taking slightly more of a back seat, he appears in animated stings and in varying positions of flight on all corporate materials and business cards, having now retired from appearing on product packaging—which has made even more people happy.

The art in all this for us comes from being able to engineer a little bit of magic at exactly the right moment. That's what we are after, and to get anywhere near that we have to start from a point of acceptance that the people we are trying to talk to have no interest in what we have to say. They really don't. We must realise that they are wrapped up in their own thoughts most of the time and mostly unreceptive or numbed to the clamouring of the world. It used to be said that the best way to stand out in a room full of shouting was to whisper. Nowadays you'll likely find a whole gang of people in there whispering as well. Deal with it.

Competition for attention is at an all-time high, which means we must look at not just the thing we are designing but everything else around it too. Ask questions about what that person is doing at the time they come close to your work, what they are doing before and what they are doing after. Study them carefully and look for new opportunities to catch their eye. We are looking for a gap in the fence here, a glitch in the matrix, a moment of calm. And that is all we will ever have, just one moment. Remember that every day as you sit at your desk please. We are not creating work for an art gallery or a design museum, this is the real world. You've got seconds before your message is passed over, swiped to the left, or just goes unnoticed like so many faces in the crowd. Once you know and believe this you are in with a chance of creating something effective. Because despite its brevity, indeed almost because of its short life, joy creates powerful memories we can use to get across our message.

Levi's
Mr Strauss' Socks

This was an imaginary product, insofar as it was invented by GBH whilst working on other sock packaging for Levi's. Our thought was could we make a pair of socks using the same materials and 48 needle machines, as would have been used when Levi Strauss was alive in the late 1800s.

Even Levi's themselves didn't know if Mr Strauss sold socks in his lifetime, but they agreed that if he had they'd probably be just like these. Each pair comes with a free moonshine jar and mending kit.

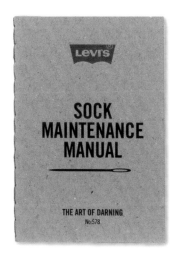

The Adria
Branding & Hotel Touchpoints

A Qatari-owned 26-room hotel in Knightsbridge gave us the opportunity to do away with room numbers. We made an A-to-Z of British icons and customs as room names. A was for Adria, B was for Bowler and M was for Mini—the smallest room in the hotel!

Keys were kept inside leather books. The presentation of the key became a custom during the check-in process. The guest chooses the letter on the enormous reconfigured lift panel to reach their room.

It is very important that we must never fear or complain about the lack of time we have in which to make our magic because it's all about the quality of the moment rather than the length of it. Don't labour the point. Always leave them wanting more.

The Japanese people revere the transient beauty of cherry blossom: its life of just a few days only adds to the beauty and symbolism of their national flower. And in terms of memorability, this Maya Angelou quote gets right to the heart of it: "I've learned that people will forget what you said, people will forget what you did, but people will never forget how you made them feel." Realising and trusting in this truth is what the joyful ingredient in our work is all about.

Joy is a pleasure that comes from the now. There are infinite possibilities to get to this response and a number of well-documented ideas about how to do so. The most popular is to start with something that at first glance fits into our perception of the world, but then a second glance makes us realise there has been some strange mutation, a collision of two things that caused a spark, and what we thought we were looking at isn't what we thought it was at all. It's the shock of the new, the surprise of the reveal. It's the way most humour works. We set up a scene where we all think we know what's going on, then all of a sudden everything changes and it's "get out of town" and you're feeling the joy again.

However we have also found over the years that there are some well-loved crowd-pleasing favourites that you can use for our own ends if you know what you're doing.

AB Walker
Branding & Film Installation

AB Walker is a family-run funeral directors with 180 years' experience. In step with the progressive owners of today, GBH advised ways of blending their heritage with a modern twist throughout the business. At the heart is this flower kaleidoscope. It appears stationary but on closer inspection the petals constantly bloom and grow at the speed of a clock. It appears in windows and consulting rooms, giving hope in the belief that the beauty of life continues in a way that straddles both religious and secular beliefs.

From the Archive
It's the Little Things

Sometimes things hidden in the deep archives of our mind pop up and give us joy all over again. Sometimes one-offs, sometimes they are small parts of a bigger project. Enjoy.

1. Barcode on *The Extraordinary World of the Football Fan* book.

2. Biscuit Dunking Guide cup. An early GBH product.

3. GBH Late Payment postcard. From the early days. Very effective.

4. PUMA Festive Gift Box. Advice on lifting heavy gifts.

5. Cabbage Man. Hoardings for the Eurostar station makeover.

6. The Verb Hotel, Boston. Bedside card for guest services.

7. 'Thought of the Week' message board. See what we did there?

8. Proposed logo for Groupe Allard. A unique property developer.

9. GBH branding for Teleconnect. A Spanish telecom company.

10. Solar charging station. German retail park.

11. GBH Recession Party invitation. October 2008. GDP -2.2%.

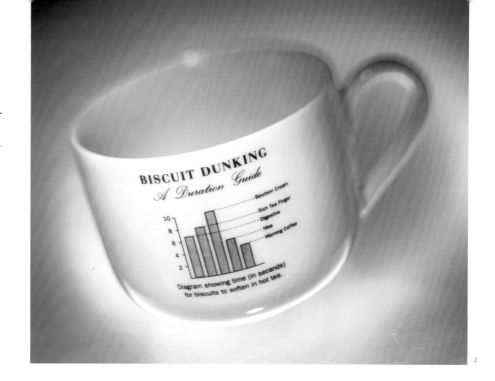

2

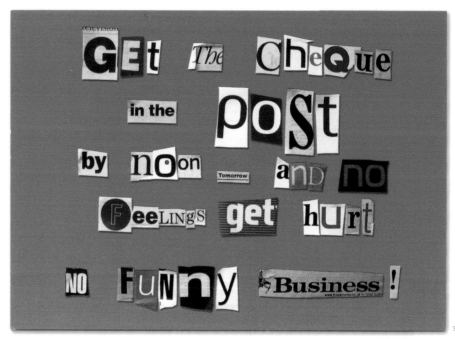

3

1

4

5.

9.

YOU CAN'T ALWAYS GET
WHAT YOU WANT

But just dial '0' and we may be able to help

6.

FOUGHT
OFF
THE
WEAK

7.

10.

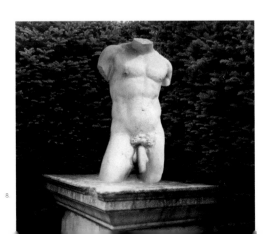

8.

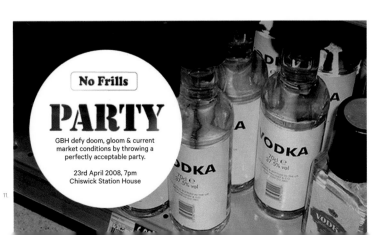

No Frills

PARTY

GBH defy doom, gloom & current
market conditions by throwing a
perfectly acceptable party.

23rd April 2008, 7pm
Chiswick Station House

11.

Mama Shelter
Branding & Hotel Touchpoints

We thought a ridiculous-sounding hotel brand deserved an equally ridiculous logo. If the chicken doesn't charm you, perhaps the hidden egg will? Mama was the first business hotel that strived to offer something different—with an eclectic approach to style and experience. A curious mix of things that never conforms to brand convention. A place that's full of surprises. That's all warm and cosy but stylish and chic too.

There are just certain things that humans are pre-programmed to find more joyful than others. It therefore comes as no surprise that the work of GBH contains more than its fair share of animals and quite a few references to nudity (not together, obviously, that's going too far). There's a lot of mileage in using babies but we never really went that route. Monkeys yes, but rarely babies. Shooting from the hip now. Big is good. Getting supersize when one is expecting regular is nearly always a hole-in-one. The public's love of all things enormous is almost Neanderthal in its mass appeal. Go the other way and you'll find that tiny can create widespread pathos. In an increasingly digital world, there's always the chance to go analogue. Those that missed it the first time round can get a lot of joy from all things analogue. It's almost as simple as knowing that zigging when the others zag makes a great starting point to standing out and creating delight.

We believe that making work that lifts the spirits of other people is a worthy task, but we need to let you know that the quest for joy can be a cruel mistress.

Why so? Well in an ironic twist, the making of joy is a serious business: it's not all larking around, it can be a thankless and undeniably joyless pursuit at times. It can be like trying to light a fire in a wet forest, in the middle of a monsoon, with no matches, in the middle of the night. Because it's an alchemy that needs a very certain state of mind for its creation. The way to do this is to try and detach ourselves from the world we live in and enter that timeless world where joy flourishes: we trick the mind to go there.

PUMA Peepshow
Changing Room Installation

There's a special feeling that comes with discovering something for yourself. Using digital in a retail environment in unexpected places, as analogue-looking as possible, masks the technology and intensifies the thrill of discovery. A metal cabinet housed in each changing room plays a different scenario each time the door is opened. It feels like a bespoke dose of PUMA personality served up for an audience of one.

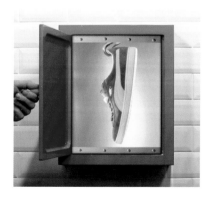

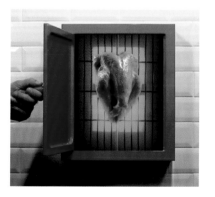

It's a subject that can't be approached head on, we have to think sideways. What does that mean? Well we have to think around the problem, learn all about the problem, then we turn our back on the problem, just think of something else, think of nothing, and then like a rainbow after the rain, somehow out of nowhere, a joyful, beautiful, miraculous thought appears. It's that moment we keep getting up and coming back into work for. Right here, right now! It's perfect, the most perfect moment there is, until you realise what's wrong with it. The perfect joy is a holy grail; like a diamond, all joy has some small flaws. It's our job to disguise and polish them. We can only really understand this by looking backwards, but we have to work by going forwards. It's the cross we have to bear. So we smile, or sigh inside, then carry on.

There's an element of sadness (even anger) which is a vital part of the recipe of joy. Being unable to get into this elusive state of mind we are describing here can be stressful. It's the opposite frame of mind you need to be in to do everything else in your life. Trying and failing repeatedly can make you miserable. We must always have an eye on ourselves to make sure we don't become the nemesis of joy for those around us whilst we are busy trying to create it. Joy is a special form of truth revealed in an enthralling way, it's the most direct and powerful way we have to stop people in their tracks. It's something we'll never stop searching for. But the most amusing truth we have discovered is that we could all be having so much more fun in the process if we were just trying to be serious instead.

PUMA Jamaica
In-store Campaign Posters

Before he was the world's fastest man, GBH met one of the world's fastest teenagers. We travelled to Jamaica with a bag of shoes and clothes from PUMA to give to Bolt and the team. We photographed 17-year-old Bolt in casual and sports apparel to create these in-store lenticular posters that animate as you walk past them.

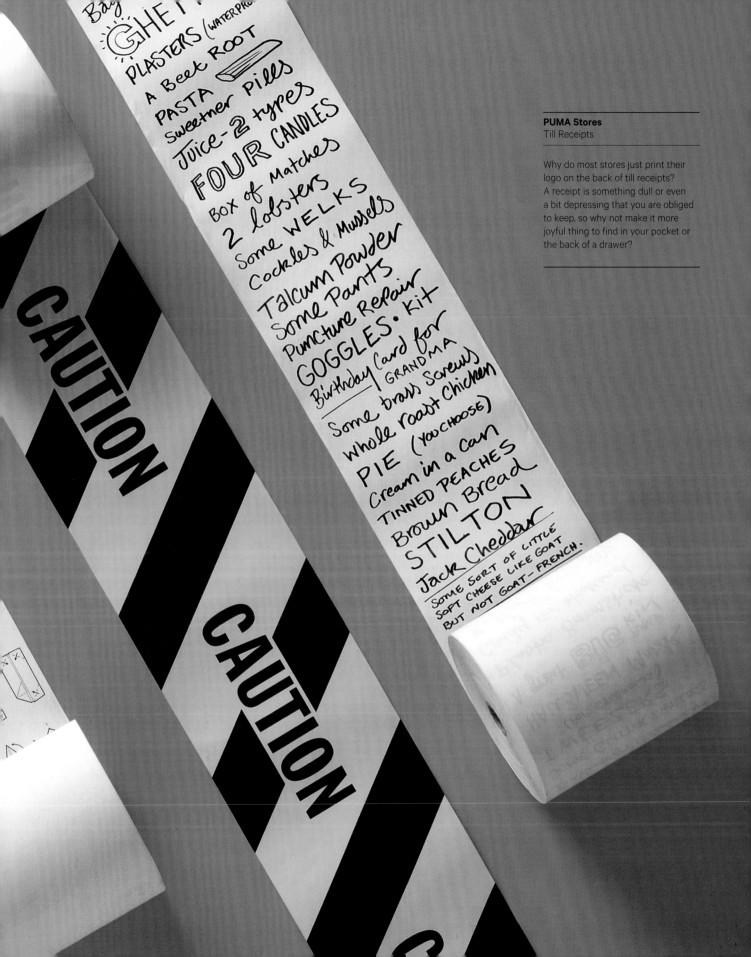

PUMA Stores
Till Receipts

Why do most stores just print their
logo on the back of till receipts?
A receipt is something dull or even
a bit depressing that you are obliged
to keep, so why not make it more
joyful thing to find in your pocket or
the back of a drawer?

TO CATCH A MOUSE,

Make a Noise Like a Cheese.

Let's just pause and think about that out-there statement for a while.

We think this weird little one-liner gets right to the heart of how we do what we do. Let's break it down. Firstly, don't BE cheese, because that'll never work. The mouse has got sooo used to that. He's seen an awful lot of cheese over the years. Secondly, the mouse got smart and he wants something new. As creatives, we've evolved too. We know that we need a lot more than conventional theory to catch a modern audience's attention. So, we'll be setting our trap with the fine art of Art Direction, for a start....

PUMA
'Spackle' Campaign

Conceived as a flexible print and TV campaign that "filled the gaps"—Spackle is a Polyfilla-style crack-filling product in the US—this project was built on a simple insight; people like products like them.

We applied the thinking to all manner of stereotypes, but found the perfect muse in the animal kingdom. Inspired by early prototype footwear styles, we looked for similarities or metaphors of attraction and rejection within the animal population, before pairing the two in a way that just ran and ran.

The work became a delicate interplay between the two rival personalities, carefully celebrating the physical properties of both species and product with wit and mischief.

Tuning the frequency, we'll need to understand the delicate, precise act of sending a message on exactly the right wavelength without interference. But remember, to the mouse, less is more. Oh, and don't forget to make it sticky.

Before we get into unpacking the fine art of Art Direction, let's set out some pretty harsh realities. First up is the unarguable fact that our audience didn't get up this morning just so they could see our work. They're busy with their own lives and they don't really care about what brands do or say as long as they pay their corporation tax. It's our job to make our client's products and initiatives matter, to make them care. Realising that is the first step to being heard.

Then there's the fact that they're a moving target. Our audience is on the move and we need to move with them. Which media will they consume our story in first? 360-degree projects need multiple front doors. We need to catch our target in a triangulation of crossfire to get our messages heard. Visual communication today is Dealey Plaza all over again. No one knows where the magic bullet in a coordinated campaign of creativity will come from. We just can't be sure what part our audience will see first. The old model has been turned upside down from the rigorous pyramid of consistency we preached in the 80s and 90s. The logo is no longer king of the hill. Now, we consume brands via their experiences, events, content and conversations, and check out at the bottom of that pyramid via the logo, before returning to see how things have changed. A brand's symbol is like a hotel concierge, constantly aware of what's on in Brand City.

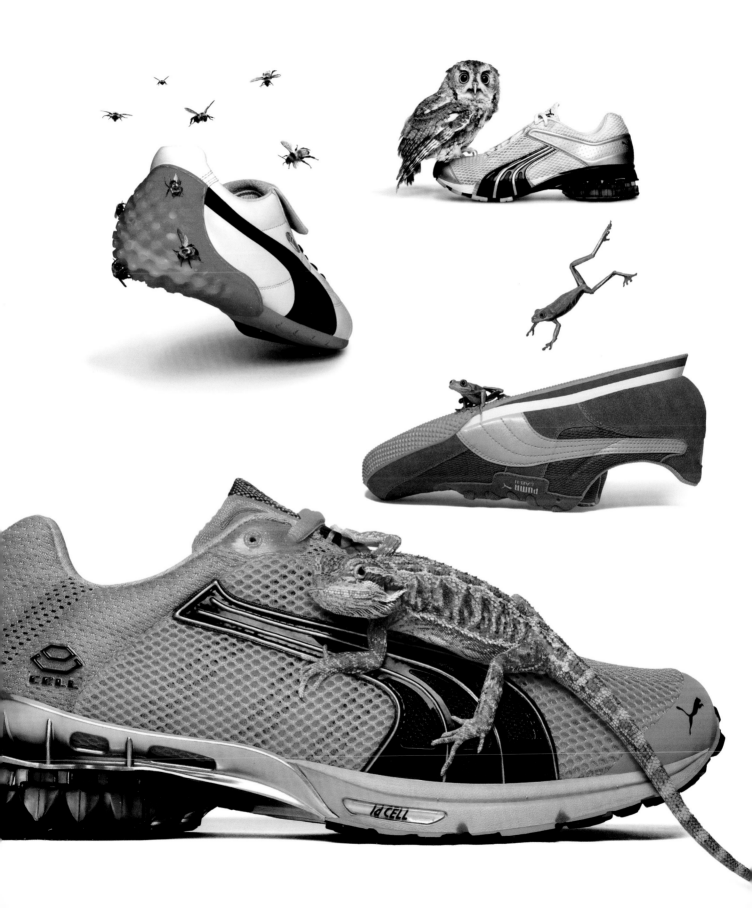

While the pyramid of consistency has inverted, our relationship with brands has deepened. We want creativity that entertains us, we enjoy the dialogue and we engage to take part because we love playing the game.

To communicate our message in this context, we need to understand The Catch as well as The Throw. Far too much is said about the importance of the idea, often by people who have ideas. It's just a part of what we do; the root, but not the branch. There's a wonderful directness in the simplicity of an idea, but the art of Art Direction is about intimately understanding how the audience will catch that throw. Imagine for a moment, a quarterback picking out the passes—he needs to 'feel' how his runners will move—where they'll be informs where he'll put that ball. He's predicting their behaviour and when he connects experience and instinct with timing, it's a joy to behold. Touchdown!

That's what we can do, creative people. And it's what we've always instinctively done, in nature and in history. Take the animal kingdom for example, there's some amazing Art Directors in there. Let me introduce you to the alligator snapping turtle. It's developed a worm-like tongue and a dark, camouflaged shell over centuries of quantitative consumer research that it uses in tandem to attract its prey. It flails its tongue around like a writhing worm, whilst hiding in the rocks, and when a fish sees the bait, it snaps its mouth shut eating the fish. Predators evolve through adaptation to catch prey, but in this natural 'arms race' prey constantly adapts to avoid its fate.

PUMA
'Gaffer' Teamsport Product Typeface

If a sports brand wanted to go beyond kit and boot deals to get their message on to the field of play, there's a vast amount of red tape and restrictions to cut through. For PUMA's four-year teamsport product cycle leading up to the 2014 World Cup, we found a way through. Their above the line campaign 'Make Football Anywhere' featured images revealing gaffer-taped goalposts in urban settings.

We proposed a typeface that brought this work to life, inspired by the way real gaffer tape tears and folds. We ripped and stuck the characters together repeatedly until we had it 'right'. The giant alphabet was photographed, digitised and became the official font used not only in the advertising campaign, but on all 2011–2014 PUMA national and international team kits.

By complying with myriad FIFA regulations around legibility, stroke widths and sizing, the advertising campaign successfully crossed the white line onto the field of play.

PUMA 'Gaffer'
ABCDEFGHIJKLM
NOPQRSTUVWXYZ
abcdefghijklmn
opqrstuvwxyz
0123456789
!@#$%^&*()

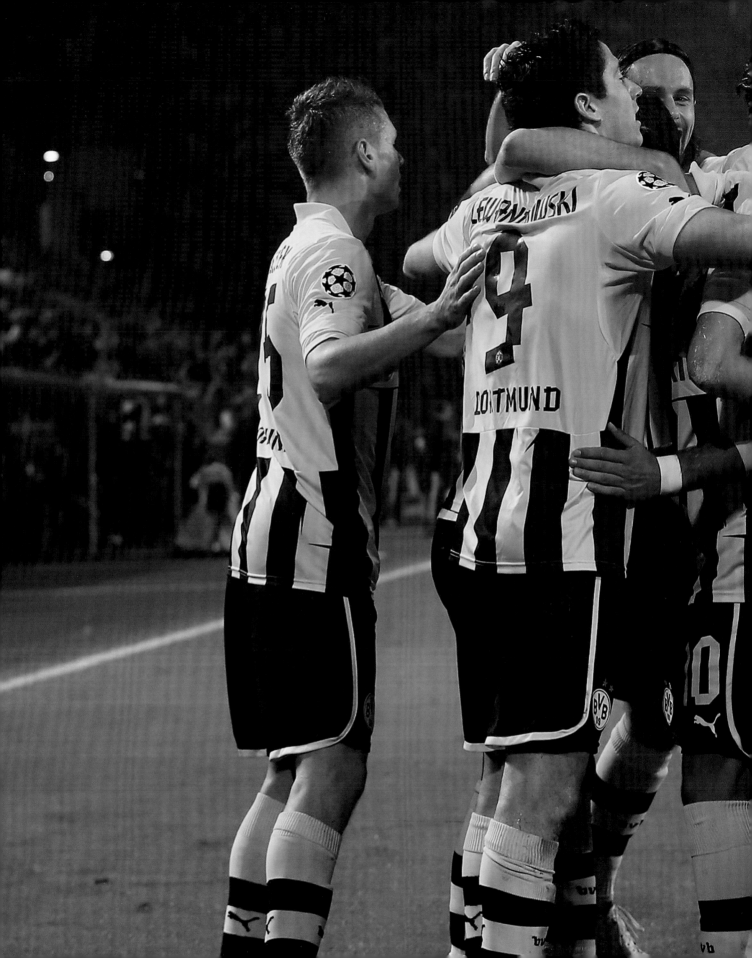

Dalla collezione Alajmo
AMO, Venetian Restaurant Branding

The renowned cuisine of Alajmo provides the purity within the opulence of Venice's controversial first shopping galleria. In a subversion of the Venetian mask, the 'true self' is revealed via a dining philosophy so pure that it dissolves the pretentiousness of its surroundings. Represented by the gold leaf, AMO removes pretension and material symbols of status from each portrait, leaving just the purest self.

The menu is re-appropriated as a deck of cards available to purchase called 'Smaschera' (unmasking). Six archetypes question the random association with each diner. Each table is a mischievous mix of vice and virtue, but all are united by the purity of AMO, universally dealt as the final card accompanying the bill.

In the ultimate game of cat and mouse, all living things adjust to the environmental conditions imposed on them if they want to survive. A creative idea is no different, it's a living thing too. A fragile organism that competes for its audience in an ever-changing ecosystem. Just like in the animal kingdom, it has to constantly adapt to its habitat to survive. This tight evolutionary relationship is called co-evolution, and we're in a time when the audience and the idea are evolving in a co-ordinated fashion at an extraordinary rate.

Lamarck's theory of the "inheritance of acquired characteristics" was an ancestor to Darwin's theory of evolution. It's well worth a look. Amongst other things, Lamarck believed that elephants used to have short trunks, and as a response to water being out of reach, the elephant bequeathed a longer trunk to its offspring. He also believed that humans would be born without unnecessary body parts such as appendix and little toes. Presumably—with the rise of the smartphone—young people will soon end up with a phone cover for fingers and a swipeable thumb.

In history, we see the fine art of Art Direction too. Here, identity is in a deep co-evolutionary relationship with differentiation. Historically, humans conceive their visual identities as a communication of their similarities and differences to other groups. This differentiation has its roots in biology and can often be the difference between life and death. In the beginning, we used the simple rules of 'kin' and 'place' to define our tribe. But as tribes became bigger and the population grew, we needed more sophisticated ways of differentiating.

AMO

MMXVI

Tribes, clans and lineages were just the tip of the iceberg: as trade and travel became commonplace, the need for identity grew, so the desire for symbolism grew with it. Religious and political allegiance became prime messages. From the Akkadian Empire way back in 2350 BC, through the Phoenicians, Romans, Egyptians, Ottomans and Anglo-Saxons—right up to today's Shoreditch Hoxtonites—we have wrapped these fine differences up in a rich and evolving visual language that conveys meaning. Our tools, our weapons, our dwellings, our shields, our helmets, our flags and now even our explorer beards are all carefully considered elements of Art Direction, adaptations of ourselves as we evolve to keep ahead of mimicry, our predators and in step with our habitat.

So, genetic and historical origins nicely established, how does the fine art of Art Direction apply to creativity? Well, it's about that catch. It's about how the things we do make you feel. It's the vitally important sensory, intellectual and aesthetic choices we make as we wrap our message in the clothes of relevance.

Let's be bold and take the evolution of the Bible as an example. It's the sheer size of the first book, its case binding, its vellum smell, the cradle that carried it in church, the delicate nature of its paper. It's the way the first letter of every word in each hallowed chapter was embellished by skilled illuminators working tirelessly for years on its manuscripts, or the progressive decision to bestow the revolution of moveable type on this revered set of stories. It's the way Picasso twisted bulls, horses and men into a violent, Cubist war.

Ipanema with STARCK
Footwear campaign

Combining Ipanema's love of fashion and fun at the beach with Starck's desire to make products that are 'better', more intelligent and ultimately more elegant saw the creation of a dynamic range of flip flops designed to enhance the fun-loving lifestyles of modern women.

This offbeat collection called for a lateral and unexpected, yet chic and stylish concept. The advertising campaign delivers a mix of ingredients that cause unexpected, surreal visions and sexy mirages to delight and surprise audiences. A day with Starck on the beach is no ordinary sunny day....

PUMA
'Future Forever Victorious'

To offer a more meaningful
alternative to yet another new
kit each season, we proposed a
relationship between the three launch
kits for PUMA's new partnership with
Arsenal FC, with the cup, home and
away shirts all being part of a more
unified story.

PUMA's youthful Arsenal cup kit
would launch at an accessible price
point with an unorthodox name,
'Future', whilst the traditional red and
white home kit was called 'Forever'.
The final part of the trio is Arsenal's
iconic yellow away kit 'Victorious', with
which many historical successes are
intrinsically linked.

The new kits were soaked in
an alchemy of colour that envelops
the players within Arsenal's rich
history of innovation, community
and excellence.

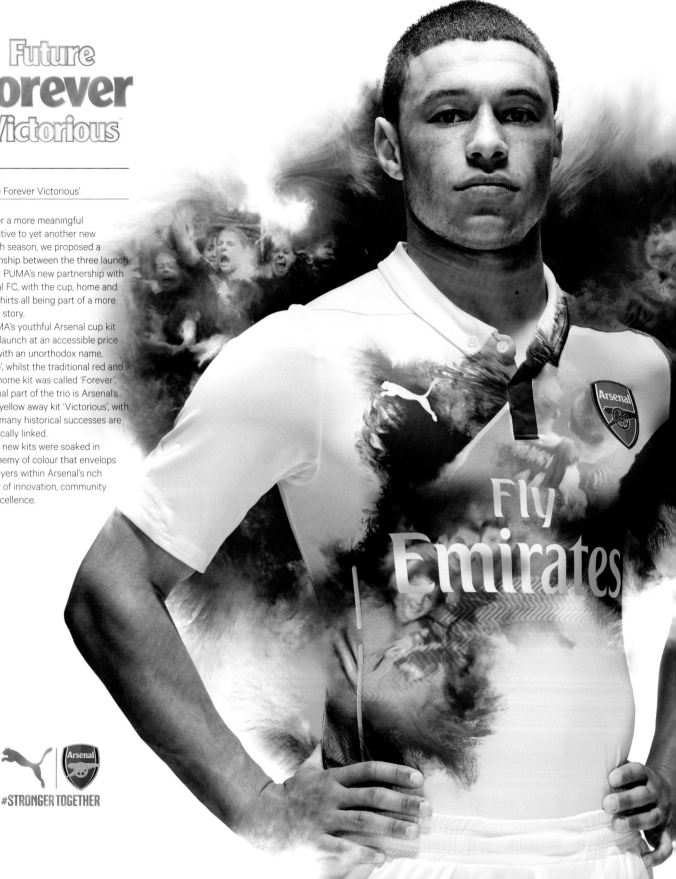

#STRONGER TOGETHER

It's how Matisse evoked a crustacean with a torn spiral of coloured paper and how Da Vinci implied a deep personal relationship with a smile we are still not sure is really there in that portrait. It's why we can remember that black-and-white image of Marilyn's dress, Hiroshima's cloud, Sgt Pepper's album cover and the lone man in front of the tank in Tiananmen Square.

It's about the fine choices we make as skilled visual communicators, in order that they affect and enhance the way our audience receives our message. Often, these tiny, numerous decisions can elevate our work to extraordinary heights.

Take Jeremy Deller's 2016 memorial to the fallen in the Battle of the Somme, *We're Here Because We're Here*. His brief? Commemorate the deaths of 19,240 young British servicemen a century ago in a way that will resonate with the public today.

Thousands of carefully chosen and theatrically trained young men appeared like ghosts from our past, right where modern life least expected it. In our train stations, streets, restaurants, shopping malls, right in the very fabric of our everyday lives. Right where they would be now, had they survived.

The artist's decision in how they interact was fundamental to how we perceived that work, and ultimately, to its success. He decided that the 'soldiers' should walk, sit, smoke, stare, sing, but that they should not speak. Their silence became their power. Staring straight at us, they never crossed the frontline into our time. Like apparitions from our conscience, they sat, they waited—occasionally bursting into private, communal song—but not one of them uttered a word to modern life.

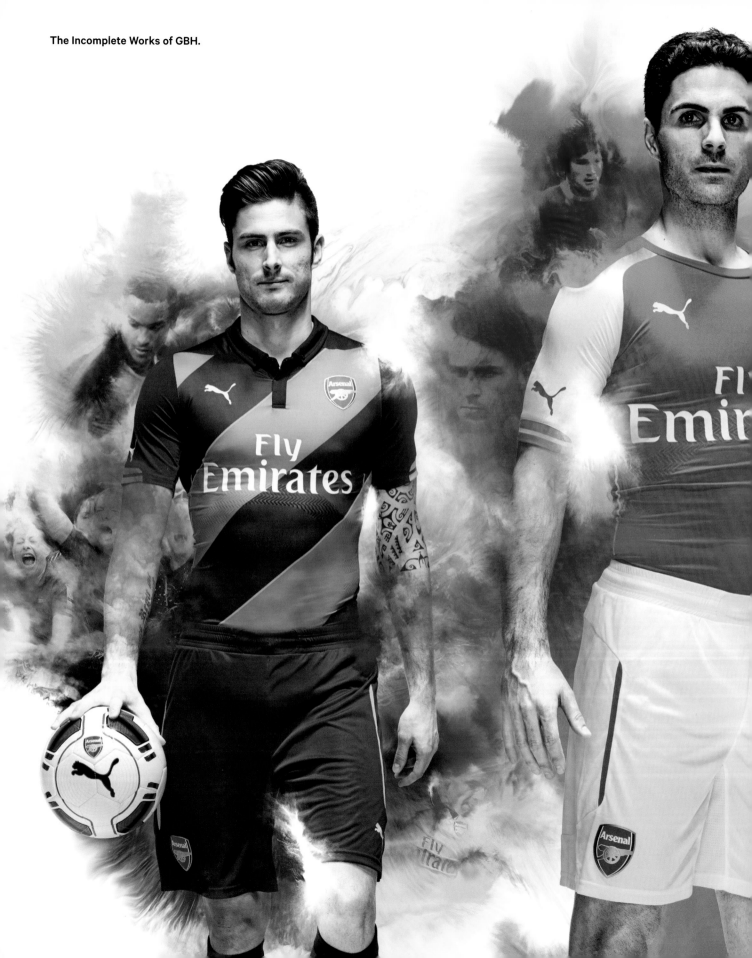

'FOREVER'. THE NEW
ARSENAL HOME SHIRT
AVAILABLE NOW

PUMA.COM

More than 100 images tease and
reveal the new kits in action. Viral
films amplified the launch as young
fans ('Future'), three separate
generations of a die-hard Arsenal
family ('Forever') and iconic ex-
Arsenal legends ('Victorious') were
combined with the players' lip-synced
performances to communicate
a profound sense of responsibility
to the Arsenal fan.

The project was a delicately
constructed message, as choosing
the words to work both in isolation
and within a triptych was challenging.
We wanted to find a reverent, regal
tone befitting of the club's standing.
We set out to create a modern
maxim, with Arsenal's own values
of progression, community and
excellence at the fore.

The choice to 'bleed' the design
onto empty white shirts was
deliberately emotive. We wanted the
Arsenal players to activate the colour,
to agitate it. The decision to ask the
players to echo the past by speaking
in the voices of young hopefuls,
fervent fans and legendary players in
viral films conveyed a sense of pride
and responsibility to the worldwide
family of Arsenal fans.

Royal Mail Special Stamps
Inventive Britain

A set of eight suitably inventive stamps chart Britain's long history of imaginative leaps and far-reaching ingenuity. All the imagery, in one way or another, express the overarching idea that 'brilliance is beautiful'.

The stamps are appropriately organised in related pairs: the Colossus computer and the World Wide Web; cat's eyes and fibre optics; stainless steel and carbon fibre; DNA and the i-limb.

81

COLOSSUS the world's first electronic digital computer

81

WORLD WIDE WEB revolutionary global-communications system

1ST

CATSEYES light-reflecting road-safety innovation

1ST

FIBRE OPTICS pioneering rapid-data-transfer technology

(Turn the book 90° to crack the code within the Colossus stamp).

If approached, they handed the recipient a tiny white card, displaying name, rank, battalion and regiment of a real soldier who had died at the Somme. Immediately and effortlessly, via sensitively presented facts, the vast scale of the tragedy is reduced right down to one contemporary individual being inextricably twinned with a life, lost forever. By these subtle visual and verbal choices, the art director gave a profound meaning to his message.

To make this work well, the creative must be more of a conductor than a soloist. Without ego, he or she listens only to the idea for the inspiration as to how to execute it. It's collaboration that makes work this good. A concert of creative, client and problem in perfect harmony. The idea is the root, and then, the controlled humility of the 1,400 volunteers are the organic branches that carry the idea to its audience. The throw is caught perfectly and the outcome is a message that will never be forgotten by those who received it, regardless of how busy or disinterested they once were.

These conditions prove that now is the perfect time to be creative. The ecosphere we work within today can be compared to the Industrial Revolution of the nineteenth century. The ferocious pace of change that delivered mechanisation via steam is mirrored by the rise of the screens. The wheel continues to turn, and we turn with it. We evolve to revolve. In the seventeenth century, Sir Christopher Wren was a world-class mathematician, pioneering surgeon, astronomer, philosopher and even the inventor of a transparent beehive whilst he was busy working as the renowned architect that we know of today.

Although they are visual expressions of specific breakthroughs, they were art directed to resemble collectively small pieces of abstract art.

Stamp design requires a deft balance to be struck between diving deep into a subject, but then staying on the surface visually. No matter how involved the subject is, these precious little miniatures must remain both instant and impactful.

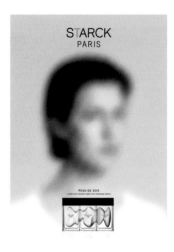

STARCK Paris
A perfume 'Between Real & Imagined'

A new approach to perfume and a love affair with the skin sees an attempt to reproduce the unknown rather than the known via this project.

At the centre of this story lies three fragrances, the bottles are a reminder of the molecular selves that connects all things. Representing 'Silk, Elsewhere and Stone', the three fragrances mirror man, woman and something in between. 'Elsewhere' is deliberately not gender-related, but a perfume that is less, a pure spirit existing in the realm of the unconscious mind.

This ethereal tour of the senses is evoked by mysterious imagery and an absence of erroneous elements. A series of teasing direct mail was produced, mixing science with poetry, and understanding with meaning.

Or take Leonardo da Vinci, quite possibly the most talented person who has ever lived: engineer, mathematician, inventor, painter, sculptor, writer, botanist, geologist, anatomist.... The modern creative's powers are also incredibly diverse.

In today's technological revolution, we've an opportunity to be Renaissance men and women. We need to be a many-headed Hydra, a creative mutant who knows no fear and is brave enough to share. Once again, the polymath is on the rise, with collaboration ably at its side.

In the future, the fine art of Art Direction will continue to be communication's most powerful ally. It's the way we'll make our messages cut through the fog of modern media and become memorable. Making unforgettable visual communication is what we strive to do. Art at its best understands this, as the circle of creation isn't complete for the artist until the work is perceived and interpreted. People buy advance tickets—wait hours in line—to go and look at art in a special, quiet place called a gallery. Whereas designers fight to get our audience to turn their heads when passing by. It's the visual noise of Times Square versus the quiet solitude of the Louvre. So much of what we do in commercial art (that's how we prefer to think of what we do) is just put out there, but how much of it really 'sticks'? Can we honestly compare 'clicks, likes and page impressions' with art that at its best is ingrained on the subconscious retina of humanity?

Making work that matters is about catching that mouse and most importantly of all, it's about the fine art of how we make our ideas truly 'sticky'; Art Direction.

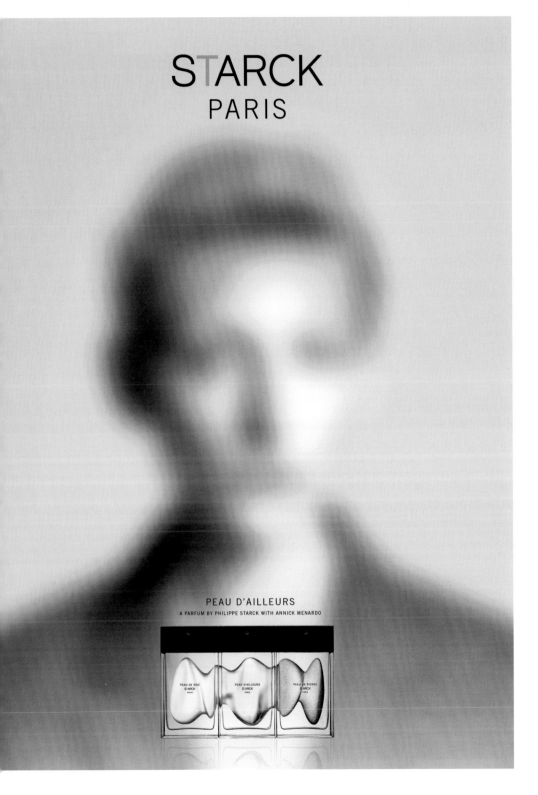

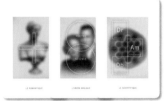

A Measure of Success.

Success. What hell is that? Is it about money? Is it a state of mind, a zen-like tranquillity born of rock-solid self-confidence? Is it a shelf-full of semi-precious metal from our peers? Is it fame, notoriety, early retirement, or is it that deep sense of personal satisfaction that only comes from sitting under a broad oak tree at the end of a particularly hard day of manual labour with an ice-cold beer and an achingly sore back?

Success | noun. Is it 1. The favourable or prosperous termination of attempts or endeavours?
2. The accomplishment of one's goals? 3. The attainment of wealth, position, honours, or the like?
or is it 4. Something else entirely?

PUMA Bodywear
Our First Product

Another early ambition met… we've
even designed our own underwear.
 A range of male and female
bodywear for PUMA was our muse,
and we managed to have all manner
of fun with the two-sided carton
packaging. Uli Weber's stunning
specimens of fitness were twinned
with a subversive touch of PUMA
mischief: X-ray photographs which
packed a surprise into each pair.

Does it come from a moral satisfaction that we've mattered? That we've helped others, made a difference, done some good? Is it a body of work that's stood the test of time, or is it a deep-rooted desire to be a pioneer? Oscar or Nobel Peace Prize? Fame or notoriety? Your money or your life?

A creative person's quest for satisfaction never, ever stops. On and on we go, relentless in the pursuit of perfection. "I want it to work, to be the best thing I've ever done, to be the best anyone's ever done… I want to do it again, only better. I want to make a dent, I want to be the greatest designer/art director/ painter/photographer/adman of all time." Jeez. We need to get over ourselves.

All of this starts with an age-old desire to be noticed. To earn our stripes. Perhaps we weren't top at school, but we're not alone. Most right-brainers have an academic deficiency of some sort or another. Many creatives are dyslexic for example. We have to find another way to impress, to succeed. For most of us, 'this' is the only thing we're VERY good at. Everything else is learned behaviour. Writing, strategy, presentation and people skills, diplomacy, politics, financial savvy, managing staff, resource planning, project management, business plans, setting budgets and targets, accounting, salesmanship, collaboration, competition. It's all learned and we have the scars to prove it.

But being creative. That's natural. A God-given talent they say. We can think and we can draw. No one can teach that… can they?

When one of us at GBH first realised he could draw, he quickly realised he could earn. We're not sure what this says about us, but he charged his

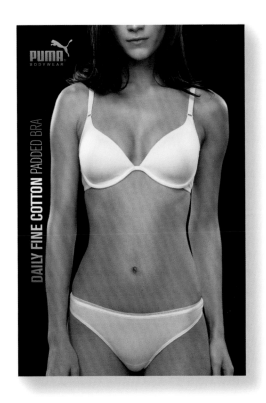

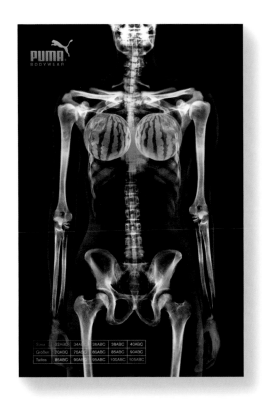

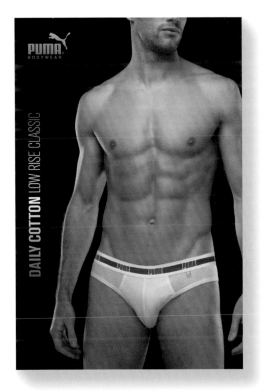

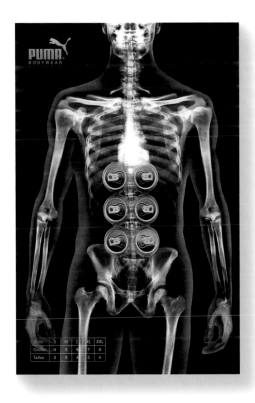

classmates to draw *Star Wars* Stormtroopers or sportswear brand logos on their school exercise books. Adidas, Fila, Tacchini, Ellesse, PUMA. How ironic it is that 30 years later we've ended up charging PUMA to draw PUMA logos? It's funny how life comes full circle.

He had a little mini-business doing it when he was 12, under the school radar. He got pretty good at it. He got a lot of pleasure from it. A little bit of fame even. It got him into trouble, which was kinda cool, and he even got paid. In fact, his 'talent' opened him up to all the things that we thrive on today as creatives. We become addicted to being good, because it helps us to stand out and to be liked.

It's our mum who notices first. She begins by putting our drawings on the fridge. She never put our brother or sister's drawings on the fridge. This made us unpopular with our siblings, but that was pretty cool when we were eight or nine. We were the chosen ones. It made us feel six feet tall. We got so used to this modest adulation that we craved it. We started producing more and more drawings. She had to get smart, so she became selective, otherwise she couldn't see the fridge anymore. We all remember her standing over a curious line-up of our handiwork, a perfect storm of early 60s, 70s, 80s or even 90s nostalgia in mixed media: felt-tip, biro and those weird, water-soluble coloured pencils you could lick, depending on your age. She'd run the rule, she had her own criteria. She'd decide which were good enough and which were not. We started to learn what she liked, what she wanted. That's where the fun started.

GBH Christmas Card, 2002
Our First Billboard

A desire to go past conventional Christmas cards and a boredom with producing one year after year was the motivation to decide early on that we'd do these things differently. After all, why couldn't we be both global and local with our Christmas message?

One Christmas, in the early 2000s, we rented a single 48-sheet billboard in west London and enjoyed our seasonal greetings writ large. We aimed the message at "clients, friends and general passers by" and sent an early viral video of the bill-posting by email and that fledgling .mov media became the message.

In a Banksy-like twist, we broke in to our own billboard site and spray-can signed the 'card', sending a second video one week later.

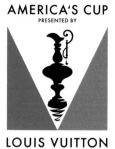

The 35th America's Cup
Our First Global Branded Event

The America's Cup has the oldest trophy in sporting history, so designing the race identity for its 35th outing was a pretty big deal.

Sponsored by title partner Louis Vuitton, the logo is born out from their revered 'Gaston' symbol. We deconstructed the historic marque and used the existing triangular forms to represent the competing sail boats. The marque comes to life in animation, where the final two boats, the challenger and defender, go head-to-head, battling it out for the famous cup.

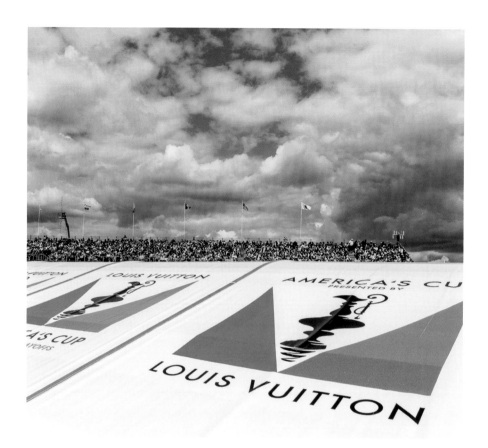

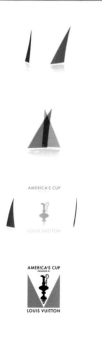

BMW FlyTime™
Our First Live TV Broadcast

The America's Cup is often referred to as F1 on water. Powered by a wing sail and the crew's skill, the boats can fly above the water on hydrofoils.

This unique aspect of the race provides an opportunity for sponsor BMW. Based on the design of the in-car head-up display, the FlyTime™ TV graphics enhance the entertainment and analysis for spectators worldwide.

The formula is simple: the longer you fly the faster you go, the team that masters the most FlyTime™ will ultimately win the 35th America's Cup.

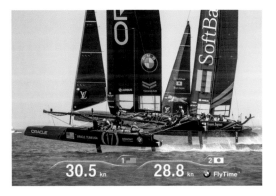

PUMA FIGC
Our First Football Badge

What are the chances of a small studio in Chiswick, west London being asked to design the national team badge for three-time FIFA World Cup winners, Italy? Well, it happened, and then due largely to this man—Andrea Pirlo—the Azzurri went on to win the 2006 FIFA World Cup, taking them to the heady heights of four wins in total.

This led to an immediate redesign in order to squeeze in the fourth star and an invitation to design both the Cameroon and Ivory Coast national team badges too.

From school we found college and from the fridge we found International Advertising & Design Award Schemes. What were we looking for? Satisfaction, fame, to be noticed... a place in our profession's history... or is the perfection we pursue just a muse, an allegory for our own quest for happiness?

There's something deeply satisfying, gratifying even about standing out. We think creative people find this need comes naturally. Since a young age, we've been finding our voice, honing our talents. Rightly, we're coached to be individuals, to be unique. This takes time. Originality isn't Xeroxed overnight and delivered midday tomorrow.

Deconstruct, reconstruct and re-invent. That's the very foundation of creative education. We're not natural employees, us creative types. There's something very independent about being creative. A solace even. We evolve to find the confidence to be ourselves—authentic voices ready to shout and scream from a unique perspective. Yet, right when we're ready to go it alone, we are required to collaborate by commercial realities. Designers are commercial artists after all.

Once again, the challenge renews. We leave education and the first thing we learn out in the big wild world is to conform. Fuck that! We have to work with other people to achieve our aims. It's not easy. Finding collaborators who hear our voice, speak our language and share our passion can be tough. The gears mesh, it grates. The search can go on and on... from choosing a university course to deciding on a project, a classmate to work with, a job to work on, an agency to work in and a client to work for.

PUMA Ocean Racing's 'Marmo'
Our First Toy

Uber-cool vinyl figurines and contemporary plush toys have always been our thing, and it was a big privilege to design something for kids, especially as we all have some of our own. PUMA's involvement in the 2012 Volvo Ocean Race and our work on their race boat livery; Mar Mostro (Monster of the Sea) provided the perfect opportunity.

To help children understand the plight of the ocean, PUMA asked us to find a way to engage children at each race city. 'Marmo' (Mar Mostro Jr) was the creation, and he was the hero of a specially written book called *Marmo Saves Our Seas*. The book was read to an enthralled young audience at each race leg by a seven-foot Marmo in costume. A limited edition of plush toys and related products were also born in his honour.

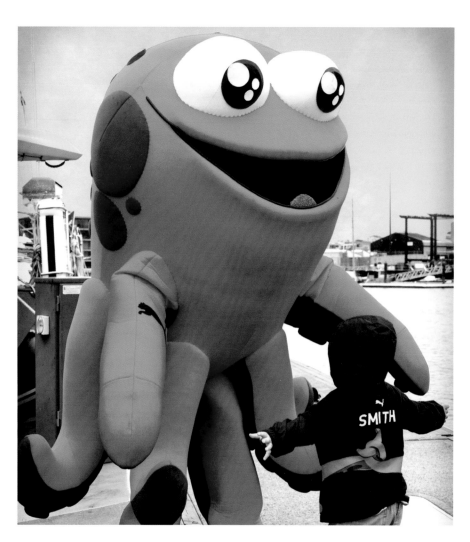

Suddenly, right when we were least looking, we find a like mind. Or perhaps two. Someone as mad as we are, who overlaps and is different all at once. Suddenly 1+1=3. It's a joy. Our voice has grown. Finally we can be ourselves, only better. Is this success? Hell no. We're just starting out.

At first we earn trust, not money. We complete projects, we amass experience. We become sought after, respected, even valued. Our opinion is sought and paid for. We go to expensive, black-tie award dinners to get the accreditation we crave from our peers. Our work gets put up on the fridge again. Often, it's a commercial, profit-making kind of fridge this time. We pay to win. We convince ourselves that this is "good business", that we're "putting something back". That we're building our profile, attracting better talent, clients and projects. Of course we are. Everyone does it, right? No! All we're really doing is helping the guy who owns the fridge to get rich.

Is this success? For a while it certainly feels like it, yes. People congratulate you at first, and then, after a while—especially if you keep winning stuff— they stop. But in the end, we're still looking for something better, so we keep going.

Is it fun? Hell yeah! Everything we ever wanted is now ours, almost. We're doing great work. We're earning trust, building a reputation. We took a risk, backed ourselves and went out on our own. Perhaps we did it with like minds. Our company is growing. We're paid well. We've won awards. People know who we are, what we've done. They rate us. We're inside the circle. We're in. So, is that success? Of course not. Well... it's a small measure of success.

Royal Mail Special Stamps
Our 'FAB' First Front Page

Celebrating the ingenious and expansive brilliance of animator and filmmaker Gerry Anderson MBE in the miniature form of postage stamps was a genuine challenge.

An army of loyal global fans only added to the pressure. Mountains of original research led us to a wonderful twin set including the UK's first ever lenticular postage stamps, which used analogue imaging technology to bring the iconic *Thunderbirds* puppetry and vehicles to life.

Once our FAB Thunderbird stamps were finally 'go', Gerry Anderson's status as a national treasure became clear, as our stamps and their associated collectibles made the BBC News at One and *The Times* newspaper front page.

A few centimetres on the yardstick of progress. All that really happened is we joined a society within which are others who are looking for something more meaningful, just like us.

Sadly, inside the circle, there are only people like us. Hunters and gatherers, feeding off one another. Incestuous and cannibalistic. Sharing their victories, pushing their profiles and fighting for scraps. We have to get outside this circle to thrive. Imagine how weak our genome would be if we had never left the cave. That's creativity at its worst, right there.

Once we've achieved this 'success', we need to find the courage to go alone, all over again. To look at success objectively, and to see it for what it truly is, we have to get out of that inner circle. In fact, we have to work even harder as an outsider to get into the inner circles of others. That's where next.

That's where we'll meet incredible people. We'll see the same fire in their eyes. They have dreams too, but from a different perspective. We want to work with them and they want to work with us. What's our dream project? Let's go get it. Anything is possible. Outside the circle, it's 1+1=3 all over again. We'll find a fresh set of collaborators. We'll learn something new. We'll work with the best, to do the best work. It's that simple.

Let's be honest, as creative people, we suffer from something of a disorder. We hate to do the same thing twice. We're all about bigger, better, next. We want to do things that have never been done before. We want to be first.

Success is so relative. There will always be someone more successful than us inside that circle.

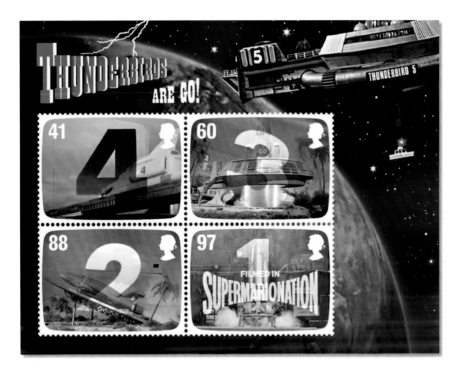

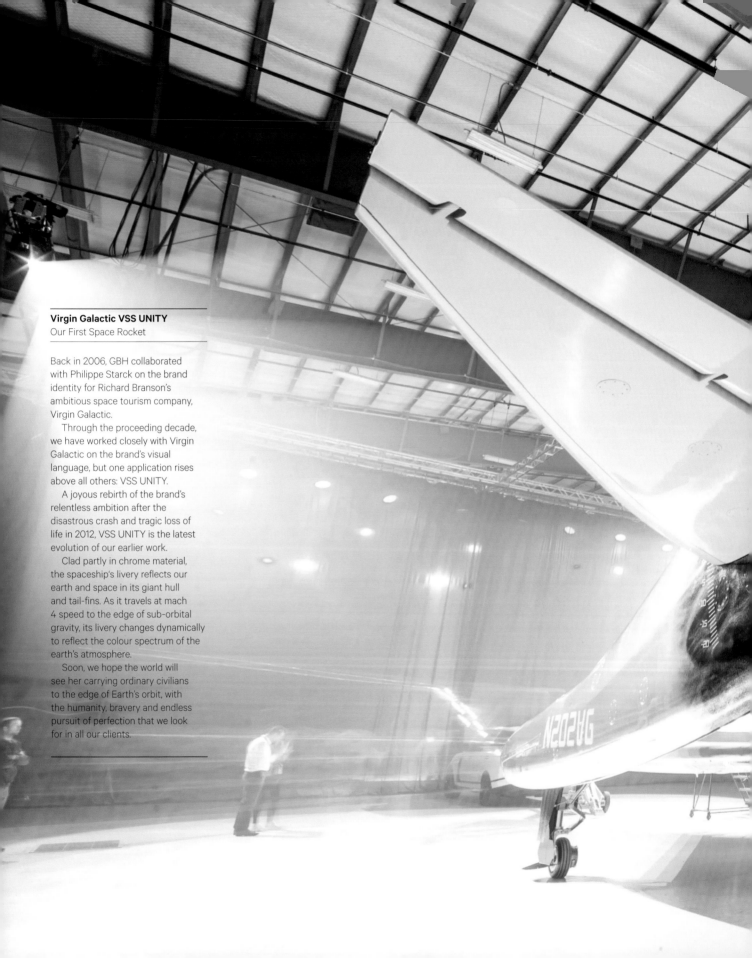

Virgin Galactic VSS UNITY
Our First Space Rocket

Back in 2006, GBH collaborated
with Philippe Starck on the brand
identity for Richard Branson's
ambitious space tourism company,
Virgin Galactic.

Through the proceeding decade,
we have worked closely with Virgin
Galactic on the brand's visual
language, but one application rises
above all others: VSS UNITY.

A joyous rebirth of the brand's
relentless ambition after the
disastrous crash and tragic loss of
life in 2012, VSS UNITY is the latest
evolution of our earlier work.

Clad partly in chrome material,
the spaceship's livery reflects our
earth and space in its giant hull
and tail-fins. As it travels at mach
4 speed to the edge of sub-orbital
gravity, its livery changes dynamically
to reflect the colour spectrum of the
earth's atmosphere.

Soon, we hope the world will
see her carrying ordinary civilians
to the edge of Earth's orbit, with
the humanity, bravery and endless
pursuit of perfection that we look
for in all our clients.

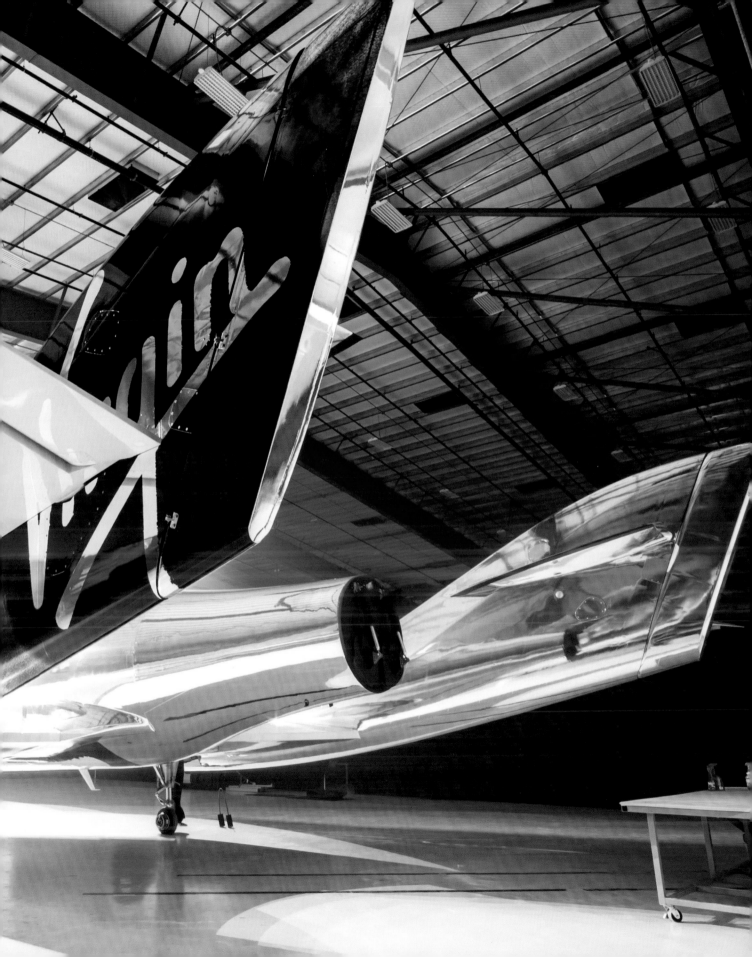

VSS UNITY Launch
From Paper Planes to Han Solo

At VSS UNITY's unveiling in Mojave, California in late 2015, the assembled community of ticket holders were treated to the evocative sight of the unmistakeable Jedi Rebellion pilot Han Solo in the cockpit.

A long way from when G, B & H met at London's Royal College of Art in 1992, where we designed a calendar together, called the 'Paper Plane Yearbook'. (Selected months are shown below.)

Who'd have thought that 25 years on, we'd have journeyed to the edge of outer space together? You really couldn't make this up. Proof that boyhood dreams really do come true.

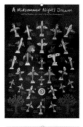

Someone who has something we don't, that we want. Even if there isn't, it's good to believe there is, because it keeps us honest and stops pop from eating itself. The ultimate fulfilment doesn't lie inside these tiny circles of success, but in something so much bigger: putting back. Help others to learn. Set them a bar to raise. Inspire them to do better work than we did. Share.

Wise people say that if we want to be remembered, we have to write a book. Well, how funny ;–) Here we are. But that's not a measurement of success in itself. We can pay to publish a book, just like we can pay to win an award.

Becoming an educator, inspiring someone else to go further, to do better, that's success. It's a success so great that those we inspired will inevitably surpass our own achievements. They'll stand on our shoulders, tread on them even, to reach even higher than we did. So is that success? Yep. That's what success is to us, and that's what this book is for.

Did our work on the fridge help our brothers and sisters to do better drawings? No. But that's the theory anyhow. Sorry brothers and sisters, we guess you've either got it or you haven't.

Will this book help other designers do better work? Let's see. We hope so.

Legacy... that's the only kind of success we're truly interested in. It's an ambition that's constantly evolving. Just like the monkeys on our cover, we aren't finished yet.

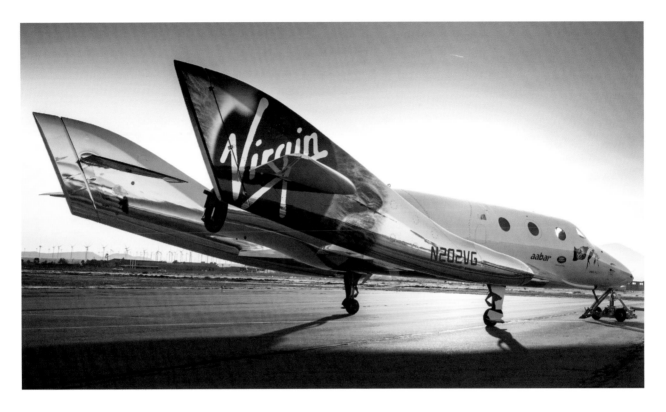

We Salute You.

Having opened our hearts and revealed our deepest fears and secrets, we began to wonder if we were alone in experiencing these feelings or if all creative people go through the same thing. So we talked to three of the most influential and inspiring people we've met along the way, asking them how they cope with balancing the privileges and burdens of being a creative individual.

Margaret Calvert OBE RDI
Our Teacher

Margaret Calvert OBE RDI is a
typographer, graphic designer and
educator—having taught, part-time,
at the Royal College of Art from 1967
to 2001, with a brief period as Head of
Graphic Design from 1987 to 1991.

She is probably most famous for
her work with Jock Kinneir on the
radical redesign of the British road
signs, launched in 1965, and, to a
younger audience, for her appearance
on BBC's *Top Gear* in 2010 where
James May interviewed her about
the design process of road signs in a
2009 Vauxhall Insignia.

To GBH she will always be our
teacher, our conscience and our
source of inspiration. She has
bestowed on us a memory bank of
pithy one-liners on getting the job
done that have stayed with us to
this day. She taught us at the Royal
College of Art from 1991–1993 and
although she has touched the lives
of thousands of artists and designers,
we'd like her to know there's no one
who holds her in higher regard and
with more affection than GBH.

Thank you Margaret.

*A term coined by Professor Richard
Guyatt in an article for the Swiss
magazine *Graphis*, published 1969/70,
covering visual communications in
the 60s at the Royal College of Art.

Looking back on a life spent mixing work with play,
I realise how lucky I've been in finding myself pursuing
a career in Design that leaves me believing there are
still fresh challenges ahead.

Through drawing and painting at a very early
age, we are free to interpret the world as we see it,
until we are transported into a less personal space
by the attractions and expediency of a digital world
still in its infancy.

To have it all at our fingertips, displayed on the
largest screen available, is now the norm, and has
been for a long time. But we all know (hopefully) that
the fast-moving benefits of technology should not be
an end in itself—that there are other ways of realising
ideas and solving problems, which may require a
more time-consuming and physical "head, heart and
hand" approach.*

Design education, still undervalued by successive
governments incapable of appreciating the enormous
contribution it can have on the economy and quality
of life, is still one of the most valued legacies left to us
by the Victorians, with an art school in almost every
major town or city—initially established to supply
industry with the required skills.

Despite amalgamations and huge fees imposed
on an ever-increasing number of students keen
to follow a course in Art and Design, there are
still opportunities to pursue paths that embrace
more than one discipline, giving students a greater
understanding of new problems to solve and a chance
to form lifetime partnerships.

MARGARET CALVERT OBE RDI

Philippe Starck
Our Champion and Tormentor

Safe to say Starck is the world's
most famous and prolific designer.
He operates on a higher level, with
a belief that we must only create if it
will improve on what already exists,
that it will make lives better. With a
personal approach that is poetic and
political, benevolent and rebellious,
pragmatic and subversive, he is a
constant source of surprise and
inspiration to us.

Incredibly he has allowed GBH to
participate in his vision and, for over
15 years, we have had the honour
of working as hard as is humanly
possible with him (each time a
little harder than the last). Through
thousands of handwritten faxes and
emails on tracing paper we have been
dared, inspired, challenged, insulted,
beaten and loved. We have given our
very best and created some of our
favourite work with him. We wish him
peace and love forever.

Thank you Philippe.

I find myself, to my astonishment, confronted with thousands upon thousands of projects that I have dreamed up, fomented, developed, drawn, printed, designed, promoted.... So many things costing time and energy. Logically, over a normal lifetime, one might create 100 or so objects. I'm close to 10,000.

I give birth to a new project every two days. It's inhuman. It's beyond morbid, it's monstrous. The only plausible explanation is this: only thanks to this level of production do I exist. The only certainty that I exist is this form of secretion. I secrete projects as a snail secretes its trail. The trace I leave behind is neither better nor worse than a gastropod's. A few little traces, visible to me and others. But they allow me to perceive my reflection in other eyes.

And yet I'm not afraid of death. To fear death, you need to be alive; you have to love life. And here I feel complete disinterest. It's alarming. I might die any minute. No doubt I'd find it a shame because there is surely more to do. That apart, who cares? I feel as if I were barely a passage: a wave, 'nothing'. Nothing worth mentioning.

I am, in a sense, ashamed to exist. Why? No bar room psychology, thank you. My feeling is that, if I did exist, I'd need to do better: existence should be something more or better than this. Existence doesn't seem to me much to write home about. It's my only form of indolence: I can't be bothered to live. The void would suit me better. If anyone asks for the word that best sums me up, one word comes to mind: elsewhere. Not 'nowhere' and not 'here'. I feel as if I were always elsewhere.

This permanent, one might say structural, relativity is both a boon and a catastrophe.

I have contrived to fly. I've never set foot on the ground. I've never made contact with society— a society which I anyway have my doubts about and with which I've never had much in common. In order to escape this nevertheless significant entity, society, I've learned how to fly in my imagination and my dreams. This is a double-edged benefit. One day I shall die having seen and understood nothing of what constitutes our human—our collective—life. I should like to be part of the group. I should like to understand the things others understand. But I shall depart uncomprehending. I shall finish my life without having lived. I'll have lived my life according to my own rules—following a personal ethics that I have, it is true, rarely betrayed, but in my own world and not in the 'real' world.

The Faustian myth of a man who sells his soul to the devil in exchange for a second life is precisely my experience. As if by accident, I sold my soul for the gift of flight in my mind. It worked. It would be bad form to regret it. But it is a strange sensation to have missed out on something so important for everybody else.

PHILIPPE STARCK

Antonio Bertone
Our Brother

Antonio Bertone was Chief Marketing Officer for PUMA. After 20 years with the company he went on to create and reinvigorate other brands. He founded Kyte & Key to unleash a range of smart wearable products. He is on the board of a brewing company. He's the "Director of Vibe" for Samuels & Associates, a Boston developer. He was Marketing Director for the America's Cup before going on to reinvent the retail side of North Sails, the world's biggest sail company.

To us he's one of the most enthusiastic, infectious and likeable people we ever met. He's the guy who builds bikes and makes sausages in his garage. First a client, then a friend and finally a brother of GBH. We have had the biggest, most creative ride of our lives with Antonio. From the early days of digital pumas and boats like a sneaker through another 500 projects over the next 12 years together. Work and play, friendship and trust all combine to make us all want to walk through fire for this guy.

Thank you Antonio.

Balancing the privilege and the burden of being creative, I feel like I'm one of the luckiest people on the planet. I get to be exposed to these incredible conversations, or experience these incredible places. Be it a foreign land or a giant big box retailer. In these scenarios I'm trying to soak up as much of what they have and where they are so I can reflect that back in what I do, because I truly feel I have no marketable qualities, apart from having these near Tourette's moments where I have to interject into whatever situation I may be in the result of all I'm inhaling.

It is not exclusive to a design review, or a product briefing. I find my OCD will opine on anything, like an uncontrollable precocious child that must be heard! I have been fortunate in my life to use this thing, this burden as the title suggests to create things, stoke emotions, indulge fantasies, and hopefully intrigue, beguile and please.

Soon in my career I figured it out. This is the game, the game is to create the emotion, create the connection, educate, inspire the masses or the solo, connect to people with the work, which sometimes is better than the product you are selling.

Being this token jester within a commercial organisation has its privileges and its crosses. The privilege is of course to be allowed to spin whatever tale you wish. To 'promote' or 'introduce', or my favourite word 'launch', everyone is 'launching' something! And now I have developed a physical ailment so when someone talks about "launching" something I immediately 'launch' whatever my last meal was out of my mouth.

Back to the privilege. We have the privilege to create the conversation, build the narrative and the world around this 'Thing' we are supposed to expose. And from there will come a religious moment where masses of humans are taking their hard-earned money out of their pocket and throwing it at the glorious company that created this 'thing'!

Yes! We've done it again we've 'launched' a thing and people are eating that shit up! You are amazing!

The other side of that cross is exactly as I mention above, except that instead of the shit being eaten up it falls flat on its face like a lead balloon of your soul. I don't want to put the creative set above any other group of individuals but I will for this moment, because I can, as this is my story—so ha!

I will go out on a limb to say that no matter what the 'thing' is that we are supposed to be 'launching' or 'whatevering', whether we love or hate it we put a lot of ourselves in it. So if it fails to connect, inspire or even be noticed, you feel that in a way that is different to most. The highs are highs and the lows are in the soul-sucking category. I still wouldn't have it any other way, that's why we are 'launching' this book!

ANTONIO BERTONE

We especially salute you.

Adam Petrick, Benjamin & Jeremie Trigano, Piero Gandini, Anna Chapman, Kristi O'Connor, David Stuart, Henri Seydoux, Susan Newsam, Dick Powell, Richard Hill, Filip Trulsson, Terence Parris, Cyril Aouizerate, Baron Nicholas von Bruemmer.

Karen Ware, Jo Bradshaw, Russell Saunders, Pak Ying Chan, Piers Komlosy, Mark Wheatcroft, Louisa Neale, Christina Sankey, Ian McLean, Richard Coward, Ross Goulden, Sophie Paynter, Phil Bold, Harry Edmonds, Jacob Vanderkar, Lucy Williams, Adam Mileusnic, Erika Manning, Andrew Kidd, Chloe Stokes, Charlotte Williams, Bethan Jones, Elizabeth York Hale, Janice Bonner, Tandy Hodson, Dave Wood, Josh Nathanson, Jessica Dolman, Heidi Shepherd, Jenny Abri, Marie-Alix Thouaille, Will Kinchin, Jack Mercer, Sophie Both-Turner, Elizabeth O'Dwyer, Sam Smith, Nathan Smith, Billy Steel, Greg Nicholls, James Fishlock, Jon Bland, Guy Smith, Liam Hine, Eddie Fowler, Brinley Clark, Faye Brinkworth, Gordon Haxton and the sadly missed Richard Neiper.

Danielle Matthews, Richard Evans, Kerry White, David Lowbridge, Alexandra Boylan, Sarah Holdges, Emily Kavanagh, Luke Taylor, Edward Heal, Robin Howie, Laura Bowman, Dulcie Cowling, Amelia Roberts, Joe Carter, Wilem Schoeman, Andrew Tharagonnet, Tara Woolnough, William Southward, James Reynolds, Elliott Cranmer, Anna Soderberg, Paulina Munakova, Pete Dungey, Eloise Young, Jo Bell, Rachel Baker, Bia Santiago, Felix Boyten-Heyes, Ian Froome, Joanne Hawkes, Charlotte Alcock, Barbara Ryan, Sam Part, Dani Sayers-Beaumont, Hamish Gardner, Jonny Drewek, Josh Hight, Katharine West, Artur Kluska, Sarah Jones, Jessica Morgan, Tommy Taylor, Gregory Kirkland, Jonathan Lax, Peter Robert Smith, Alan Levett, Timor Celikdag, Malcolm Goldie and Uli Weber.

†If you believe your name has been omitted in error, please email us at wtf@gbh.london

G, B & H
Nelly Dimitrinova
2009
oil on canvas
42 x 29.7 cm

We're legally obliged to salute you.

Fear of Failure.

The Extraordinary World of the Football Fan

Client: Jeremy Sice/Tim Rich/Rick Glanvill Head: Tim Rich. Photography: David Partner

PUMA Stores
Branding and Interior Installations

Client: Antonio Bertone/Adam Petrick. Changing Room Photography: Martin Langfield. Mannequin production: Andre Masters. Mannequin models: Piers Komlosy/Pippa Jarvis. Dylan Projection: Paul Raffael, DDC. Coding: Sven Girsch, DMX Programming. Cats: Dylan & Casey, Steve Martin's Working Wildlife. Film Production: Jamie Ruscigno, Jewels Sattersfield, Steve Ackerman. Production Edits: Russell Stopford, Berkeley Cole, Remote Films. Shoe Wall production: Paul Raphael, DDC. Animation: Remote Films, Neocco

Land Securities
'Multiple Choice' Campaign

Client: Anna Chapman/Kristi O'Connell

PUMA
Arsenal FC Kit Launch Projection

Client: Filip Trulsson/Terence Parris/Tim Stedman. Arsenal FC: Charles Allen/David Adams/Daniel Johnston/Vinai Venkatesham/Gordon Tannock. Film Production: Partizan. Event Company: Innovision. Water Projection: EMF Technology

D&AD
The 2001 Annual

Client: David Kester/Louise Fowler Photographer: Paul Tozer

STARCK PUMA
'Highly Evolved Shoes' Campaign

Client: Antonio Bertone/Adam Petrick Photographer: Jason Tozer

Royal Mail
Star Wars™ Minisheet

Client: Catharine Brandy/Eliza Marciniak Imagery: TM & © Lucasfilm Ltd, all rights reserved. Stamp Imagery provided with kind permission of Royal Mail Group Limited ©

Eurostar
35 Step Nightmare Press Kit

Client: David Azema/Richard Hill/Jean-Marc Barbaud. Production: Names withheld

Outside the Circle.

Land Securities
'Bag & Arrow' Campaign

Client: Anna Chapman/Kristi O'Connell, Photographer: David Sykes. Street Photographer: Nick Turpin. Film Director/Producer: Enda Hughes. Bag & Arrow actors: Geoff Nursey & Jon Millington

Eurostar
The Business Premier Experience

Client: Richard Hill/Jean-Marc Barbaud/Mark Elliott Photographer: Bruce Anderson/John Edwards

Parrot Pot
Promotional Films

Client: Henri Seydoux. Animation: Neon

PUMA Mar Mostro
Boat Livery, Campaign & Apparel

Client: Antonio Bertone/Ken Read/Kimo Worthington/Bridgid Murphy. Boat Livery: Dean Loucks, TAOD

STARCK Naked
Underwear Packaging

Client: Antonio Bertone/Adam Petrick Photographer: Jason Tozer

PUMA UN-Smart Phone
Branding and UI Design

Client: Antonio Bertone/Adam Petrick Voice-over production: Jonathan Cook, Hobsons

PUMA Non-Corporate Box
Emirates Stadium, Arsenal FC

Client: Filip Trulsson/Terence Parris/Dominic Wolz/Omar Perez Prieto. Production: Standard8. Model maker: Olly Redding. Interior photography: Sara Hibbert

The Kamikaze Within.

Miss Ko
Branding & Restaurant Installations

Client: Claude Louzon. Photographer: Uli Weber. Tattoo Artist: Horikitsune. Faces Photographer: David Graham. Animations: Jonathan Lax, Gekko. Signage: Richard Conn Associates. Dessert menu photography: Billy Steel

Eurostar
Frequent Traveller Branding

Client: Kirsty Hollywood/Richard Hill/Dorothee Mariotte. Production: Adrian Monk, The Input Group. Imagery: Frankie & Jonny

PUMA Re-Cut
Recycled Product Branding

Client: Adam Petrick/Hailey Broderick

GBH Christmas Card, 2001
Close-to-the-wire message

PUMA Gondola
Venice Store Launch Stunt

Client: Antonio Bertone/Adam Petrick Production: Paolo Luccheta, RetailDesign

Groupe Allard
Explosive Branding

Client: Alexandre Allard. Photography: Jason Tozer. Animation: Framestore

Only One Paris
E-Cigarette Branding

Client: Eric Series, Mathias Herzog Photographer: Mara Sommer

PUMA Phone
One Piece Pulp Packaging

Client: Antonio Bertone/Adam Petrick Production: Phil King, Pulp Circle

The God Complex.

FLOS
'City of Light' Branding & Campaign

Client: Piero Gandini/Rosaria Bernardi Photographer: David Sykes Model Maker: Wesley West

PUMA Raw Football
Teamsport Brandbook

Client: Filip Trulsson/Johan Adamsson Illustration: Mark Bonner, GBH

PUMA Unity Kit
A Continent United in Football

Client: Filip Trulsson/Johan Adamsson. Unity Image: Syrup. Player photography: Harald Loos

PUMA
500 Projects

Client: Antonio Bertone/Adam Petrick

GBH Christmas Card, 2011
Jesus Saves Initiative

SLS Hotels
Branding in Beverly Hills

Client: Sam Nazarian/Theresa Fatino. Illustration: Steven Noble. Digital screens: Jonathan Green. Imagery: With kind permission of the National Portrait Gallery

STARCK Network
Branding & Website Design

Client: Philippe & Jasmine Starck/Mahaut Champetier de Ribes. Consulting & programming: Jonathan Green

Virgin Galactic
The World's First Spaceline

Client: Richard Branson/Susan Newsam/Adam Wells/Tom Westray/Stephen Attenborough/Ned Rocknroll. Flight-path photography: Ron Dantowitz, MarsScientific.com

People, not Projects.

Land Securities
'Built for Fashion' Campaign

Client: Anna Chapman/Kristi O'Connell Photography: Jason Tozer

Land Securities
'Famous Faces' Campaign

Client: Anna Chapman/Kristi O'Connell. Photographer: David Graham. Models: Julia Roberts/Tom Jones. Legal advice: Guy Heath, Partner on behalf of Nabarro LLP

PUMA
'DuoCell' Campaign

Client: Antonio Bertone/Adam Petrick. Director/Producer: Robert Jitzmark. Illustration/animation: All rights acknowledged

PUMA
'Hello' Campaign

Client: Antonio Bertone/Adam Petrick Photographer: Juergen Teller

Tretorn
'Swedish Goodness' Campaign

Client: Antonio Bertone/Sabrina Sandberg/Bridgid Murphy. Photography: Timur Celikdag. Set Design & Build: Anna Burns & Karl Kramer

ZA Café Literaire, Paris
Paris Restaurant Branding

Client: Philippe & Fabienne Amzalak. Food Photography: Sara Morris. Animation: Peter Robert Smith/Emily Knight. Typewriter Film: ShootMedia. Interior & Exterior photography: Elodie Dupuis

Turtons Protective Clothing
Brand Identity

Client: Pat & Richard Saville. Illustration: GBH Photography: Matt Stuart

Samuels & Associates
The Verb Hotel, Boston Fenway

Client: Steve Samuels/Joel Sklar/Robin Brown/Sabrina Sandberg/Mike Fitzpatrick Interior Design: Elizabeth Lowrey, Elkus & Manfredi Architects. Lettering Artist: Alan Levett. 'V' Sign photography: Mike Diskin. People photography: Drex Drechsel. Interior photography: Adrian Wilson. Ephemera: David Bieber/Steve Mindich

A Child of Six Could Not Do This.

STARCK Eyes
Campaign and Retail Store POP

Client: Alain Mikli/David Schulte/Sandrine De La Pommeraye/Philippe Starck. Photographer: Timur Celikdag. Retoucher: Simon Ing, Invisible Inc

Royal Mail
Doctor Who Anniversary Stamps

Client: Dean Price/Helen Cumberbatch Stamp Imagery provided with kind permission of Royal Mail Group Limited ©. Stamps Doctor Who Logo © 2012 and TM BBC. Licensed by BBC WW Ltd. Acknowledgements BBC, DOCTOR WHO (word marks, logos and devices), TARDIS, DALEKS, CYBERMAN and K-9 (word marks and devices) are trade marks of the British Broadcasting Company and re-used under license. BBC logo ©BBC 1996. Doctor Who logo ©BBC 2012. Dalek image ©BBC/Terry Nation 1963. Cyberman image ©BBC/Kit Pedler/Gerry Davis 1966. K-9 image ©BBC/Bob Baker/Dave Martin 1977. Licensed by BBC WW Ltd. Mini Sheet Comic Strip Illustration: Lee Sullivan

PUMA Clever Little World
Environmental branding Scheme

Client: Antonio Bertone/Adam Petrick. Clever Little Bag product design: Yves Béhar, Fuse Project

PUMA Ferrari
Retail Store Installation

Client: Antonio Bertone/Adam Petrick Set build: Anna Burns & Karl Kramer

Cidade Matarazzo
São Paulo Retail Branding Scheme

Client: Alexandre Allard/Remy Fleury

MOB Hotel Of The People
Branding and Hotel Touchpoints

Client: Cyril Aouizerate/Steve Case/Philippe Bourguignon/Michelle Reibier

Royal Mail
Britain In Miniature Part-work

Client: Marcus James/Dean Price. Stamp Imagery provided with kind permission of Royal Mail Group Limited © Acknowledgements. The Sky at Night: Stamps Dick Davis. Images Courtesy NASA/JPL-Caltech, The Sky at Night with BBC permission. Sealife: Stamps Andrew Ross. World of Invention: Stamps Illustrator Peter Till. Images courtesy Science Museum/SSPL. Abolition of the Slave Trade: Stamps Howard Brown Celebrating England: Stamps Silk Pearce. Christmas: Stamps Rose Design Stamp Illustration: Marco Ventura. Images: Cherubim image courtesy Saint Vincent Archabbey Scout Centenary: Stamps The Workroom. Gez Fry Birds: Stamps Stamps Kate Stephens. Stamp Illustration British Army Uniforms: Stamps Atelier Works. British Grand Prix: Stamps True North. Beside the Seaside: Stamps Phelan Barker. 60th Royal Wedding Anniversary: Stamps Studio David Hillman. Images Official Diamond Wedding Silver Proof Crown Images courtesy of the Royal Mint, 2002 Queen and Prince Philip photograph by John Swannell, Camera Press London. All other 60th Royal Wedding Anniversary images from the Robert Opie Collection.

PUMA Stores
Local Advertising Campaign

Client: Antonio Bertone/Adam Petrick Illustration: Andrew Rae

The Art of Simple Joy.

PUMA Icons
Branding System

Client: Antonio Bertone/Adam Petrick Icons: Greg Kirkland/Alan Levett

Eurostar
Business Lounge Installations

Client: Richard Hill/Jean-Marc Barbaud. X-Ray photography: Colin Gray Retoucher: Peter Ruane

PUMA Phone
User Interface Design

Client: Antonio Bertone/Nina Nix. Phone development: Jérôme Nadel, Sagem Wireless. Icons: Greg Kirkland. Photography: Sara Morris

PUMA Redworld
Branding System

Client: Antonio Bertone/Adam Petrick Icons: Greg Kirkland/Alan Levett

Miss Ko
Cocktail Menu

Client: Claude Louzon. Illustrations: Yeji Yun

Parrot
A Branding Story

Client: Henri Seydoux. Illustration: Greg Kirkland. Animation: 12foot6

Levi's
Mr Strauss' Socks

Client: Nina Nix/Stephen Gambie

The Adria
Branding & Hotel Touchpoints

Client: Ziad Chemaitilly, Diyafa Qatara Interior designer: Karin Cooper, Urban Velvet Design Ltd. Operations consultant: Mohamed Gemei. Leather bound books: Pemberton & Milner.

AB Walker
Branding & Film Installation

Client: Julian & Matthew Walker Animation: Jonathan Lax, Gekko

From the Archive
It's the Little Things

1. Barcode on *The Extraordinary World of the Football Fan*. Photography: Mark Leech. 2. Biscuit Dunking Guide Cup. 3. GBH Late Payment postcard. 4. PUMA Festive Gift Box. Illustration: Colin Shearing. 5. Cabbage Man Hoarding. Client: Richard Hill/Jean-Marc Barboud. Photography: Chris Moyse. 6. The Verb Hotel, Boston. 7. "Thought of the Week". 8. Proposed logo for Groupe Allard. 9. Teleconnect identity. Client: Nicholas Von Bruemmer. 10. Solar Charging Station. Client: Antonio Bertone/Adam Petrick. 11. GBH Recession Party invitation

Mama Shelter
Branding & Hotel Touchpoints

Client: Jeremie & Benjamin Trigano Chicken photography: Jill Greenberg Luggage label illustrations: James Joyce

PUMA Peepshow
Changing Room Installation

Client: Antonio Bertone/Adam Petrick. Film Production: Washington Square Films, NY/Art & Graft. Screen technology: Spies & Assassins

PUMA Jamaica
In-store Campaign Posters

Client: Antonio Bertone/Adam Petrick Photographer: All rights acknowledged

PUMA Stores
Till Receipts

Client: Antonio Bertone/Adam Petrick

To Catch a Mouse, Make a Noise Like a Cheese.

PUMA
'Spackle' Campaign

Client: Antonio Bertone/Adam Petrick Photography: Andrew Zuckerman

PUMA
'Gaffer' Teamsport Product Typeface

Client: Filip Trulsson/Johan Adamsson/Terence Parris. Typeface in association with Dalton Maag. Image: Martin Rose, Getty Images Sport

Dalla collezione Alajmo
AMO, Venetian Restaurant Branding

Client: Raffaele & Massimiliano Alajmo/Marisa Huff. Image retouching: Simon Ing, Invisible Inc

Ipanema with STARCK
Footwear campaign

Client: Marina Pozza / Philippe Starck. Photography: Timur Celikdag. Post Production: Simon Ing, Invisible Inc. Styling & Model making: Alun Davies

PUMA
'Future Forever Victorious'

Client: Filip Trulsson/Terence Parris. Arsenal FC: Charles Allen/David Adams/Daniel Johnston/Vinai Venkatesham/Gordon Tannock. Photography: David Clerihew. Retouching: Danny Holden, Tapestry

Royal Mail Special Stamps
Inventive Britain

Client: Dean Price/Helen Cumberbatch. Stamp Imagery provided with kind permission of Royal Mail Group Limited © Imagery: World Wide Web: Internet blog map image ©Matthew Hurst/Science Photo Library, Fibre Optics: CGI illustration by Gekko Animation Limited; Catseyes is a registered trade mark of Reflecting Roadstuds Ltd, i-limb is a registered trade mark of Touch EMAS Limited 1/a Touch Bionics.

STARCK Paris
A perfume 'Between Real & Imagined'

Client: Pedro Trollez/Sonia Graffin/Olga Pellicier/Philippe Starck. Photography: Timur Celikdag. Post Production: Simon Ing, invisible Inc

A Measure of Success.

PUMA Bodywear
Our First Product

Client: Antonio Bertone/Adam Petrick Photography: Uli Weber

GBH Christmas Card, 2002
Our First Billboard

The 35th America's Cup
Our First Global Branded Event

Client: Antonio Bertone/Dan Barnett. Sponsor: Louis Vuitton. Animation: Smoke & Mirrors. TV Graphics: Brandspank. Event photography: Garry Williams JR/Ainhoa Sánchez

BMW FlyTime™
Our First Live TV Broadcast

Client: Klaus Hammerstingl, BMW. ACEA: Antonio Bertone/Dan Barnett/Denis Harvey. TV Graphics: John Rendall, Virtual Eye. Yacht photography: Ricardo Pinto/Matt Knighton

PUMA FIGC
Our First Football Badge

Client: Filip Trulsson/Johan Adamsson. Image: Valerio Pennicino/Stringer, Getty Images Sport

PUMA Ocean Racing's 'Marmo'
Our First Toy

Client: Mark Coetzee/Andrea Brenninkmeyer/Antonio Bertone/Hanna Cutler/Danielle Marcus/Owen Martin/Filip Trulsson/Jochen Zeitz. Illustration: Neil McFarland. Book Text: Christina Hodson

Royal Mail Special Stamps
Our 'FAB' First Front Page

Client: Alastair Pether/Helen Cumberbatch. Stamp Imagery provided with kind permission of Royal Mail Group Limited © Stamps Joe 90©™ and © ITC Entertainment Group Limited 1969 and 2011; Captain Scarlet™ and © ITC Entertainment Group Limited 1967, 2001 and 2011; Thunderbirds™ and © ITC Entertainment Group Limited 1964, 1999 and 2014; Stingray and © ITC Entertainment Group Limited 1964, 2002 and 2011; Fireball XL5™ and © ITC Entertainment Group Limited 1961, 2002 and 2011; Supercar © ITC Entertainment Group Limited 1959, 2002 and 2011. All rights reserved. Pack Words; Chris Bentley. Pack acknowledgements; Gerry Anderson photo copyright unknown; Joe 90 annual and images used in books/trading cards © ITV; annual covers, Reynold & Hearn Ltd. Comic Illustration by Gerry Embleton; Written by Stephen La Rivière; Thunderbirds Are Go © 1966 Metro-Goldwyn-Mayer Studios inc. All Rights Reserved. Courtesy of MGM Media Licensing. Character and elements used with permission of Granada Ventures Limited

Thunderbirds Stamps
Stamps Thunderbirds TM and ©ITC Entertainment Group Limited 1964, 1999 and 2011. Licensed by Granada Ventures Ltd. All rights reserved. Card Illustration Gerry Embleton. Acknowledgements: Thunderbirds Are Go© 1966 Metro-Goldwyn-Mayer Studios inc. All Rights Reserved. Courtesy of MGM Media Licensing

Virgin Galactic VSS UNITY
Our First Space Rocket

Client: Richard Branson/Susan Newsam/Adam Wells/Tom Westray/Stephen Attenborough/Ned Rocknroll

VSS UNITY Launch
From Paper Planes to Han Solo

Client: Richard Branson/Susan Newsam/Adam Wells/Tom Westray/Stephen Attenborough/Ned Rocknroll. Photographer: VSS UNITY/Land Rover image Nick Dimbleby

WE'RE NOT CALLED GBH FOR NOTHING.

We're called GBH because we all felt that
Gregory Bonner Hale sounded like a solicitors.

But why on earth would anyone name their agency after
one of the most heinous crimes this side of murder?

Believe it or not, this was the best use of the three initial letters
we had been dealt. Let's consider some of the alternatives:

BGH stands for Bovine Growth Hormone, used by farmers
to accelerate growth and fat production in young cattle.

HGB is a Honda motorcycle dealership in Ruislip specialising
in the incredible, but ridiculous Gold Wing.

GHB (Gamma Hydroxybutyrate) is an incapacitating agent
used by sexual predators as a "date rape drug".

Suddenly GBH seems quite the
cheery alternative doesn't it?

The first time we tried it out was on a
receptionist, and it went something like this:

"Hello, we're Mark, Pete and Jason from GBH."
"Oh, how unfortunate", said the elderly receptionist
as she went off to make the teas.

© 2016 Black Dog Publishing Limited, London, UK, the authors and the artists.
All rights reserved.

Black Dog Publishing Limited
10a Acton Street, London, WC1X 9NG
United Kingdom

+44 (0)20 7713 5097
info@blackdogonline.com
www.blackdogonline.com

Designed by GBH
Edited by Black Dog Publishing Ltd

British Library in Cataloguing Data
A CIP record for this book is available from the British Library

ISBN 978 1 910433 90 4

Black Dog Publishing Limited, London, UK, is an environmentally responsible company. *Charm, Belligerence & Perversity:
The Incomplete Works of GBH* is printed on sustainably sourced paper.

art design fashion
history photography
theory and things

www.blackdogonline.com